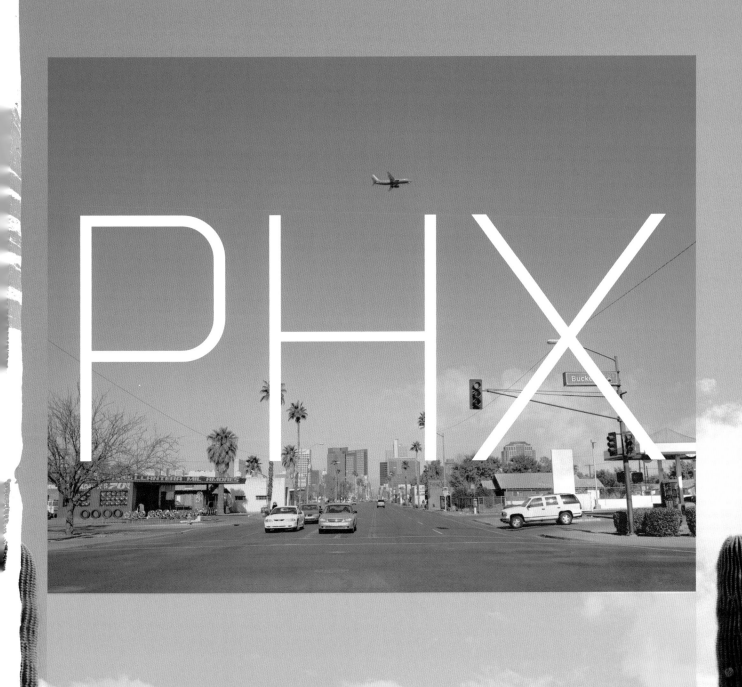

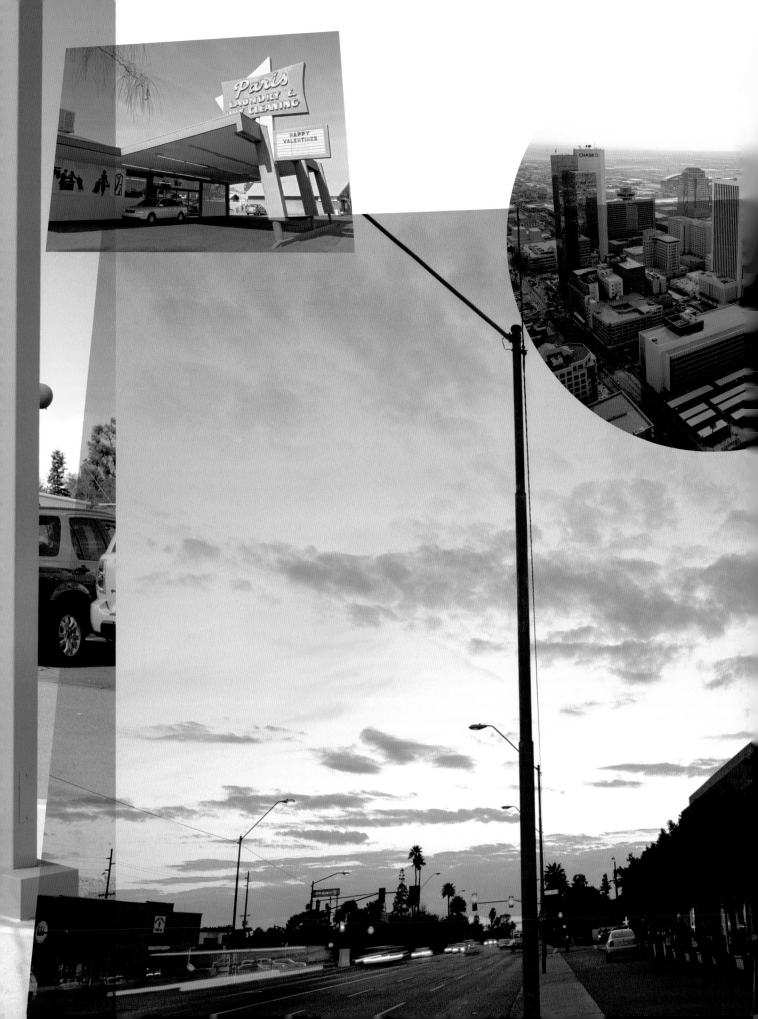

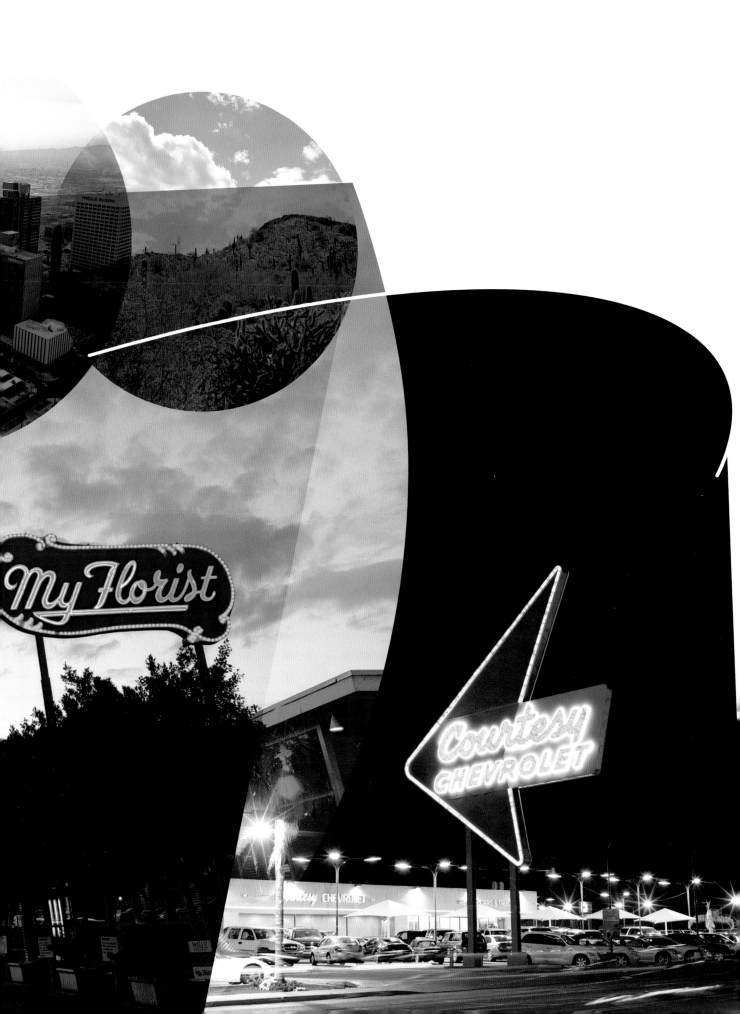

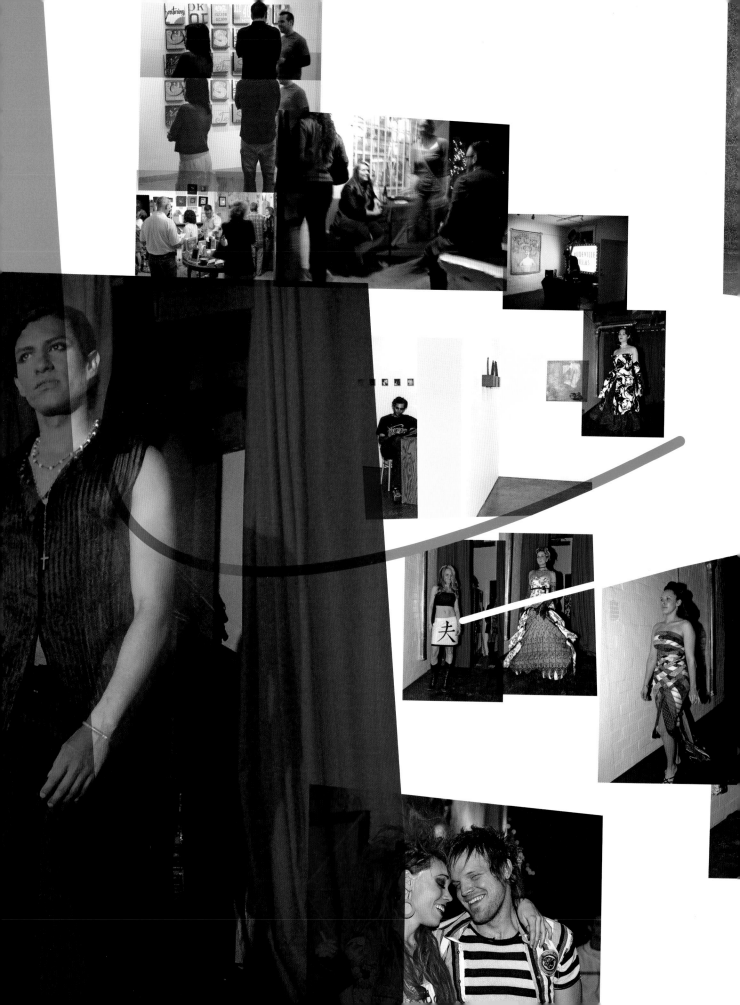

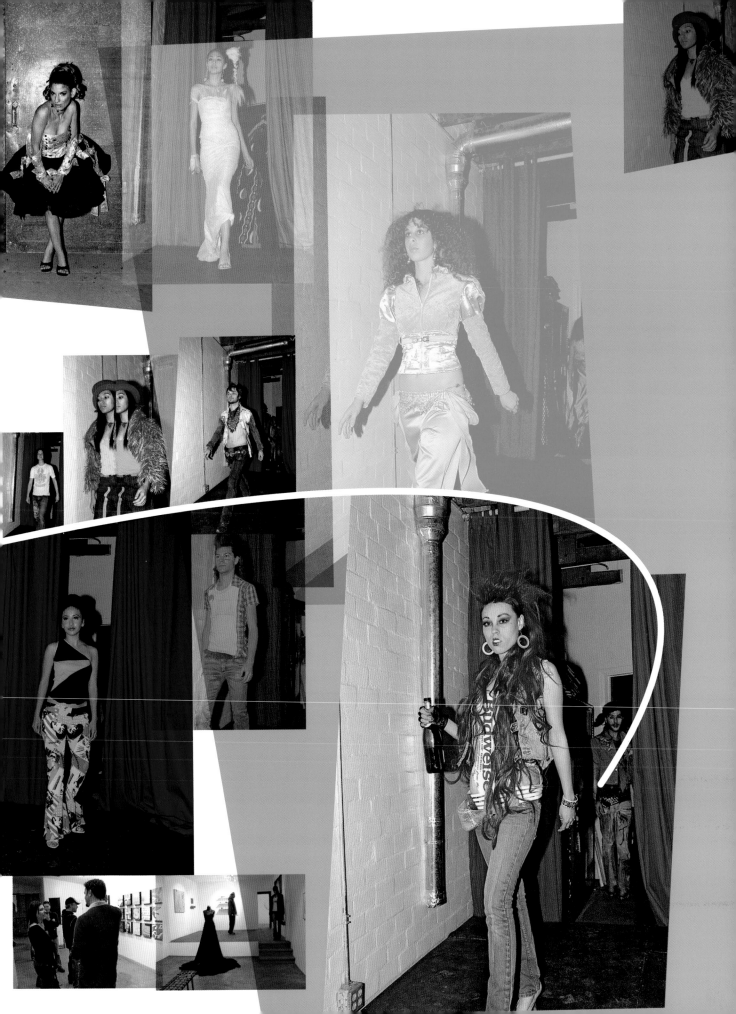

P.006 PHX CREDITS

EDITOR: EDWARD BOOTH-CLIBBORN

DESIGN: JONATHAN BARNBROOK & PEDRO INOUE AT BARNBROOK DESIGN

PROJECT EDITOR FOR BOOTH-CLIBBORN EDITIONS: ESZTER KÁRPÁTI

PROJECT COORDINATOR FOR MPAC: CYD WEST

COMMISSIONED PHOTOGRAPHY © TOMOKO YONEDA

FOREWORD © EDWARD BOOTH-CLIBBORN

PHOENIX 21: DESERT METROPOLIS © NAN ELLIN

WITH THE GENEROUS SUPPORT OF MARICOPA
PARTNERSHIP FOR ARTS AND CULTURE

FIRST PUBLISHED IN 2006 BY

BOOTH-CLIBBORN EDITIONS

UNITED KINGDOM

WWW.BOOTH-CLIBBORN.COM

© BOOTH-CLIBBORN EDITIONS 2006

A CATALOGUING-IN-PUBLICATION RECORD FOR THIS BOOK
IS AVAILABLE FROM THE PUBLISHER.

ISBN 1-86154-292-5

PRINTED AND BOUND IN HONG KONG

P.007 PHX CONTENTS

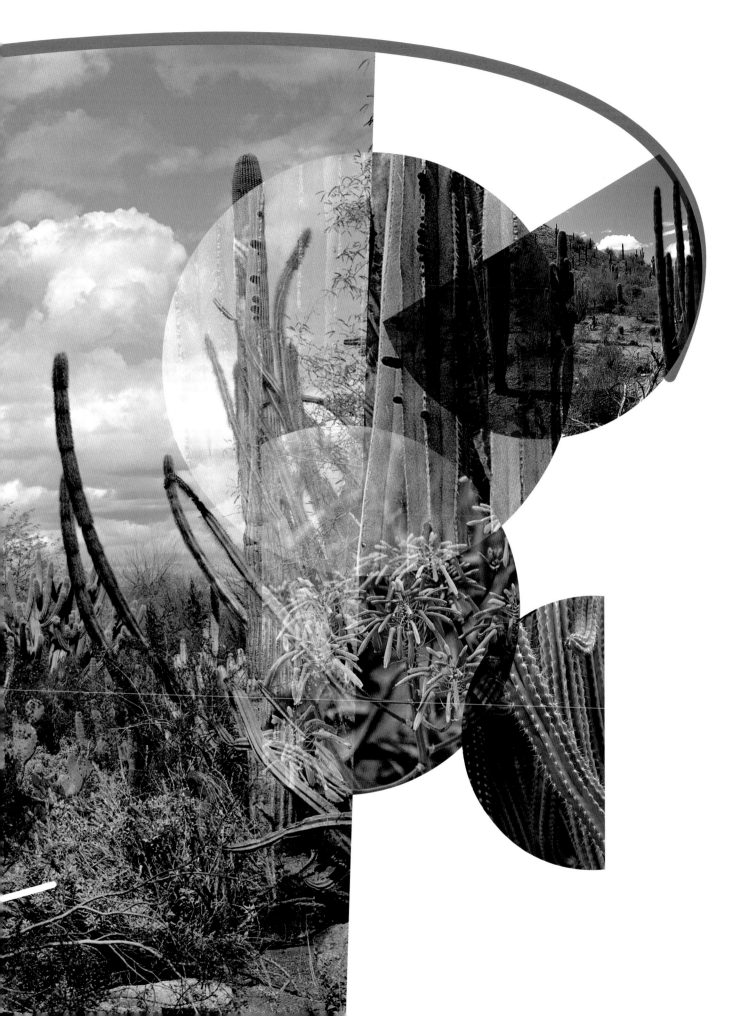

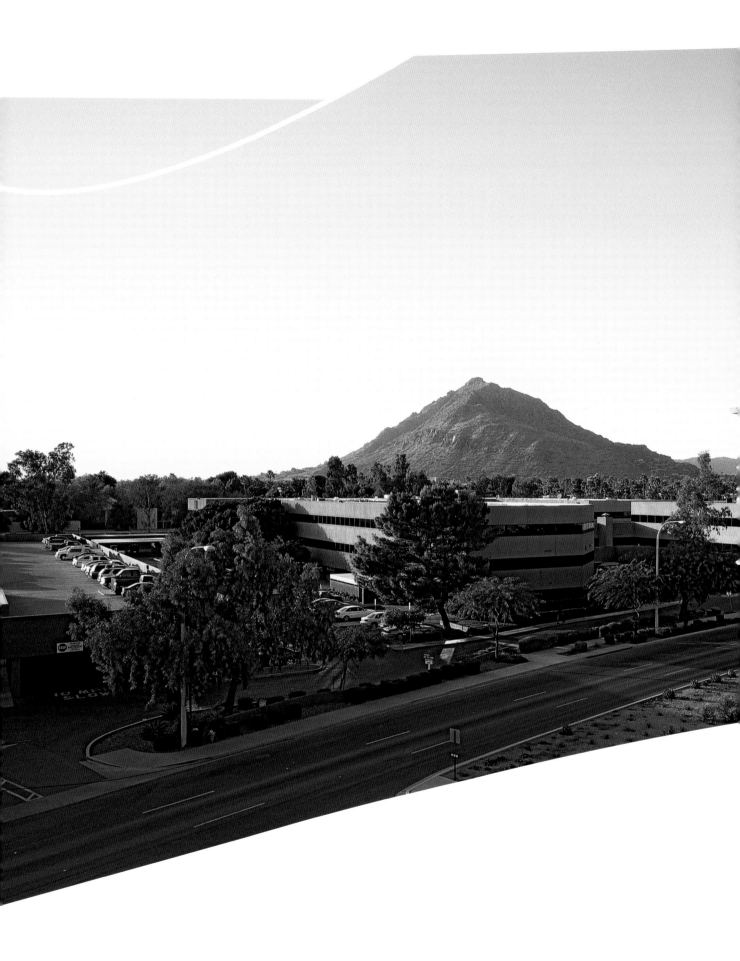

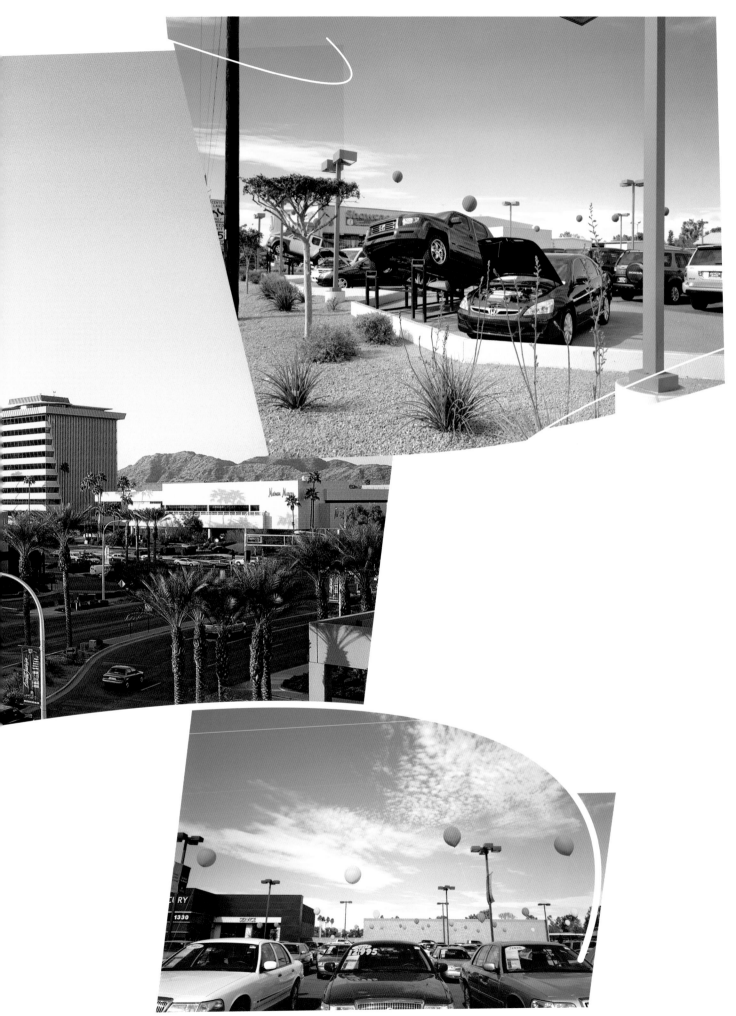

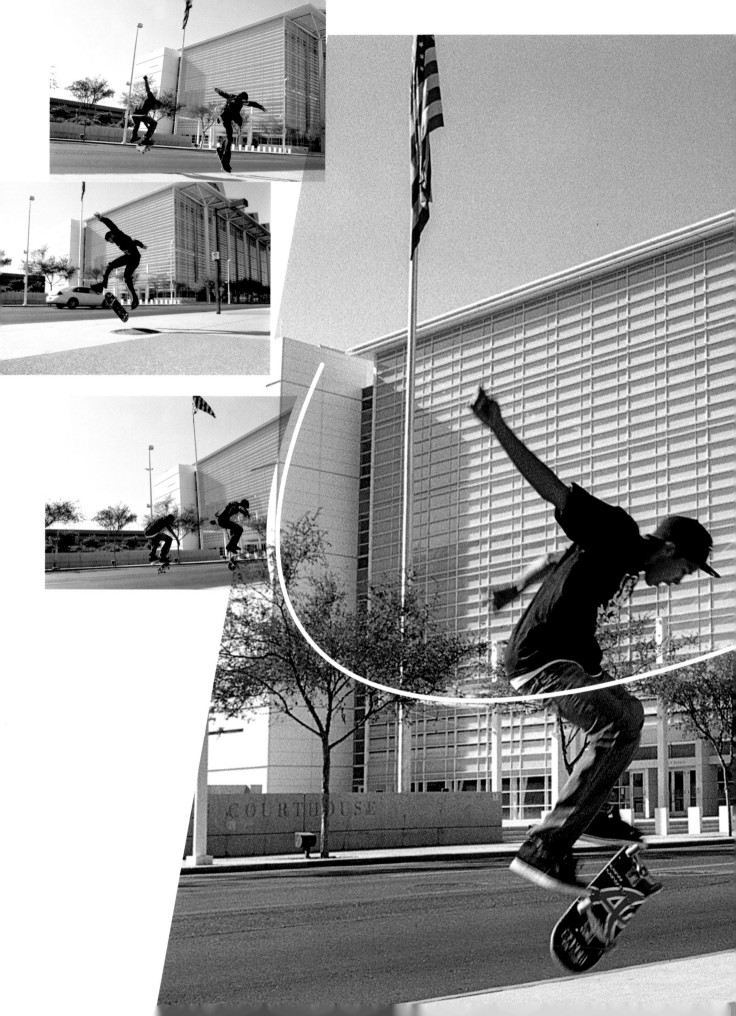

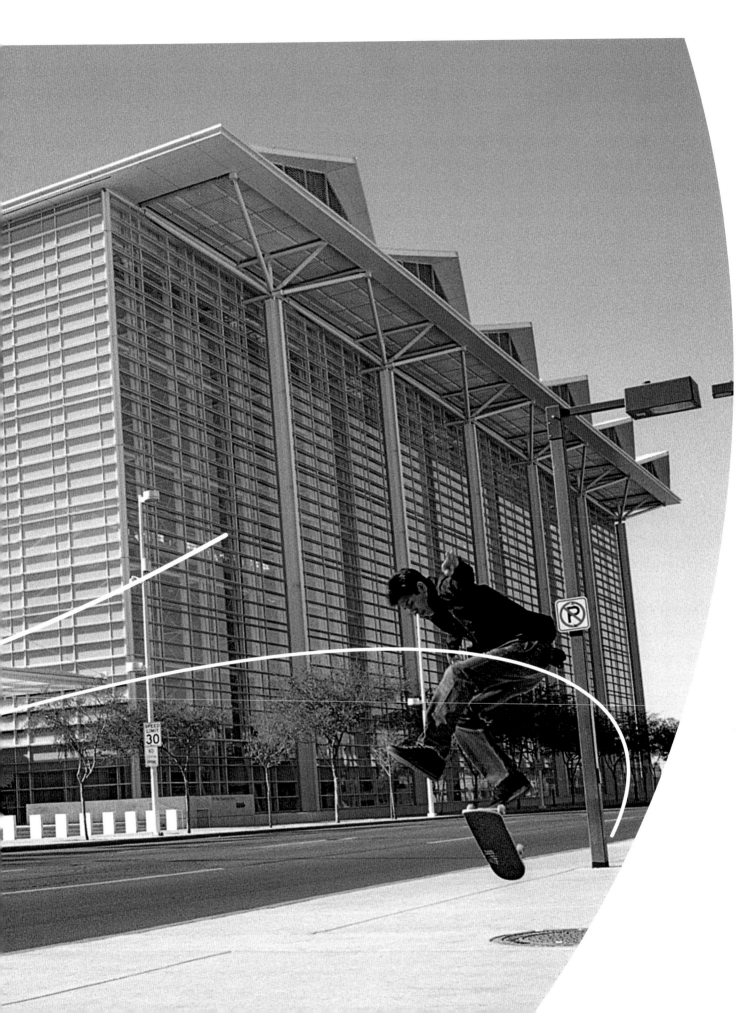

EDWARD BOOTH-CLIBBORN

I AM ALWAYS LOOKING FOR DIFFERENT WAYS OF SHOWING UP-TO-DATE DESIGN AND IN THE BOOTH-CLIBBORN EDITIONS SERIES ON CITIES I THINK I HAVE FOUND A FRESH APPROACH. TAKING THE CITY AS A CENTRAL POINT AND SHOWING THE TALENT OF THE DESIGNERS, ARCHITECTS AND ARTISTS WORKING THERE IS THE KEY TO THIS PRINCIPLE BECAUSE I BELIEVE IN LOCAL PRIDE.

MAYBE I AM TURNING THE CLOCK BACK TO THE GREAT CITY-STATES OF THE 17TH CENTURY SUCH AS VENICE OR AMSTERDAM, WHICH WERE FINANCIALLY STRONG AND SUPPORTED THE ARTS. COULD GREATER PHOENIX BE EMERGING AS A SIMILAR SELF-CONTAINED CITY-STATE IN THE PRESENT ENVIRONMENT? THE FIRST SUCH 21ST CENTURY CITY.

THE BOOKS I PUBLISH ON CITIES MUST NOT BE SELF-CONGRATULATORY OR LIKE A TRAVEL BROCHURE. THEY HELP TO PUT A CITY ON THE MAP FROM A FRESHER, DIFFERENT PERSPECTIVE, TO BE SEEN IN A NEW LIGHT IN UNEXPECTED WAYS. THE SERIES LOOKS INSIDE CITIES THROUGH THEIR CREATIVE COMMUNITY AND LIVING ENVIRONMENT, WHICH IS WHAT FUNDAMENTALLY INFLUENCES THEIR WORK.

WHEN NAN ELLIN INVITED ME TO PHOENIX IN MAY 2005 WITH THE IDEA OF DOING A BOOK ABOUT THE CREATIVE SCENE IN MARICOPA COUNTY, I HAVE TO ADMIT THAT I WAS SKEPTICAL. MY VISIT REVEALED A SIDE OF PHOENIX I HAD NOT ANTICIPATED AND I WAS PLEASANTLY SURPRISED. THE FIRST FRIDAY EVENTS WHEN UP TO 15,000 LOCAL PEOPLE COME INTO THE CITY TO ENJOY THE ART SCENE WERE FULL OF CREATIVE ENERGY, WHICH IS EXACTLY WHAT WILL ATTRACT OTHERS TO COME TO LIVE AND WORK HERE IN THE FUTURE. IT WAS REFRESHING TO EXPERIENCE THE

ENTHUSIASM OF THE GROUP OF YOUNG FASHION DESIGNERS WHO PUT ON A SHOW IN
A PARKING LOT, AND ON A LATER VISIT IN A GALLERY (SEE PAGES 4-5). THE PUBLIC
INTEREST IN THE SCOTTSDALE AND PHOENIX GALLERY SCENE MADE ME REALIZE
HOW MUCH WAS GOING ON CREATIVELY IN THE AREA.

THE EXTRAORDINARY LOCATION OF PHOENIX AND THE INFLUENCE OF THE DESERT
IS A CONTINUOUS THEME THROUGHOUT THE BOOK AND INSPIRES SOME REALLY
EXCEPTIONAL ARCHITECTURE. FROM THE POINT OF VIEW OF THE BOOTH-CLIBBORN
CITY SERIES THIS IS ONE OF THE MOST OUTSTANDING DIFFERENCES FROM THE OTHER
BOOKS. THE LOW PRICE OF REAL ESTATE HAS GIVEN YOUNG ARCHITECTS A UNIQUE
OPPORTUNITY TO CREATE INNOVATIVE WORK. I HAVE INCLUDED SOME FINE EXAMPLES
OF BOTH PRIVATE HOUSES AND PUBLIC BUILDINGS.

TO ME THE WORLD OF DESIGN, ARCHITECTURE AND ART IS LIKE A MOSAIC. EVERYTHING
RELATES TO EVERYTHING ELSE AND THERE IS ALWAYS A CROSSOVER OF INFLUENCES.
THIS IS REFLECTED IN THE PLACEMENT OF THE WORK THROUGHOUT THE BOOK. THIS
WAY THOSE WHO LOOK THROUGH THE BOOK WILL EXPERIENCE THE CITY AS IF THEY
WERE THERE.

I WOULD LIKE TO THANK MYRA MILLINGER, PRESIDENT AND CEO OF THE MARICOPA
PARTNERSHIP FOR ARTS AND CULTURE, FOR GIVING ME HER SUPPORT AND
ENCOURAGING PEOPLE TO TAKE PART IN THIS BOOK. I WOULD ALSO LIKE TO THANK
THE MPAC WHO INVITED ON MY BEHALF DESIGNERS, ARCHITECTS AND ARTISTS TO
SUBMIT THEIR WORK, THE ADVISORY COMMITTEE WHICH WAS APPOINTED TO ENSURE
THAT EVERYONE SHOULD HAVE AN OPPORTUNITY TO PRESENT THEIR WORK AS WELL
AS MARILU KNODE AND LARA TAUBMAN FOR HOSTING MY FIRST VISIT TO PHOENIX.

I HAVE EDITED *PHOENIX: 21ST CENTURY CITY* BY SELECTING WORK OF THE HIGHEST
CREATIVE STANDARDS. I COMMISSIONED JONATHAN BARNBROOK, ONE OF THE MOST
IMPORTANT AND INFLUENTIAL DESIGNERS WORKING TODAY, TO DESIGN THE BOOK.
I ALSO COMMISSIONED A SPECIAL PHOTOGRAPHIC ESSAY OF MARICOPA COUNTY BY
TOMOKO YONEDA, WHICH RUNS THROUGH THE BOOK.

THE RESULT IS AN INTERESTING COMBINATION, AS THE PHOENIX ENVIRONMENT
NOT ONLY STIMULATES LOCAL CREATIVITY BUT ALSO ATTRACTS CREATIVE PEOPLE
FROM ALL OVER TO COME AND LIVE IN THIS EXTRAORDINARY 21ST CENTURY DESERT
METROPOLIS, WHICH I BELIEVE WILL GROW FROM STRENGTH TO STRENGTH.

PHOENIX 21: DESERT METROPOLIS

BY NAN ELLIN

WHEN I LIVED IN PARIS, I WISHED I WERE THERE IN THE 1860S, AS THE CITY WAS UNDERGOING DRAMATIC SOCIAL AND URBAN TRANSFORMATIONS THAT MARKED ITS DESTINY. WHEN I LIVED IN NEW YORK, I WISHED I HAD BEEN THERE IN THE 1910S WHEN MASSIVE MIGRATION AND CITY BUILDING WERE FORMING ITS INIMITABLE CHARACTER. AND WHEN I LIVED IN LOS ANGELES, I WISHED I WERE THERE IN THE 1950S, WHEN IT GAINED PROMINENCE AS A HUB FOR POSTWAR INNOVATION. LIVING IN PHOENIX OVER THE LAST EIGHT YEARS, I HAVE FELT THAT I AM FINALLY IN THE RIGHT PLACE AT THE RIGHT TIME.

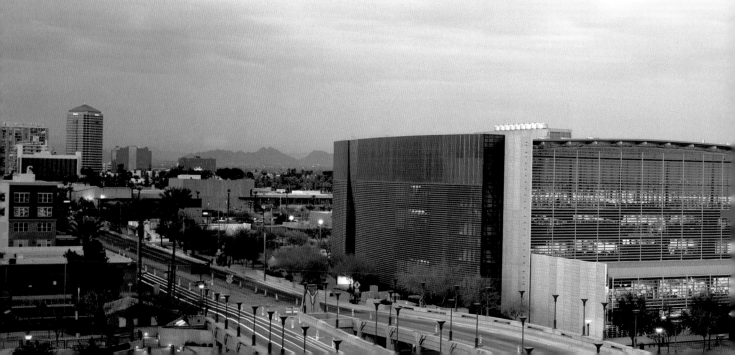

Thanks to its majestic desert setting, appealing climate, and abundant economic opportunity, the Phoenix metropolitan area is the fastest growing in the United States. In recent years, exponential growth has combined with a historically independent spirit and relatively low cost of living to attract an impressive concentration of talent, energy, and vision. Like Paris, New York, and Los Angeles at their critical junctures, this metropolis is enjoying a flourishing of expressive arts which are leaving their mark, shaping the city as well as city life.

Gently cradled within a ring of mountain ranges, metropolitan Phoenix exudes a calm tranquility alongside a youthful exuberance. The bright sun and straight wide streets lined by palm trees lend a serene – and sometimes otherworldly – quality to circulating through Phoenix. Fragrant orange blossoms and ebullient desert wildflowers announce the arrival of spring and fresh rains emit the musty scent of creosote in monsoon season. The sky looms large in the desert, allowing a visibility that is both compelling and overwhelming. Magnificent sunrises and sunsets bracket daily fares of perennially changing palettes that alternate with glittering nighttime starscapes. The big sky allows us to stretch our eyes, see the horizon, and consider what may lie beyond it.

Against this backdrop of enduring natural rhythms and undulating mountains, their distinct profiles etched by time, a vibrant culture pulsates, to the varying beats of many drummers.

Once a month, thousands of people converge in downtown Phoenix to attend the First Friday Artwalk. This human river winds through numerous galleries and studios open for the evening, partaking along the way in a great street party of *plein aire* fashion shows, performance and installation art, belly dancers, hip hop troupes, "U-Haul galleries" rented for the evening and parked on vacant lots, and an itinerant band called the MadCaPs who play from the bed of a roving pickup truck. The annual Art Detour, a pumped-up version of First Friday spanning an entire weekend, is among the most-attended arts events in the country. Given the infusion of artists and arts events along with affordable live/work space, *Art in America* recently reported, "In many ways, downtown Phoenix has the key elements that self-starting, contemporary art scenes thrive upon".[1] In addition, Scottsdale's well-established art district hosts weekly artwalks and the larger region is home to several major art museums and theatres as well as a symphony, opera, and ballet.

In this crucible of rapid growth in the Sonoran Desert at the turn of the 21st century, distinct expressions are forged. The art and design emerging from the Phoenix region falls into four categories. Some derives directly from this place, using natural materials or found objects. A second category portrays this place, both its natural and constructed features, or is somehow inspired by these. Other work is informed by local conditions, inciting paeans, critiques, or mere reflections on urban sprawl, car culture, suburban living, migrations, ethnic diversity, environmental devastation or conservation, and more. The fourth category consists of art and design that could be produced anywhere. In other words, some of the work is created *out of this place*, some is created *about this place*, some is created *because of this place*, and some is created *in spite of this place*.

Well over half of the metropolitan Phoenix population originates from other places and there are more domestic movers than any other region in the nation since 2000. Thanks to this dynamic confluence, the human fabric weaves a rich array of social diversity including contemporary Native Americans, Anglos, African Americans, Latinos, Europeans, Asians, and more. There are markets and restaurants offering delicacies from around the world, houses of worship representing all major religions, and a wide spectrum of cultural celebrations and artistic expression. A thriving gay and lesbian community hosts a Lesbian and Gay Film Festival, a Gay and Lesbian Chamber of Commerce with over 500 members, an alternative high school prom, and a gay rodeo.

Metro Phoenix has become a magnet in recent years for leaders in business, politics, education, information technology, and the biosciences. Many of them are drawn by marked efforts to "leapfrog" over other regions in these arenas and by the forward-thinking agenda of ASU, already one of the largest universities in the country and growing. Others come to this region on vacation, but end up staying. And others still come to retire, but boredom often conspires with the rejuvenating setting to propel them back to work. In many instances, they find themselves "busier than ever," perhaps on a divergent track allowed by their reflective pause.

Whether moving here in search of personal renewal, adventure, or political and economic freedom, Phoenix has long been a place where people come to restore or

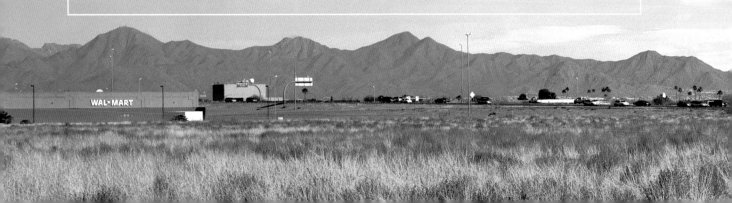

reinvent themselves. Like the mythical phoenix bird, this city is a place of rebirth. Liberated from the weight of prior expectations, obligations, or oppressions, an attitude of openness prevails along with an optimism and willingness to try new things. With the recent influx of people from all over the world and all walks of life, there is a lack of snobbery and generosity of spirit relative to more established cities. Perhaps the sunshine, the frontier legacy, and never having been a world center also play a role. Whatever the reason, Phoenix refreshingly lacks "attitude."

As we career into the 21st century, the local has become a quaint anachronism. Instantaneous exchange of information, ideas, and money, along with rapid movement of people and goods has made the world seem much smaller in certain respects.

While we enjoy riding this wave of rapid change and the benefits that accrue to being citizens of the world, the accelerated pace can be unsettling. The more mobile we become as a society, the more we crave a sense of rootedness, community, and belonging. The more rapidly the world changes around us, the more sorely we crave authentic connections with places, people, and ourselves. The more we become a "global village," the more obstinately and passionately we seek distinction. While we value access to mass information and goods, we also prize unique one-offs and face-to-face interaction. We long to feel things through real experiences, not canned and programmed ones. We demand substance, not deflective surface.

The city of the 21st century is not contained within a clear boundary, nor does it have a single center surrounded by hinterlands. Instead, it consists of hubs and nodes where transportation and communication networks overlap, extending physically as well as virtually. Its influences come from within as well as without.

Side by side with rapid change, and in the places it is most intense, expressions of creative culture often proliferate. A characterizing feature of this creative output is the blurring of boundaries between popular, mass, and high art. These expressions seek out the gaps in this network, spaces that are not yet occupied by global forces, including the costs those incur. Such creative clusters become new nodes in the network, requiring the discovery and occupation of other gaps which eventually become nodes, as the time-worn organic process of city and community-building unfolds.

Within the larger global network, Phoenix itself has been a gap and therefore an attractor for creative work. It is, in fact, the gap – or opening – that allows creative expression to spring forth in this place at this time. Phoenix was recently included among the top ten emerging hubs for creative talent in the U.S. and ranked the #1 city for entrepreneurs.[2] Moving to Phoenix twenty years ago and opening his own agency at the age of 23, advertising guru and professional drummer Louie Moses thought "This is the perfect place for an artist. You can think freely, and you have time to open your mind to new ideas." Six-time recipient of the prestigious Clio Award, his firm Moses Anshell inhabits a renovated 1920s railroad station in the warehouse district of downtown Phoenix. With a roster of clientele including Nintendo, Joe Boxer, and US Airways, the firm surpassed 69 million in billings last year. Moses maintains, "I think Phoenix has all the elements a city needs for a person to be creative...It can be a casual, relaxing atmosphere that puts your mind in a place where it can be open, but it also has the stimulation of a big city."[3]

The Phoenix metro area has become a fertile ground for young fashion designers, many of whom are drawn by three local design schools. While some focus on *haute couture* for a select clientele, most are producing "wearable art," one-of-a-kind moderately-priced casual clothing and accessories. Fashion designer Andrew Brown has chosen to live and work in Phoenix because "There is no 'group think' like there is in the L.A. and New York markets" where design tends to "elaborate on the same core style."[4]

Occupying gaps has also been occurring within the Phoenix region. Inhabiting residual spaces in the city that subsequently appreciate in value, artists move on to occupy other gaps and the process continues. The Phoenix arts community has benefited, however, from having one of the highest rates of artist owner-occupied space per capita in the nation. As a result, artists often turn a profit from this "gentrification." Not surprisingly, many artists have become integrally involved in real estate transactions and development at all scales, adding a whole new meaning to "the art of the deal."

Phoenix was originally platted on a grid system like most western towns, and urban growth has remained faithful to the grid. Periodically interrupted by mountains, canals, and rivers, as well as by master-planned communities and walled enclaves, streets generally resume their paths. In its relentless patterned predictability, the grid offers assurance that if you happen to stray, you could easily return. By chance or not, one of the strongest arts hubs in the Phoenix area is located along the only

street that defies the grid, Grand Avenue. Cutting through the city on a diagonal, Grand, not unlike Manhattan's Broadway, offers the freedoms and anomalies of living and working "off the grid."

Rather than growing up, the Phoenix metropolitan region has been growing out. Expanding at a rate of 1-2 acres an hour, the urban edge has lately been extending 1/2 mile per year. The city of Phoenix has the largest land mass of all U.S. cities and could accommodate within its boundaries Manhattan, Paris, Rome, Washington D.C., *and* San Francisco, with room to spare. The larger metropolitan region, encompassing twenty-four cities and five Indian reservations, spreads over 9,200 square miles, an area larger than the state of Massachusetts. In addition to Phoenix, which has the fifth largest population of any city in the U.S., this area includes other large cities such as Mesa, whose population is greater than Pittsburgh's, as well as several extreme-growth cities such as Buckeye, Surprise, Goodyear, and Apache Junction. In contrast to Paris, which maintains a density of 70,000 people per square mile, or traditional desert cities with a density of 35,000, or even Los Angeles with 12,000, there are less than 2,000 people per square mile in the Phoenix metropolitan area. Of approximately 1.5 million housing units, 67% are single-family houses, 27% are multi-family, and 6% are mobile homes. Less than 3% of all units were built prior to 1950 and 37% were built since 1990. The intensity of this growth machine, while the results may not always be felicitous, generates a dynamism and mindset of anticipation that lends to envisioning possibilities and better alternatives.

Given the vastness of this region and the need to navigate through it, wheels assume paramount importance. From skateboards to bicycles, motorcycles, cars, and trucks, there is a fascination, oft-times an obsession, with wheels. We customize them, accumulate them, covet others', curse them when they falter, pamper them in luxury garages, and treat them as extensions of ourselves.

In contrast to the traditional walking city, where most is accomplished on foot, Phoenix is the quintessential "driving city." Altering the scale and logic of everyday life, pedestrian paths become roads and social interactions often occur in parking lots or at the drive-through. In addition to the ubiquitous bank and fast-food drive-throughs, Phoenix has drive-through drug stores, liquor stores, dry cleaners, car washes, and libraries. Over half of the landscape is devoted to the car and the average household spends as much each year on its cars as it does on its home. This long reign of the car will soon shift as the first light-rail line opens in 2008, spawning along its 20-mile path numerous urban villages.

Phoenix is hot. It can feel like luxuriating in a nice bath or scorching on a hot griddle. While the thousands of "snowbirds" who descend each winter from cooler climates migrate home during the summer months, those who live here year-round learn to cope. Like the cost of housing in New York City or gray days in Seattle, coping with the heat fosters a sense of community. The heat is also a great leveler. We are all "survivors" together, regardless of age, income, or ethnicity.

Water is a source of delight as well as concern in the desert. Scientist and explorer John Wesley Powell described the West in 1878 as a place where optimism consistently outruns the water supply, a statement that probably still holds true today. Life in this desert city has relied upon access to water. The National Reclamation Act of 1903 made large-scale inhabitation of the region possible and careful measuring, monitoring, rerouting, restoring, and allocating of water has allowed continued growth. Phoenicians congregate around and celebrate water whether it is the canals that crisscross the region initially carved out by Native Americans, Tempe Town Lake, Rio Salado, or the urban fountains that dot the region.

The extreme conditions of this place oblige sensitive and unique responses. Desert dwellers contemplate ways to enhance our nests by taking advantage of naturally cooling breezes, erecting connective shade structures to shield us from the blaring sun, harvesting rainwater, replacing asphalt with pervious surfaces, and more. Too much comfort and our creative muses might be lulled to sleep. In addition to environmental challenges, rapid growth has incited vigorous debates among a large public, ultimately dispelling the assumption that this is a suburban city by focusing attention on revitalizing existing urban cores and building new ones. The expanse of the desert juxtaposed with expansive urban growth – the sublime with the often mundane – brings both into relief.

In recent years, Phoenix has become a regular stop along global architectural pilgrimages. The region's particular brand of Desert Modernism traces its lineage to Frank Lloyd Wright, who established Taliesin West in the 1930s and whose influence continues to reverberate throughout this valley. Moving to Arizona from Italy to work with Wright, Paolo Soleri developed his philosophy of "arcology" – a synthesis of architecture and ecology – as demonstrated at Arcosanti and Cosanti. Relocating from Wisconsin in

the 1960s to work with Soleri, Will Bruder has been carrying forth the architectural torch along with others including Eddie Jones, Wendell Burnette, Rick Joy, the De Bartolos, and Marwan Al-Sayed. Blending poetry, passion, and pragmatism, these architects skillfully inflect the desert modern tradition, inspiring the next generation who, in turn, bring global influences to the local architectural composite.

Taking cues from the desert itself, much of the best architecture and urban design emerging from this region embraces a combination of boldness and restraint, of showmanship and modesty. Combining primal instinct with technological acumen, contemporary Desert Modernists divine the thread linking traditional and modern. Enchanted by the extraordinary light emitted in this corner of the world, they deftly apply materials, color, and form to offer serene spaces for contemporary indoor/outdoor dwelling and working. Architects such as McCoy and Simon and Richärd + Bauer silhouette elegant forms against craggy buttes and landscapes spiked with saguaro cactus and carpeted with wild brush. Improvising on nature, Bruder gracefully offsets earth tones with bright hues, including a coral the shade of an ocotillo blossom and a "pungently optimistic green" matching the new growth of a palo verde tree. This noteworthy output of the last decade and a half, produced by dozens of architectural practices, has become distinguished as the "Arizona School."

Phoenix is coming of age. This book celebrates the creative energies sparked by an opportune convergence of people, place, time, and circumstance. It is a tribute to all who are forging something of value from the raw materials afforded by this desert metropolis at the dawn of the 21st century in song, dance, poetry, prose, performance, painting, sculpture, digital art, design, and architecture. This work inspires, illuminates, incites, and instructs. It brings depth, breadth, beauty, laughter, heart, and soul to our landscape and our lives.

Within this historic convergence resides the potential for a collective work of art at the urban scale. This is a city in formation. Unlike cities that are already formed, there is an opportunity to create it so it will flourish, bestowing rich harvests for years to come. Right here, right now.

FOOTNOTES:
1. John Villani, December 2002.
2. Fast Company, November 2005 and Entrepreneur, 2005.
3. Moses cited in Arizona Republic October 21, 2005 and in Fast Company, November 2005.
4. Cited in BizAZ May 1, 2004.

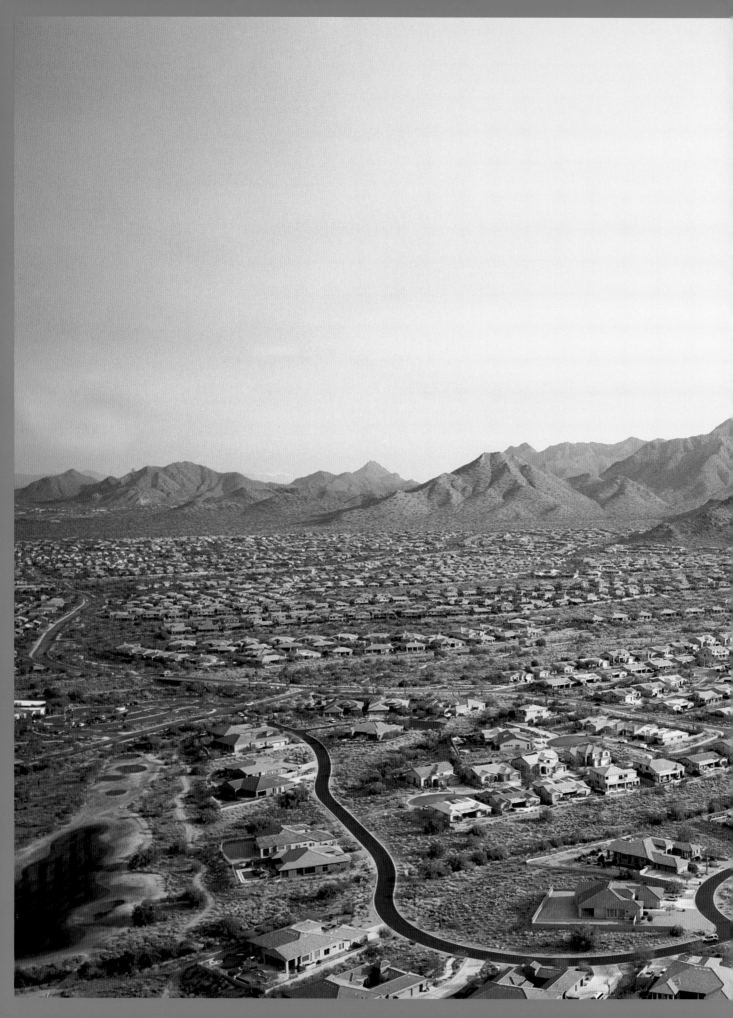

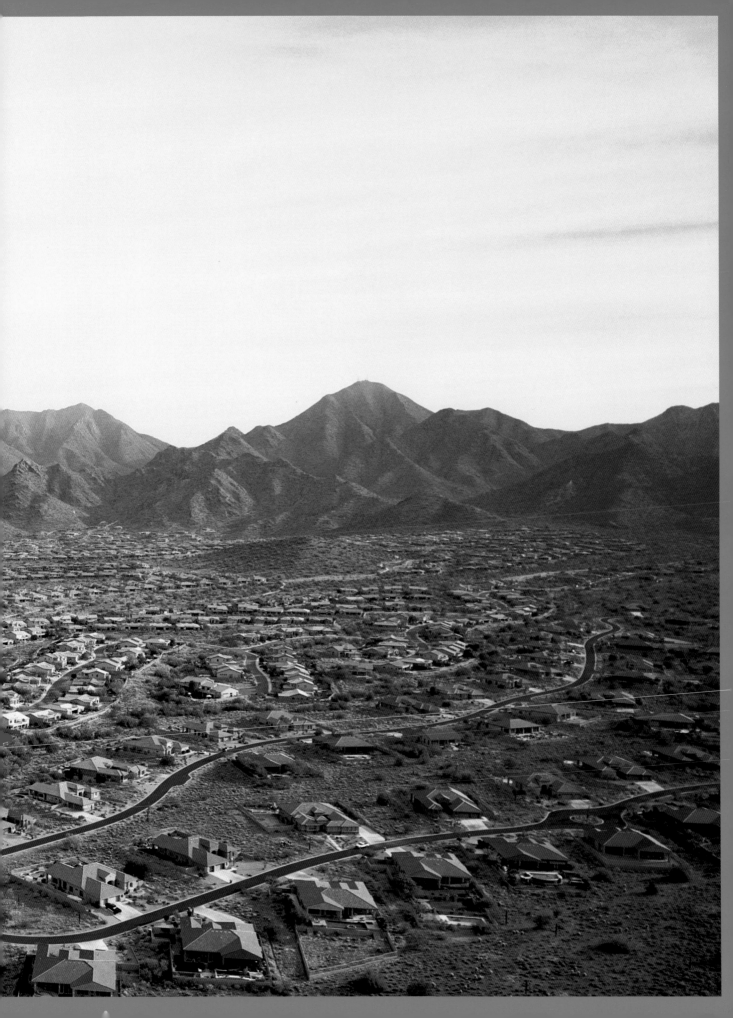

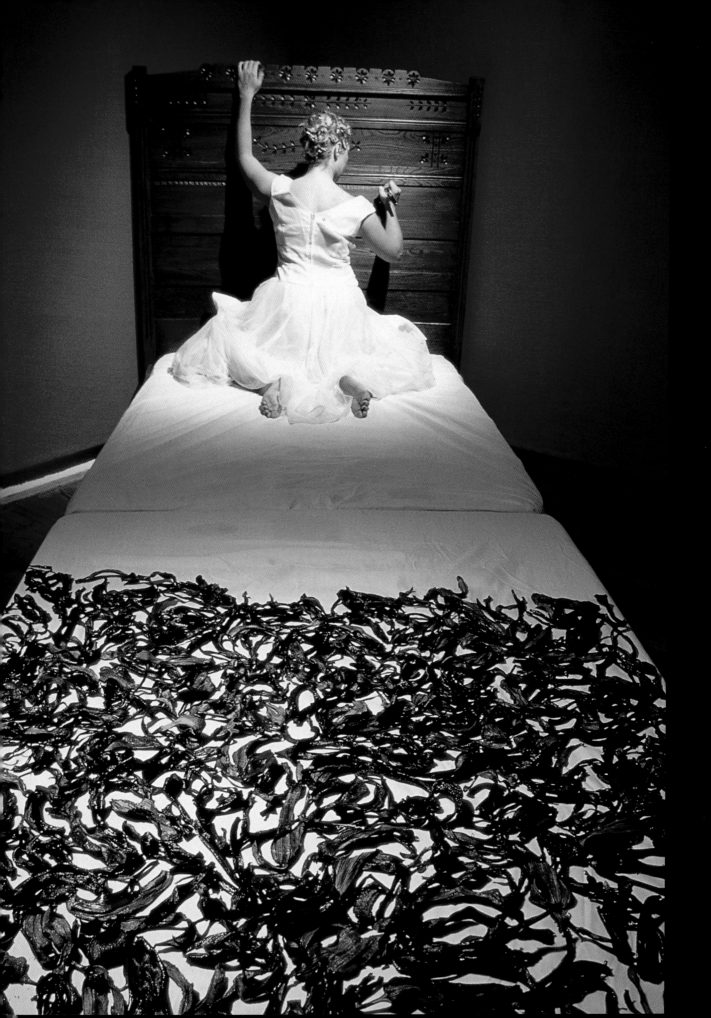

I MOVED TO ARIZONA AS A CHILD IN 1982. I EXCHANGED THE GRASSY YARD, TALLER-THAN-ME SNOW DRIFTS AND 241 SHADES OF OHIO GRAY SKY FOR A GRANITE LAWN, FASTER-THAN-ME TUMBLEWEED AND 241 SHADES OF BROWN. THE DESERT OF MY CHILDHOOD AND THE DESERT OF MY ADULTHOOD BRING ME HOPE, SOLACE, PEACE. THE DESERT WARMTH RUNS THROUGH MY VEINS AND SETTLES MY NERVES.

LIKE SIBLINGS, WE HAVE SHARED AND WITNESSED EACH OTHER'S GROWING PAINS AND GROWING JUBILATIONS.

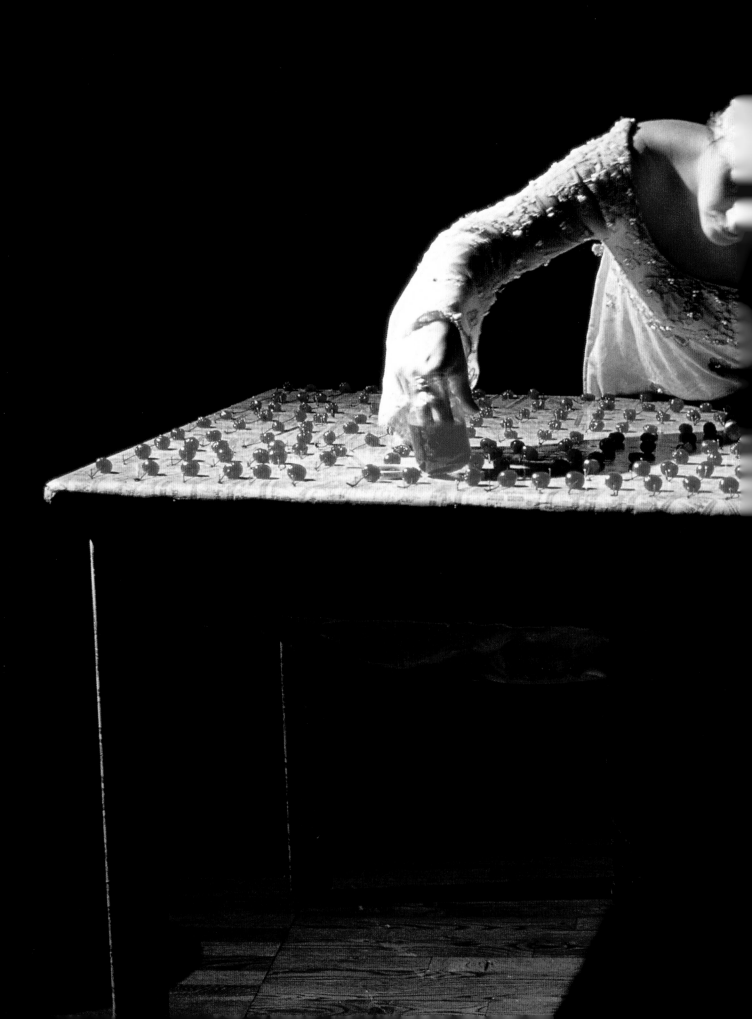

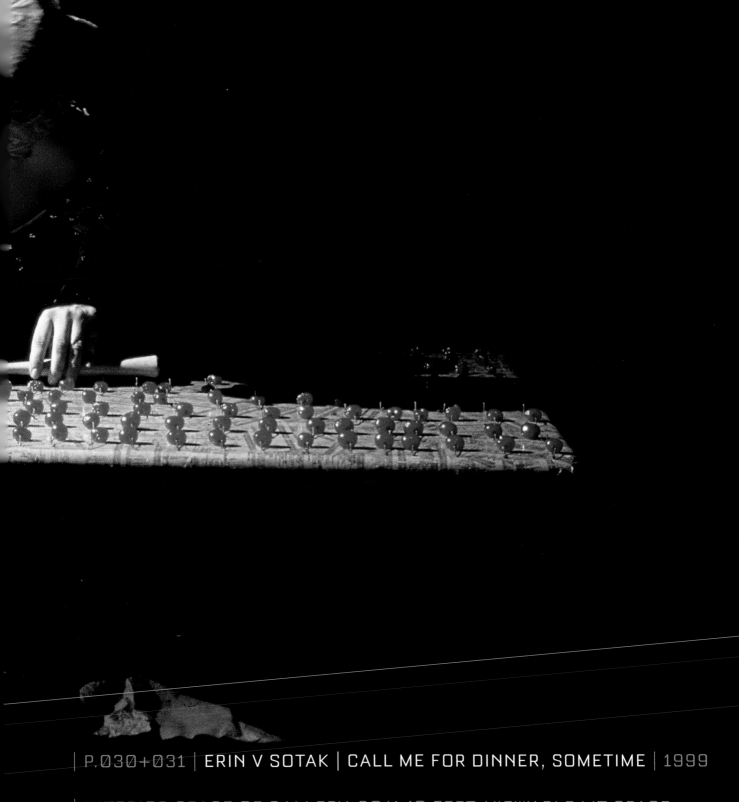

| P.030+031 | ERIN V SOTAK | CALL ME FOR DINNER, SOMETIME | 1999

| INTERIOR SPACE OF GALLERY: 30 X 40 FEET, VIEWABLE LIT SPACE:

10 X 15 FEET | PERFORMANCE AND INSTALLATION USING GLASS,

DOORS, BANANAS, TABLE, PAPER AND CHERRIES |

SUE CHENOWETH | AT THE RICH MAN'S DOOR | 2ØØ4 | 26.5 X 23.75 INCHES |

ACRYLIC, GRAPHITE AND INK ON PANEL |

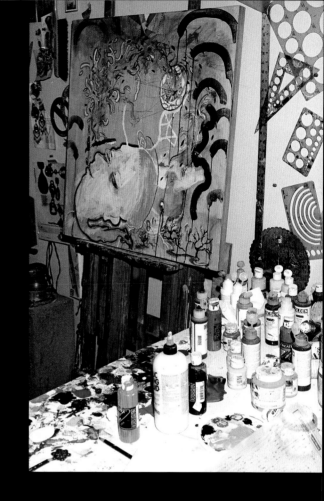

| SUE CHENOWETH STUDIO | 2005 |

PAINTING BECOMES THE TERRAIN I TRAVEL. AS THE

IMAGES EBB AND FLOW, SO DO I. THE MARKS ARE

COMPLETELY INSTINCTIVE AND UNCONSCIOUS AND

FUNCTION AS A TYPE OF RECIPROCAL MOTION BETWEEN

THE WORK AND MYSELF. THESE VISIBLE TRACES SERVE

AS A WAY OF RECORDING A PRIMITIVE LEVEL OF ORDER.

I WANT THE VIEWER TO EXPERIENCE THE BITS OF

FEELINGS WE ALL HAVE BEHIND OUR THOUGHTS.

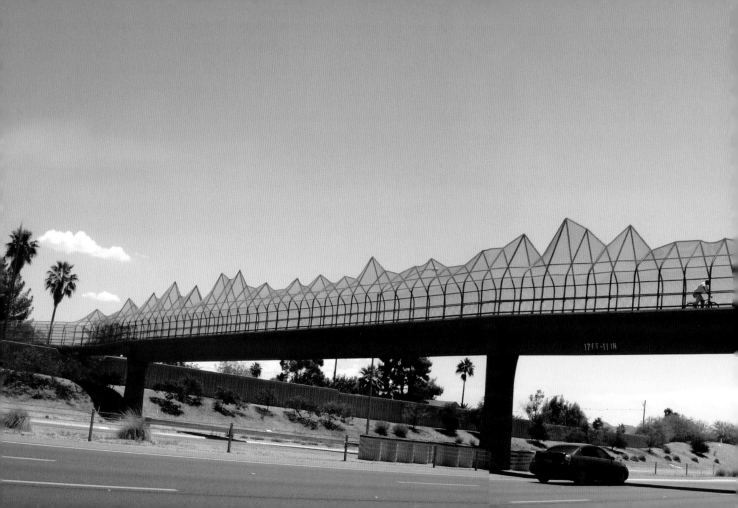

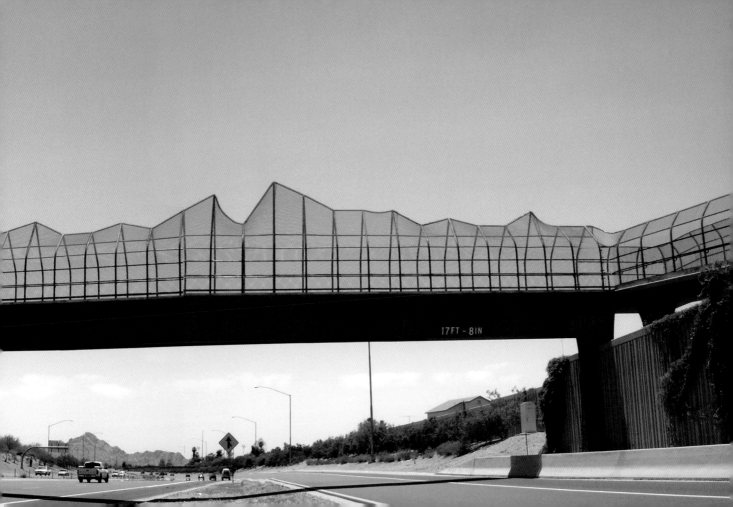

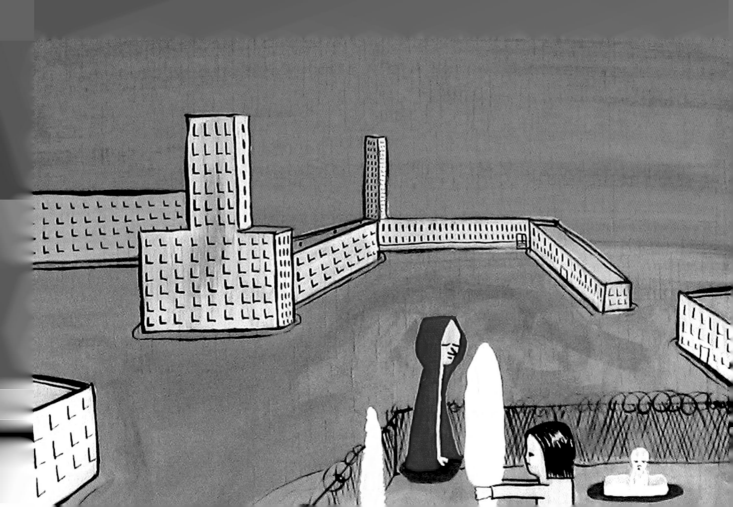

THE USE OF STREETS FOR WALKING AND INTERACTION IS HIGHLY LIMITED IN PHOENIX.

THE CITY DELIVERS SYSTEMIC AND INSTITUTIONAL LIMITS WHILE PROMISING OPENNESS.

THE CAR CULTURE PRODUCES AN AIRLESSNESS YET INFINITE SKY. I TRY TO NAVIGATE

THESE CONSTRICTIONS AND TELL STORIES ABOUT THEM BY WORKING WITH PERCEPTIONS

OF NEAR AND FAR, SIDE-BY-SIDE, DISPERSED AND BETWEEN. I BUILD CIRCULATIONS AND

NETWORKS THAT CONNECT POINTS AND INTERSECT BACK WITH THEIR OWN BEGINNINGS.

THE SONORAN DESERT PROVIDES A SET OF ENVIRONMENTAL CONDITIONS UNLIKE ANYWHERE ELSE IN THE WORLD. BORROWING FROM THE SYMBIOTIC RELATIONSHIP OF A YOUNG SAGUARO CACTUS AND ITS NURSE TREE, THE *DESERT BROOM LIBRARY* CREATES A SHADED MICROCLIMATE, PROVIDING DAYLIGHT, SHELTER AND A NURTURING ENVIRONMENT FOR INTELLECTUAL GROWTH. ALLOWING THE ROOF FORM TO EXTEND 60 FEET INTO THE NATURAL DESERT, WE WERE ABLE TO CREATE AN INDOOR/OUTDOOR TRANSITIONAL SPACE PROVIDING A SEAMLESS TRANSITION INTO THE LANDSCAPE. THE OUTDOOR READING SPACES ARE SHADED BY A SERIES OF COILED METAL SCREENS, FOLLOWING THE NATURAL FORM OF THE ADJACENT ARROYO, AND ARE COOLED BY THE BUILDING'S RELIEF AIR. PENETRATIONS IN THE ROOF PROVIDE A SERIES OF OPENINGS ALLOWING FILTERED LIGHT INTO THE EXTERIOR AND INTERIOR SPACES. EACH OPENING IS TREATED WITH A FRITTED OR COLORED GLASS CREATING AN EVER-CHANGING SERIES OF COLORS AND PATTERNS THROUGHOUT THE SPACE.

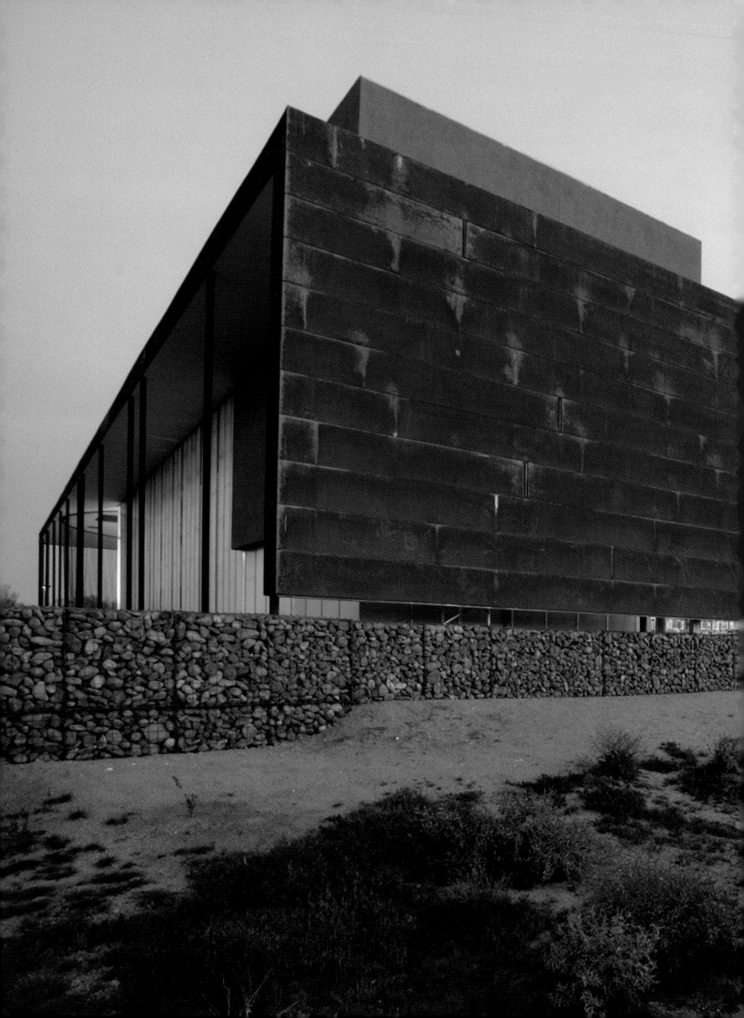

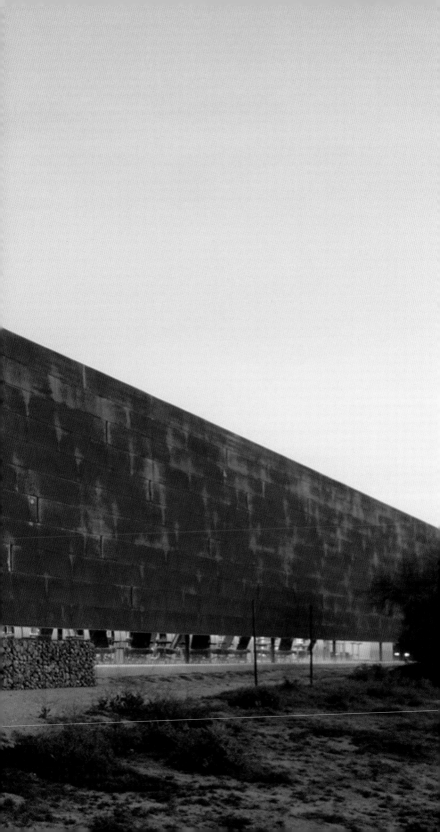

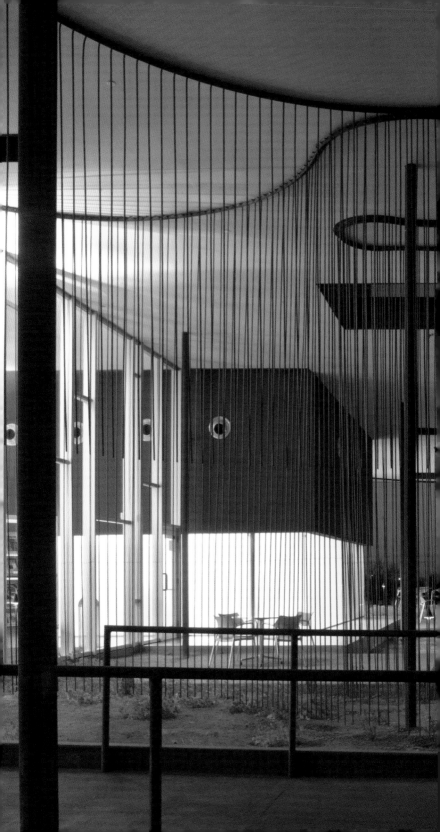

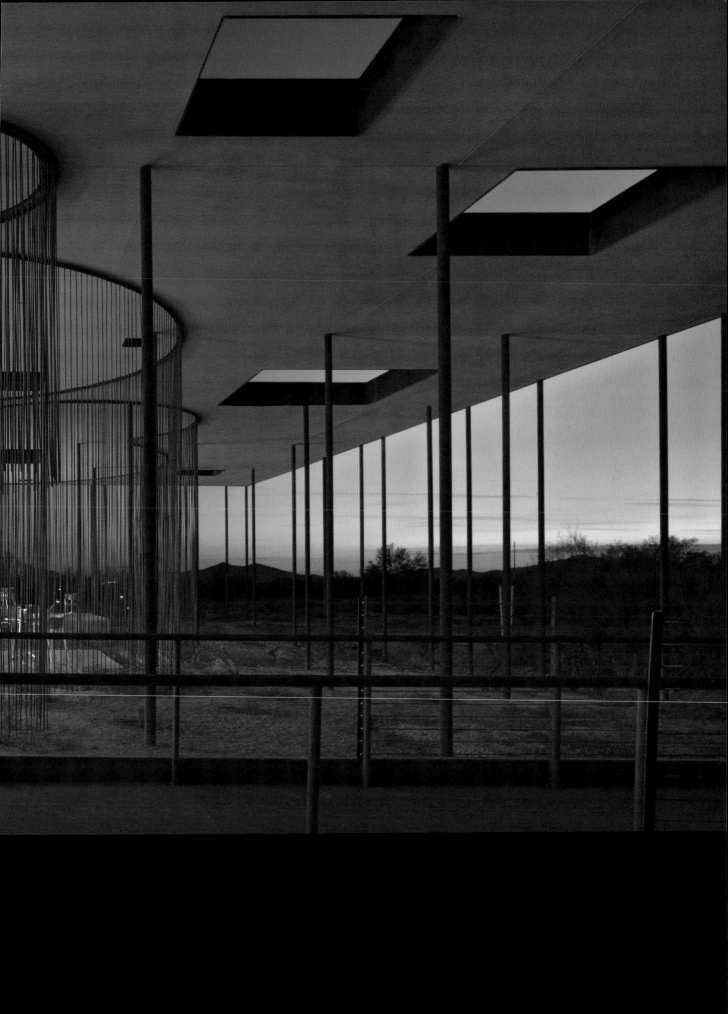

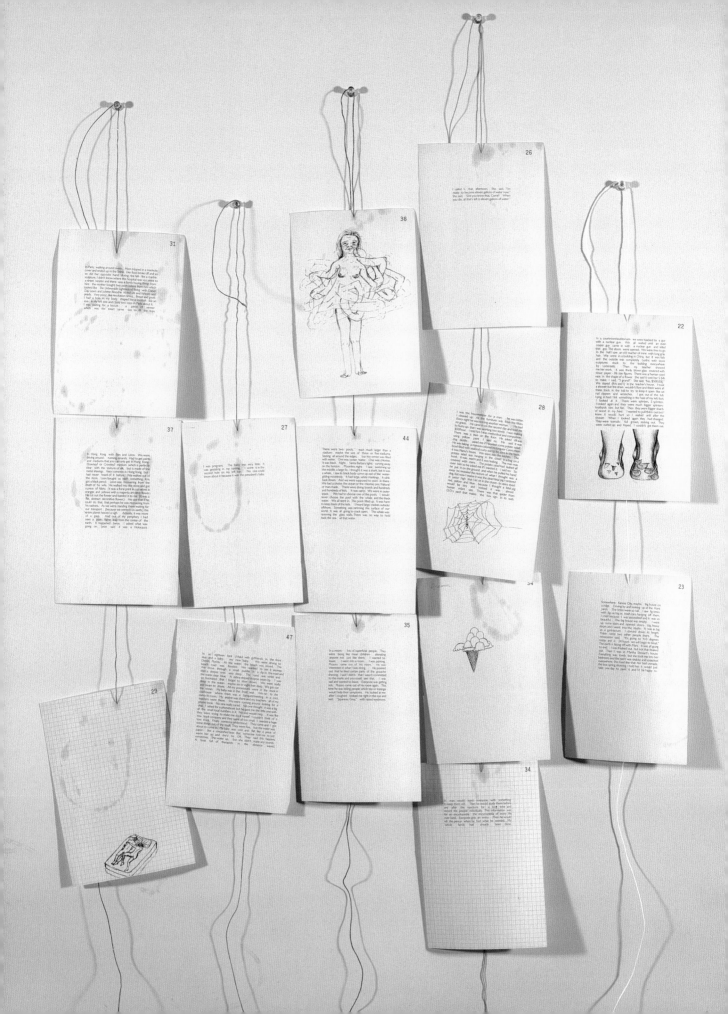

LIVING IN PHOENIX, I FEEL UNFETTERED AND FREE FROM THE STAGNATION ASSOCIATED WITH A BURDEN OF HISTORICAL BAGGAGE. THE CITY'S YOUTH CREATES A DYNAMIC, ANYTHING-GOES ENVIRONMENT; EXUBERANT AND BRIMMING WITH POSSIBILITIES. IN RECENT YEARS, PHOENIX HAS UNDERGONE A DRAMATIC TRANSFORMATION—A SORT OF CULTURAL GOLD RUSH.

THIS FREEDOM IS MANIFEST IN MY WORK AS AN ARTIST BECAUSE I DON'T FEEL THAT I AM BUMPING UP AGAINST PARADIGMS OR EXISTING MODELS. I ALLOW MYSELF TO WORK AS I PLEASE—TO BE GUIDED ONLY BY DESIRE. I THINK OF MAX ERNST AND GEORGIA O'KEEFE, HENRY MILLER AND BEATRICE WOOD, AND ALL THE ARTISTS WHO HAVE BEEN DRAWN TO THE WEST THROUGHOUT HISTORY—THE VASTNESS AND LIGHT TRANSFORMING THEM SPIRITUALLY AND CHANGING THEIR WORK.

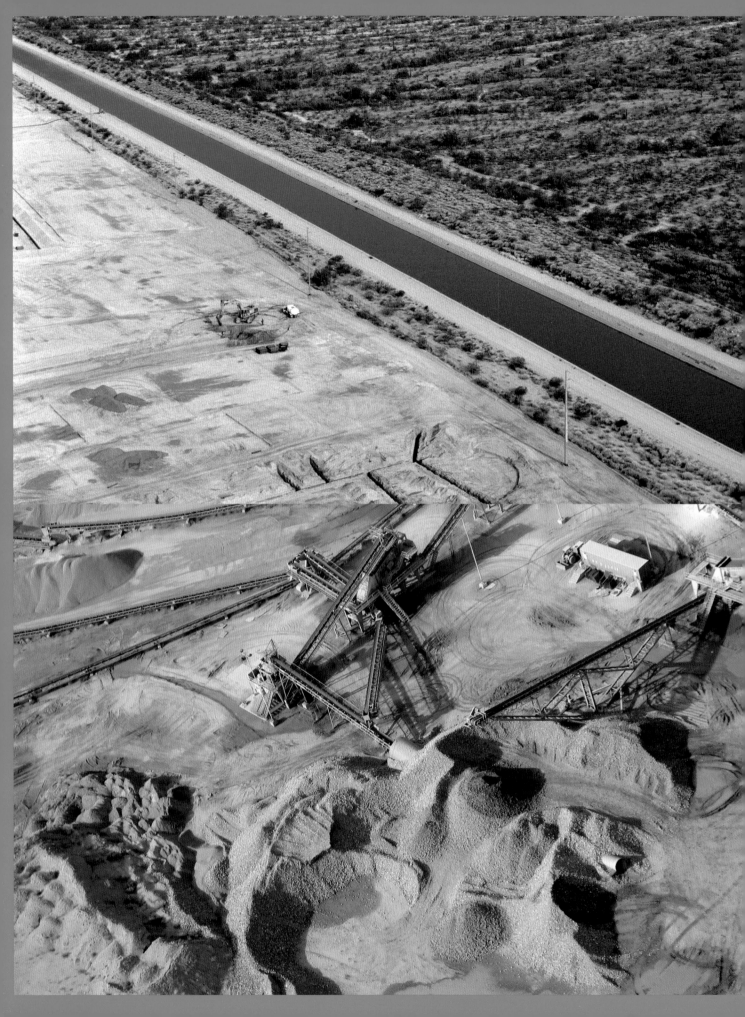

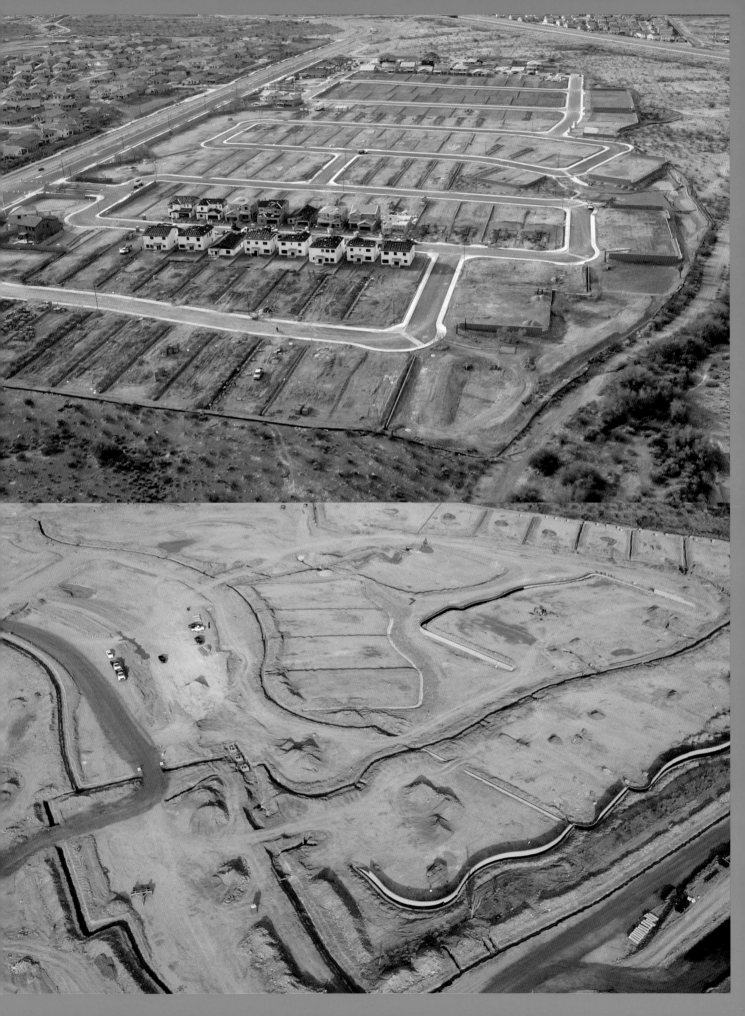

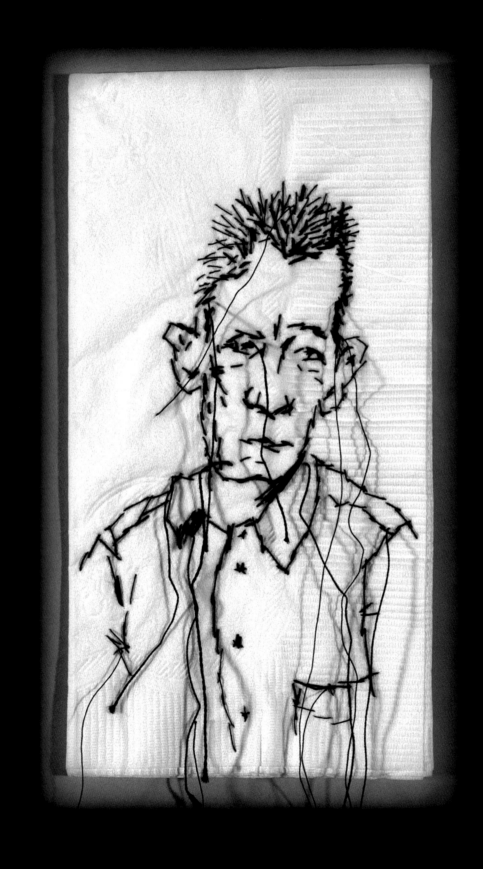

KYLE · STITCH PORTRAIT SERIES | 2005 | 7 X 4 INCHES | BLACK THREAD

ON PAPER NAPKIN |

TRAVERSING THE DISCIPLINES OF DRAWING, PERFORMANCE AND

INSTALLATION, MY WORK EXAMINES THE BODY IN MOTION: A PLACE

WHERE ART AND PHYSICAL ACTIVITY OVERLAP AND BEGIN RUNNING

LAPS AROUND CULTURE AND TRAINING, GESTURE AND PHYSICALITY,

DURATION AND ENDURANCE. EACH *STITCH PORTRAIT* IS A QUIET

PERFORMANCE ACTUALIZED ON A PAPER NAPKIN WHILE I AM IN MOTION;

THERE IS NO PRELIMINARY SKETCH MADE ON THE NAPKIN, STITCH

MARKS ARE SHORT-CIRCUITED BY UNPREDICTABLE MOVEMENTS.

I CAME HERE BECAUSE I LOVE YOU IS A MEDITATION ON PEOPLE

I MISS, LONG TO SEE OR DESIRE TO MEET.

PLANNED SIZE OF FINAL PROJECT IS THE ONE MILE
7TH AVENUE COMMERCIAL CORRIDOR BETWEEN INDIAN SCHOOL AND CAMELBACK
ROADS | LAMPSHADES™ (RUSTED METAL POLE, CUSTOM EXTRUDED ALUMINUM FRAME,
TRANSLUCENT POLYCARBONATE PANELS), ART PANELS (SAME AS LAMPSHADES™),
VINE SCREENS, EVERGREEN ELM TREES AND RUSTED CONCRETE PAVING BANDS |

STRIPSCAPE IS THE RESULT OF AN INTENSIVE INVESTIGATION INTO A COMMERCIAL
CORRIDOR IN PHOENIX, ARIZONA. THE PROJECT'S FORMS, PROGRAMS AND MATERIALS
ARE RESPONSIVE TO THE WAY THE EXISTING URBAN LANDSCAPE OF THE STRIP IS
APPROPRIATED, MODIFIED AND ACCEPTED BY THE LOCAL MERCHANTS, NEIGHBORS
AND COMMUTERS. THE DESIGN ALSO PROMOTES CIVIC LIFE THROUGH ITS APPROPRIATE
CLIMATIC RESPONSE TO THIS ARID REGION. LIGHTING AND SHADE PROVIDED BY THE
LAMPSHADES™ ARE COMBINED WITH AN URBAN GALLERY OF ART PANELS (THAT CHANGE
EVERY SIX MONTHS), THUS CREATING IDENTITY THROUGH CULTURAL AMENITIES SUCH
AS ART AND DISPLAY. *STRIPSCAPE* OPERATES AS AN "AMENITY INFRASTRUCTURE"
SYNTHESIZING, ARCHITECTURE, LANDSCAPE, URBANISM, PRODUCT DESIGN, GRAPHICS,
AND THE ENVIRONMENT FOR THE REOCCUPATION AND REVITALIZATION OF THE
COMMERCIAL CORRIDOR. THIS PROJECT WAS BORN OF A DESIRE TO FOSTER AN
APPROPRIATE URBANISM FOR THE UNIQUE CONDITIONS OF THIS DESERT CITY.

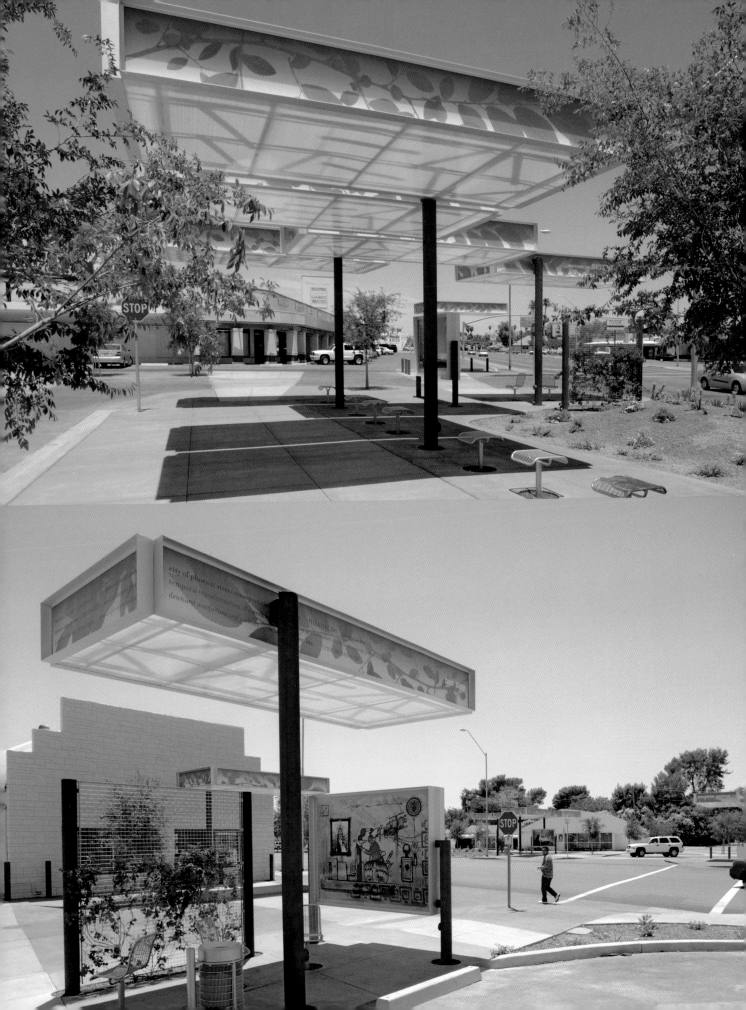

|BACK TO MAIN|

"THE COMPANY STATE" (CO.$T) IS A FICTITIOUS FASCIST STATE, IN THE TRUEST SENSE OF THE WORD. MUSSOLINI, THE INVENTOR OF FASCISM, DEFINED IT AS THE MERGING OF CORPORATE AND STATE INTERESTS AND THAT IT SHOULD MORE APPROPRIATELY BE CALLED CORPORATISM. HISTORY REVEALS EXACTLY HOW FASCISM EVOLVES INTO SOMETHING TRULY HORRIBLE. UNFORTUNATELY I SEE OUR WONDERFUL COUNTRY PLODDING DOWN THAT SAME DANGEROUS PATH TODAY. IT IS THE GOAL OF THIS PROJECT TO SERVE AS A WARNING, OR WAKE-UP CALL IN A SIMILAR VEIN AS ORWELL'S 1984, LONDON'S THE IRON HEEL, OR LEWIS' IT CAN'T HAPPEN HERE, BUT IN A MORE VISUAL MANNER.

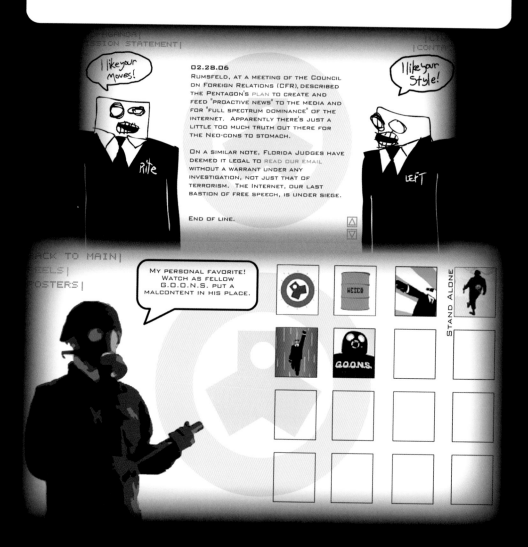

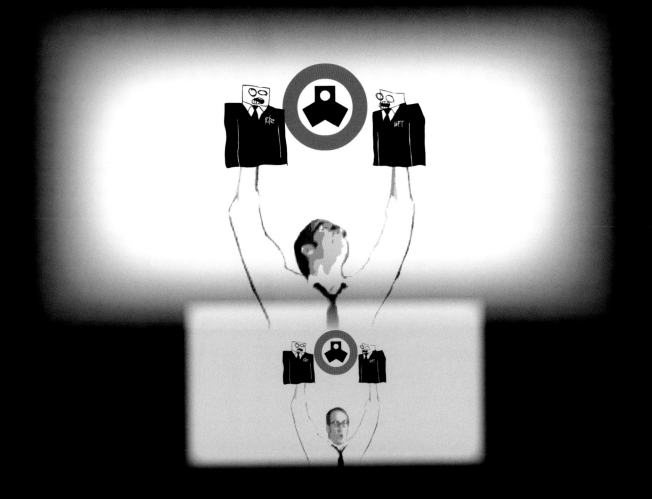

THIS PROJECT STARTED OFF INITIALLY AS AN EXCUSE TO MAKE PROPAGANDA

POSTERS. I HAD COOKED UP THIS DYSTOPIAN FANTASY WORLD FULL OF THE USUAL

SCI-FI CLICHÉS, BUT MIDWAY THROUGH THE PLANNING STAGE, I CAME ACROSS A

COUPLE OF INDEPENDENT NEWS WEB BROADCASTS THAT CHANGED THE DIRECTION

OF THE PROJECT, AND FRANKLY MY LIFE, FROM THAT POINT ON. I CAME TO REALIZE

THAT REALITY WAS FAR MORE DISTURBING THAN THE FICTION I HAD CREATED, SO I

DECIDED TO SHIFT THE FOCUS OF THE PROJECT TO THAT OF A RATHER HEAVY-HANDED

ANALOGY OF WHAT IS TRANSPIRING RIGHT UNDER OUR NOSES.

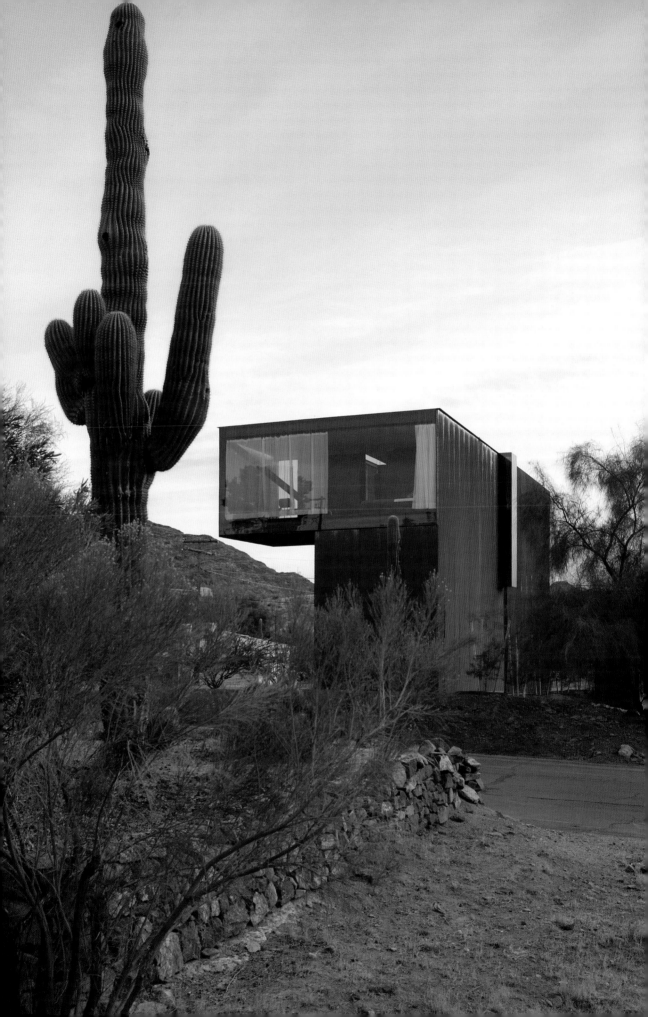

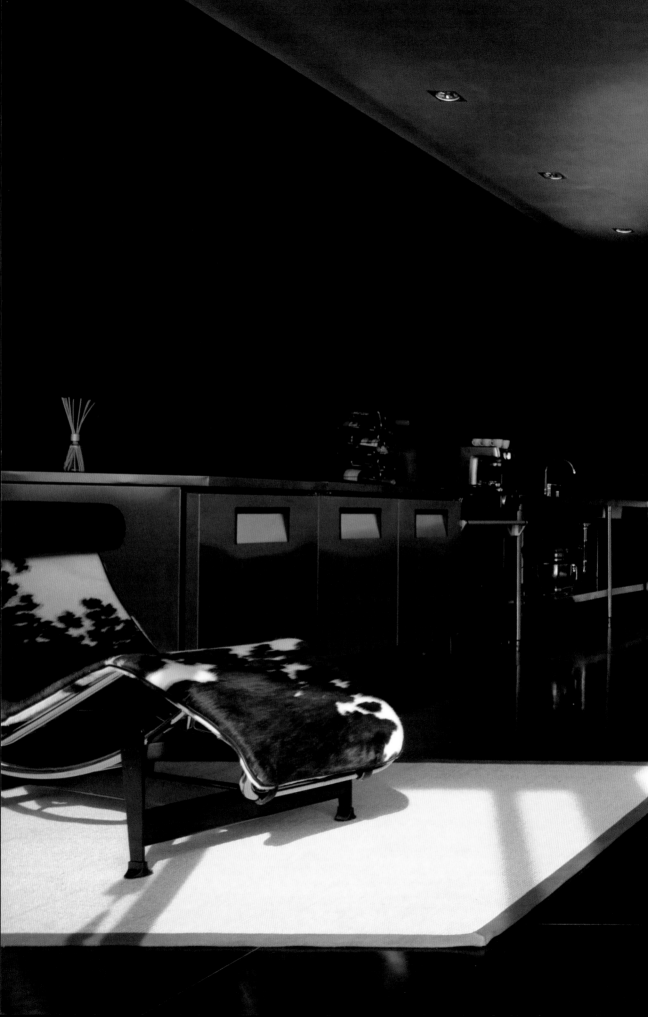

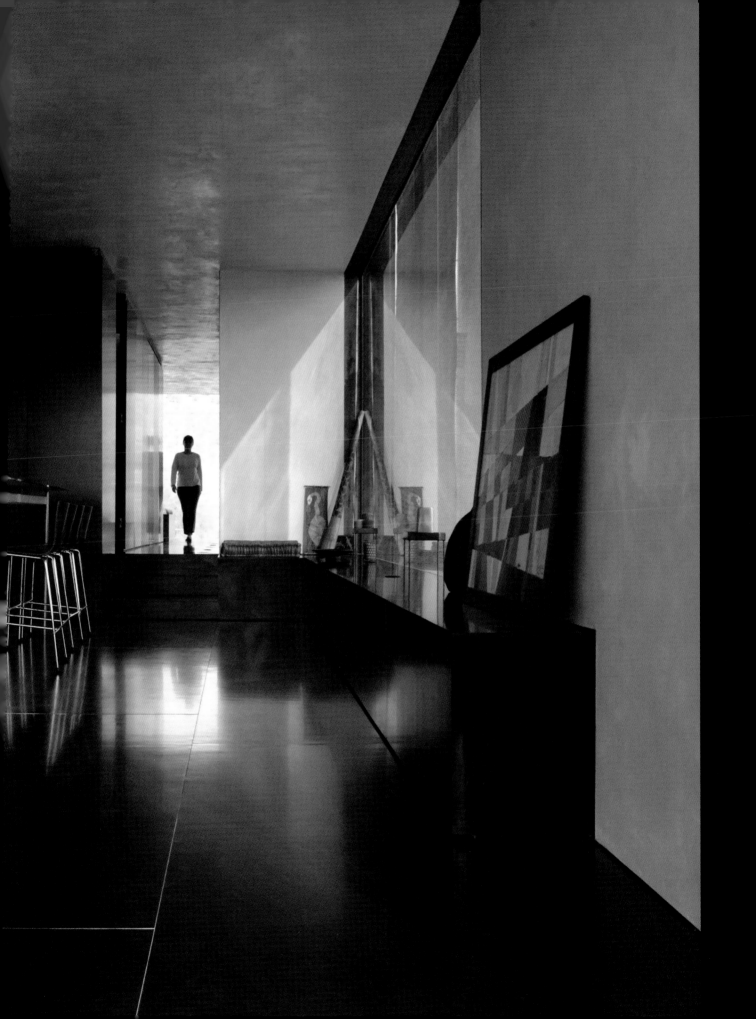

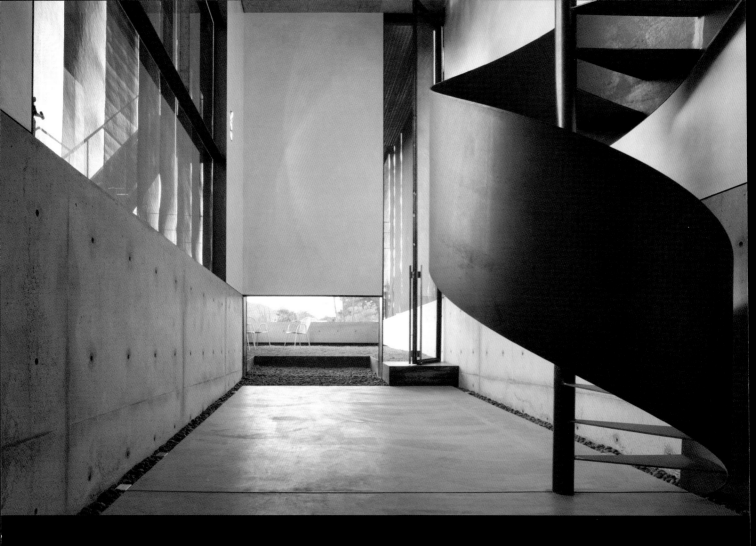

BECAUSE PHOENIX IS A VERY YOUNG CITY, THERE IS A PREVALENT MINDSET ABOUT

WORKING IN THIS PLACE THAT IS LIKE NO OTHER. OPPORTUNITIES ARE AFFORDED

TO YOUNGER, LESS ESTABLISHED STUDIOS THAT NEED NOT WORK THROUGH THE

CLASSIC HIERARCHIC SYSTEMS THAT EXIST IN OTHER CITIES. BEING A DESERT CITY

ALSO INFORMS OUR WORK – *THE XEROS RESIDENCE* (XEROS IS GREEK FOR "DRY"), IS

VERY MUCH ABOUT BEING IN THIS DESERT PLACE. THE BUILDING FORM IS POSITIONED

TO ADMIT LIGHT WHERE DESIRED AND SHIELDING WHERE NECESSARY. THE EXTERIOR

MESH FILTERS INCOMING SUNLIGHT BEFORE THE LIGHT AND HEAT ENERGY ENTERS THE

BUILDING. TREES ARE INDIGENOUS AND POSITIONED TO ASSIST THE MESH IN SHADING

THE BUILDING. THE BUILDING FOOTPRINT IS MINIMAL AT THE BASE TO RETAIN THE

MAXIMUM PERMEABLE SURFACE AREA TO ASSIST WITH RAINWATER RUNOFF.

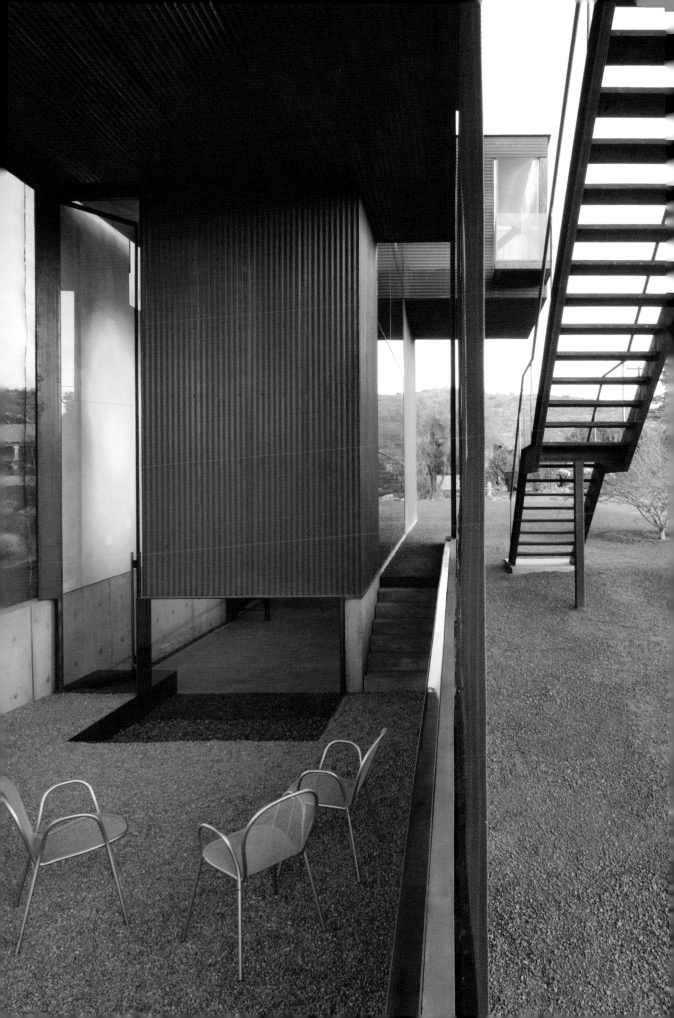

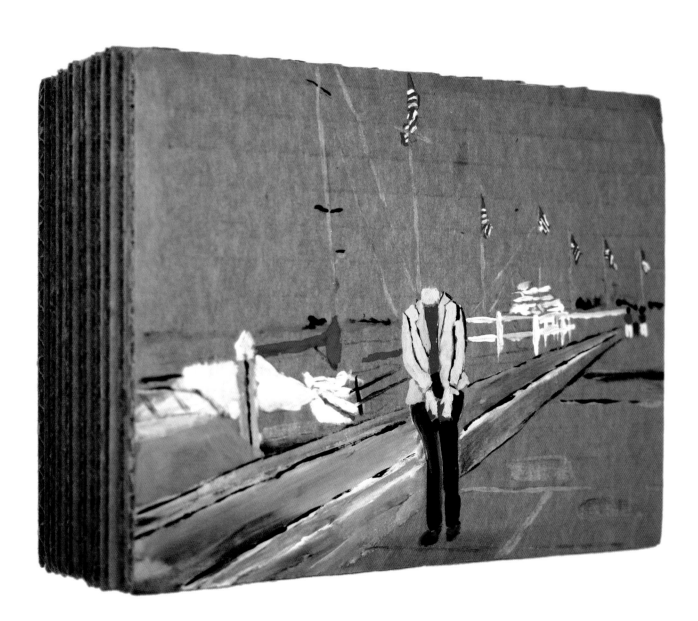

I GREW UP IN ALASKA AND HAVE LIVED IN PHOENIX FOR 11 YEARS. I FEEL COMFORTABLE IN PHOENIX

THE SAME WAY THAT I DID IN ALASKA. THE DESERT OFFERS A SIMILAR QUALITY OF QUIETNESS

THAT ALSO EXISTS WITHIN THE COLDNESS OF THE TUNDRA; A FEELING OF BEING REMOVED FROM A

NORMAL SENSE OF LIFE WHILE SURROUNDED BY BIG SPACE WITH EXTREMITIES OF WEATHER MARKING

TIME. THIS QUIETNESS IS ALSO PRESENT IN MY RECENT WORK OF BEHEADED SELF-PORTRAITS.

THEY REPRESENT MY PERSISTENCE OF PRIVILEGE DESPITE THE CURRENT STATE OF OUR COUNTRY

AT WAR – A WAR STAGED IN PLACES WHERE PEOPLE'S HEADS ARE WAGED FOR DIFFERENT DEMANDS.

THROUGH THESE PORTRAITS I FEEL SOME SENSE OF COMFORT AND OWNERSHIP IN TRYING TO SPEAK

OUT AS AN INDIVIDUAL WHILE COMMENTING ON THE EXTREME ACTS OF OTHERS.

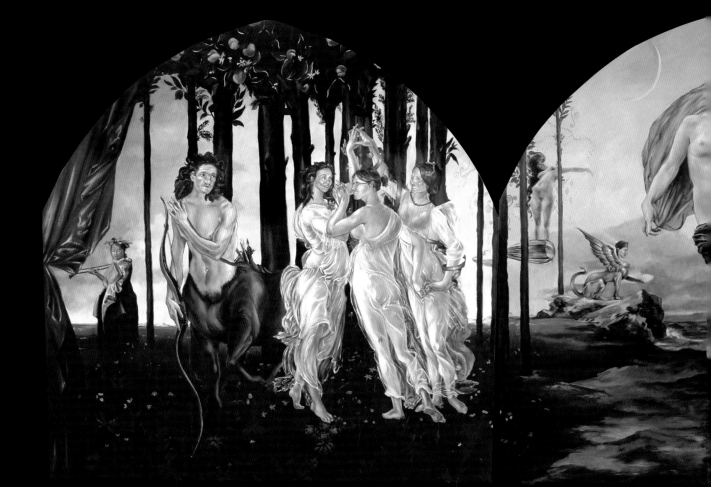

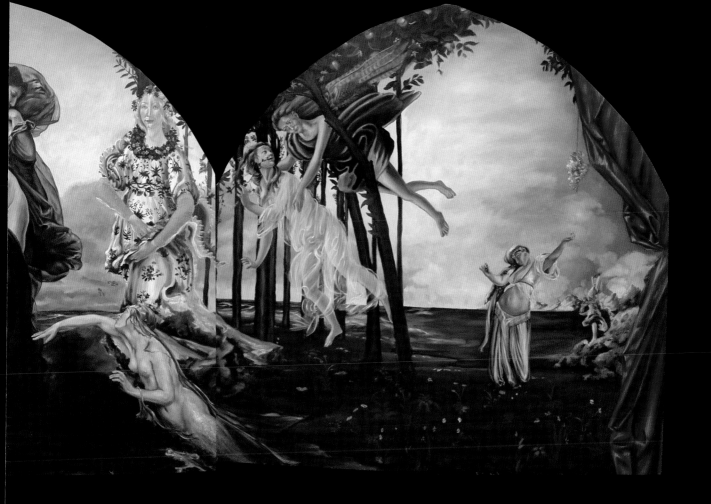

| P.064+065 | LEE HAZEL | TRIAD OF THE MUSES OF THE DAUGHTER OF ODEN, WIFE OF NEKO | 2003 | 4 X 12 FEET | TRIPTYCH, OIL ON PANEL |

THIS TRIAD IS THE STORY OF MY CREATIVE PATH, USING OLD WORLD THEMES AND FAMILIAR FIGURES FROM ART HISTORY BUT REPLACING THEM WITH MY PRESENT DAY INSPIRATIONS, INCLUDING MY ARTIST FRIENDS FROM PHOENIX AND MYSELF AS THE CHARACTERS IN THE PAINTING. REMAINING TRUE TO THE ALLEGORICAL THEMES AND MYTHOLOGICAL CHARACTERS I HAVE GROWN TO LOVE, THIS PAINTING DEPICTS THE ARTISTS WHO INSPIRE ME, PAST AS WELL AS PRESENT.

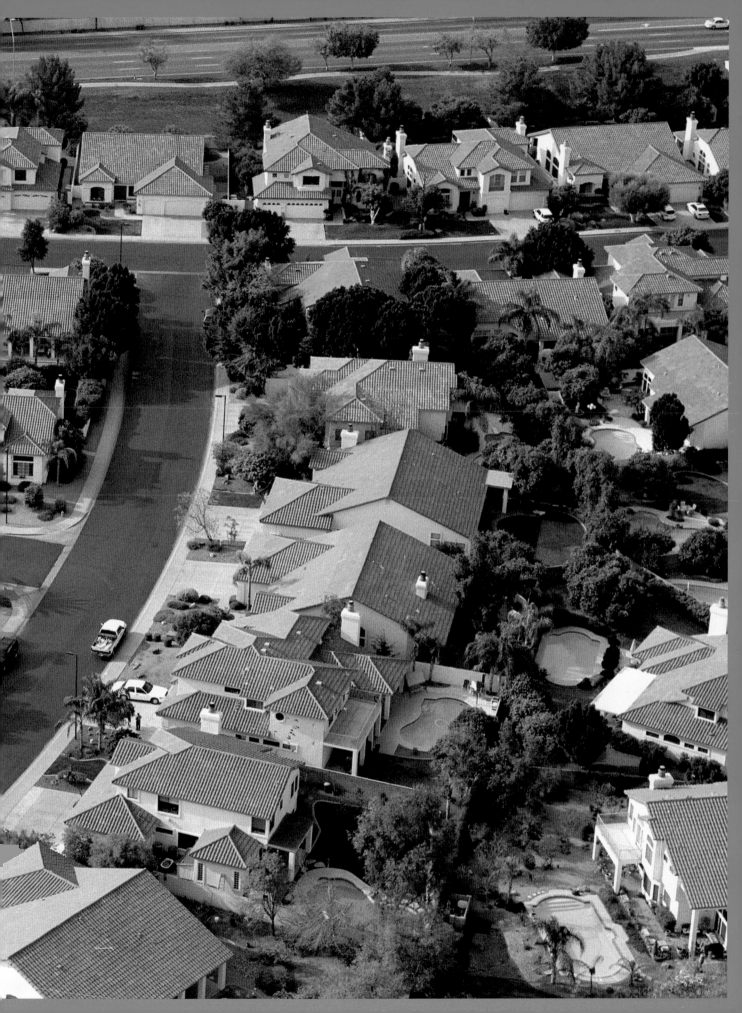

2004 | 22 X 15 X 6 INCHES | MIXED MEDIA, DOLLHOUSE FURNITURE,

MOTION SENSOR AND MOTOR |

LIFE IN THE PHOENIX METRO AREA HAS LED ME TO EXPLORE

THEMES RELATING TO THE BUILT ENVIRONMENT AND THE WAYS

IN WHICH CITY RESIDENTS INTERACT WITH AND REACT TO THEIR

SURROUNDINGS. *GRANDMA'S ANXIOUS LANDSCAPE* SPEAKS TO

THE PHENOMENON OF THE GATED COMMUNITY – CONTROLLED

ENVIRONMENTS THAT OFFER RESIDENTS THE MIRAGE OF

SECURITY TO COMBAT THEIR PARANOIA OF WHAT RAPID URBAN

GROWTH WILL BRING WITH IT. THE PIECE HANGS ON THE WALL.

WHEN THE VIEWER APPROACHES, THE ROOM BEGINS TO SHAKE

VIOLENTLY AND THE SOUND OF CHATTERING TEETH CAN BE

HEARD IN RESPONSE TO THE "INTRUDER." AS THE VIEWER WALKS

AWAY, THE SHAKING AND CHATTERING SUBSIDE, AND PEACE

AND TRANQUILITY ARE RESTORED.

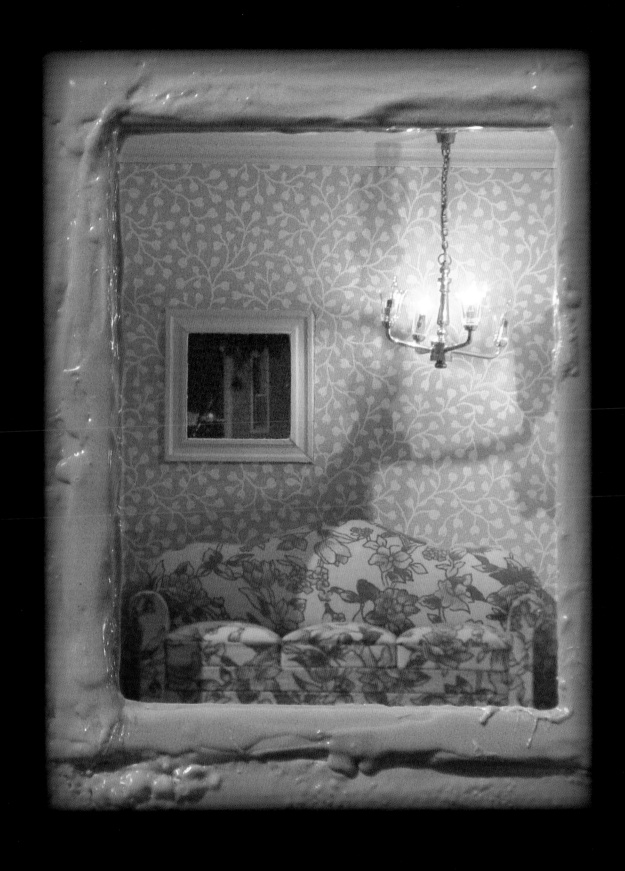

| P.070 | GALINA MIHALEVA | UNTITLED | 2003 | FIT TO WEARER | LEATHER AND HAND PAINTED
LEATHER WITH METAL STUDS AND HAND DYED SILK TRAINS, TRIM AND TURBAN |

LOOKING FOR A LIFE CHANGING ADVENTURE, I MOVED FROM BULGARIA TO PHOENIX 11 YEARS
AGO. I FELT THAT THE WARMTH AND THE BRILLIANT COLORS OF THE DESERT WOULD BE
AN INCENTIVE FOR NEW DESIGN CHANGES AND THAT, THROUGH MY WORK WITH STUDENTS,
I COULD GIVE THE CITY MORE AWARENESS OF FASHION, DESIGN AND ART.

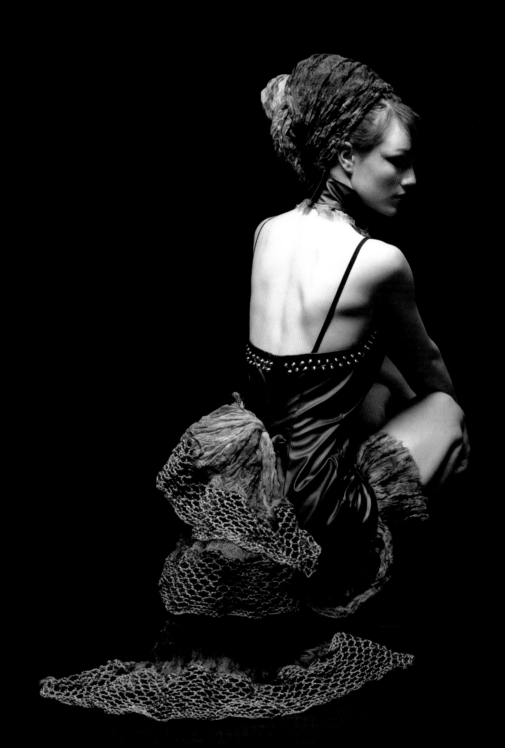

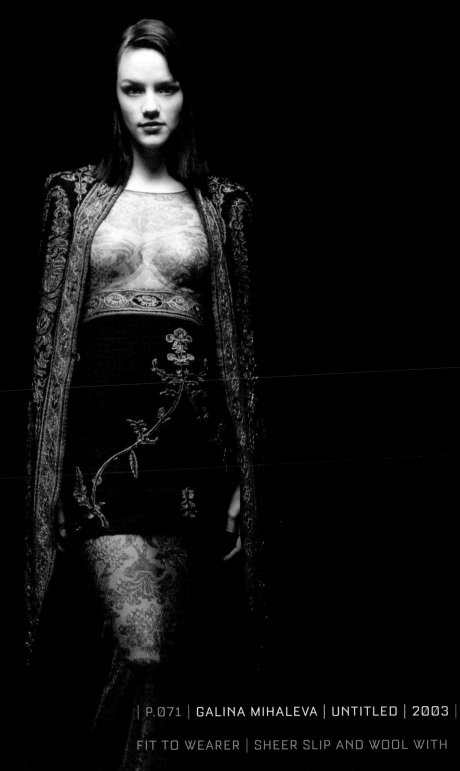

| P.071 | GALINA MIHALEVA | UNTITLED | 2003 |

FIT TO WEARER | SHEER SLIP AND WOOL WITH

HAND COLORING AND BEADING |

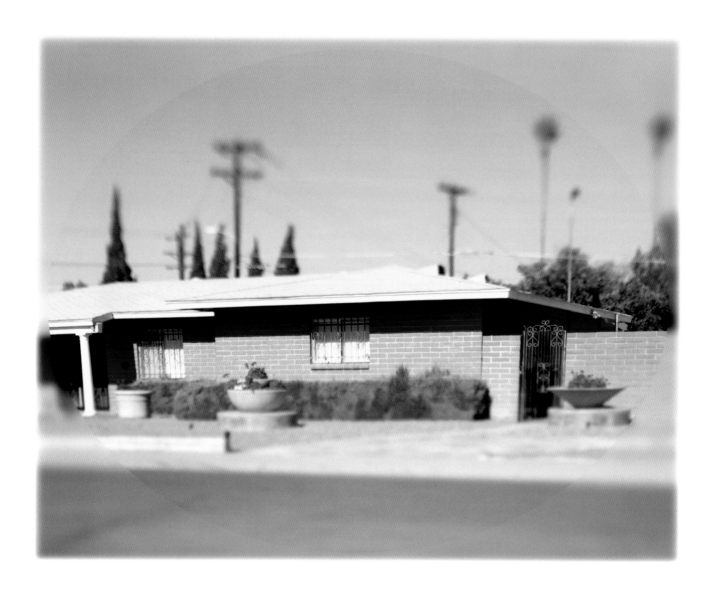

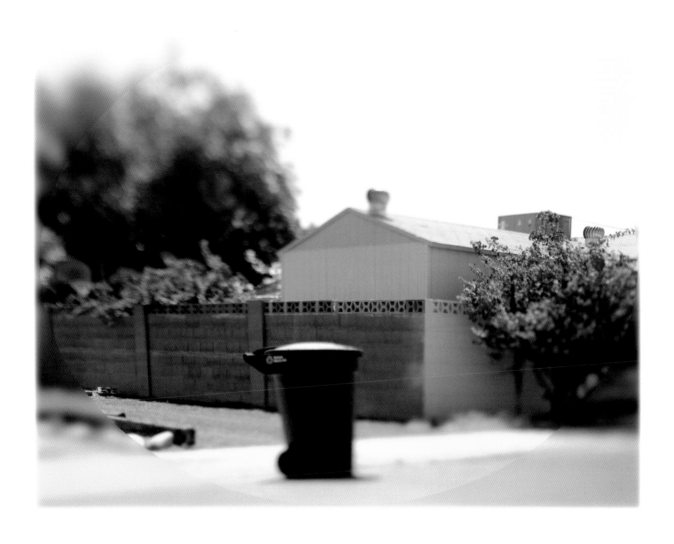

| P.073 | LEIGH MERRILL | BLUE AND WHITE SHED | 2005 | 24 X 30 INCHES |
ARCHIVAL INKJET PRINT |

I CREATE IMAGERY AT THE INTERSECTION OF FANTASY AND REALITY BY EMBELLISHING

THE UBIQUITOUS AND BANAL REALITIES OF THE PLACES I PHOTOGRAPH WITH SOMETHING

MORE DESIRABLE. THROUGH FOCUS AND DIGITAL MANIPULATION, THESE SCENES ARE

TAKEN OUT OF CONTEXT AND SIMPLIFIED, CREATING A SENSE OF BEAUTY AND PERFECTION.

THE SIMPLIFICATION OF THE IMAGES CREATES AMBIGUITY OF SCALE AND PLACE. I GREW

UP IN THE SUBURBAN SOUTHWEST AND I FIND MYSELF PARTICULARLY INTERESTED IN

THE TENSION CREATED IN THE SPECIFICITY AND CONSTRUCTED NATURE OF THE URBAN

LANDSCAPE IN PHOENIX.

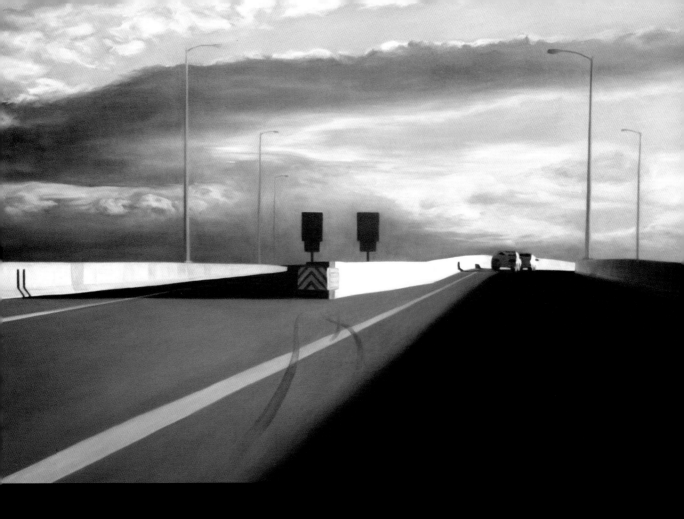

| P.074 | **JEFF LYON** | **CITYSCAPE 1** | **2003** | 48 X 60 INCHES | OIL ON CANVAS |

PHOENIX URBAN HIGHWAYS DIRECTLY INSPIRE MY LANDSCAPE PAINTING. ON ONE
LEVEL, THE WORK TAKES ADVANTAGE OF THE TWO-DIMENSIONAL, COMPOSITIONAL
ELEMENTS THAT ARE A BYPRODUCT OF THE WAY SPACE AND NEGATIVE SPACE ARE
SHAPED BY MODERN BRIDGE DESIGN. ON ANOTHER LEVEL, THE WORK ATTEMPTS TO
ILLUSTRATE THE PARADOX OF ENABLING AN UNSUSTAINABLE COMMUTER CULTURE
THROUGH RATIONAL PLANNING AND APPLICATION OF DESIGN PRINCIPLES.

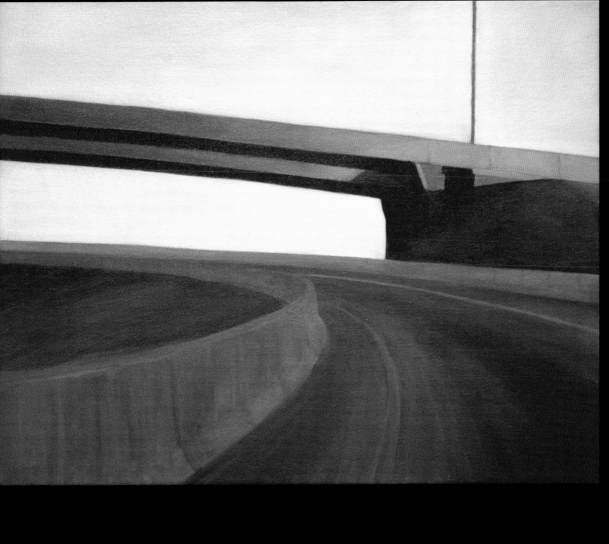

JOERAEL JULIAN ELLIOTT | THE PRICE OF A BEATING HEART AND THE SERVING OF AN OMINOUS BEING | 2005 | 9 X 12 INCHES | MIXED MEDIA, DRAWING, PEN, PENCIL AND MARKER |

THE CITY OF PHOENIX AND ARIZONA HAVE IMMENSELY INFLUENCED MY WORK. THE NATURAL LANDSCAPE AND THE MANUFACTURED SPRAWL HAVE INTENSE DUALITY, IRONY AND AMAZING METAPHORS TO DRAW FROM AS A REFLECTIVE QUALITY. THE MOST INFLUENTIAL ELEMENT OF PHOENIX AND THE LANDSCAPE IN WHICH IT IS SET IS HOW MUCH ISOLATION THERE IS AND HOW THIS ISOLATION SEEMS INESCAPABLE EVEN THOUGH PHOENIX IS MASSIVELY POPULATED.

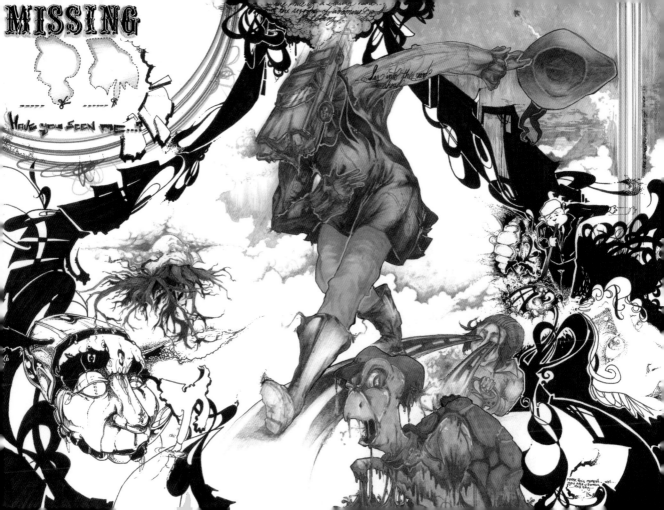

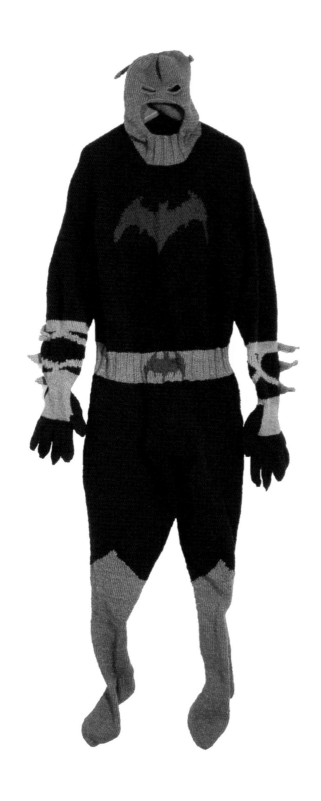

| P.078 | MARK NEWPORT | BATMAN #2 | 2005 | 80 X 23 X 6 INCHES |

HAND-KNIT ACRYLIC AND BUTTONS |

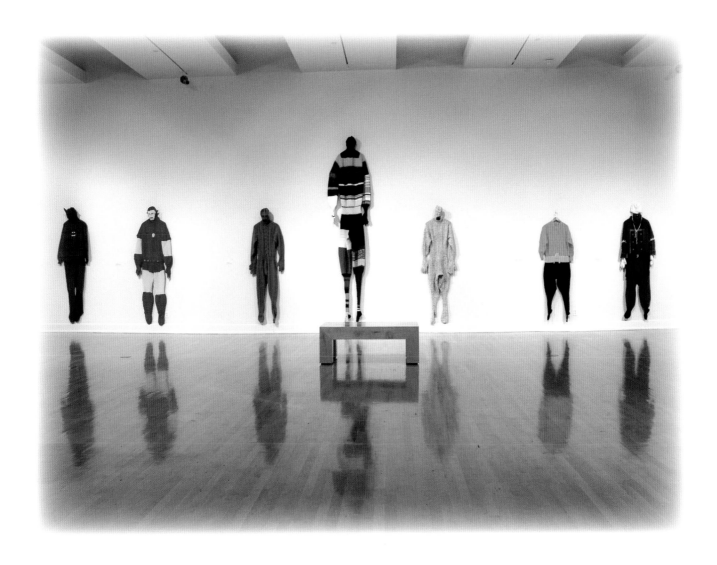

| P.079 | MARK NEWPORT | BATMAN, IRONMAN, SWEATERMAN: CABLE, EVERY-ANY-NO-MAN, SWEATERMAN, AQUAMAN, THE RAWHIDE KID · SUPERHEROICS | 2003-05 | 76 X 23 X 6 INCHES TO 120 X 28 X 6 INCHES | HAND-KNIT ACRYLIC AND BUTTONS |

MY WORK IS INFLUENCED BY MY OBSERVATIONS, MEMORIES AND PERSONAL EXPERIENCES. I FOCUS ON HOW TRADITIONAL DEFINITIONS AND EXPECTATIONS OF MASCULINITY EFFECT MY UNDERSTANDING OF HOW I ACT AND HOW OTHERS EXPECT ME TO BEHAVE.

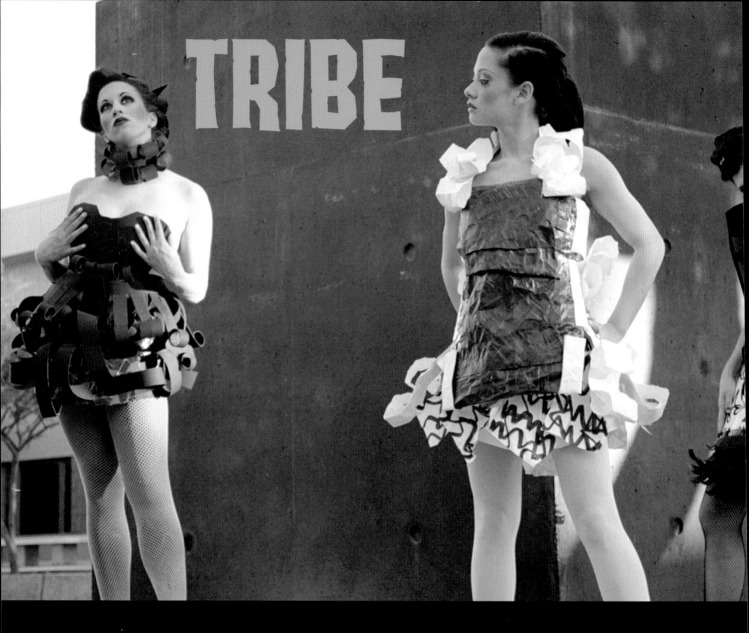

TRIBE

INSPIRATION FOR MY WORK COMES FROM THE CONSTANT CHANGES IN MY

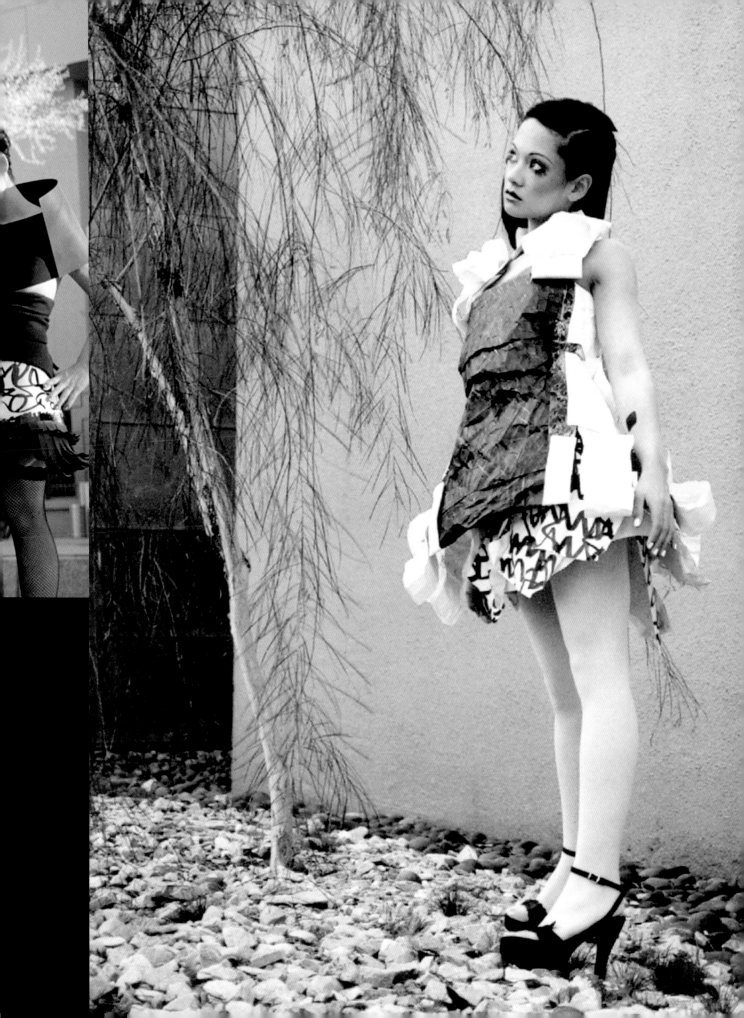

MY WORK FREQUENTLY CENTERS ON THE SPECTACULAR WEATHER

OF ARIZONA AS A METAPHOR FOR BROADER ISSUES. THE IMAGE

SOURCES RANGE FROM MEDIA PHOTOGRAPHS TO MY OWN PHOTOS

AND DIRECT OBSERVATION IN THE LANDSCAPE. *STORM #2* CAPTURES

A DRAMATIC PHENOMENON THAT COULD BE INTERPRETED AS EITHER

NATURAL OR MAN-MADE.

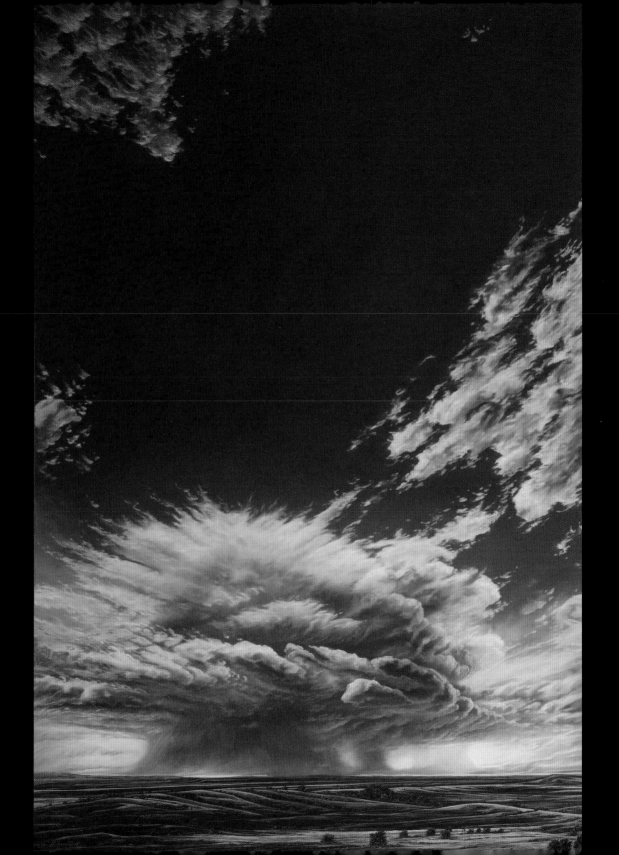

MY FAMILY HAS FARMED THE SAME LAND WEST OF PHOENIX, WHICH URBAN EXPANSION WILL SOON

ENGULF, FOR THREE GENERATIONS. SINCE JANUARY 2006, THE FAMILY BUSINESS OF SYCAMORE FARMS

HAS TAKEN ON A NEW MEANING; SOON, HOMES WILL BE ERECTED WHERE ONLY CROPS HAD GROWN FOR

80 YEARS. I CONSIDER THIS TRANSITION A PERSONAL LOSS. MY ART ADDRESSES THIS LOSS AND MY

ATTEMPTS TO RECONCILE THE URBAN WITH THE RURAL, WHILE REFLECTING ON THE "AMERICAN DREAM"

AND ITS EFFECT ON OUR SOCIETY.

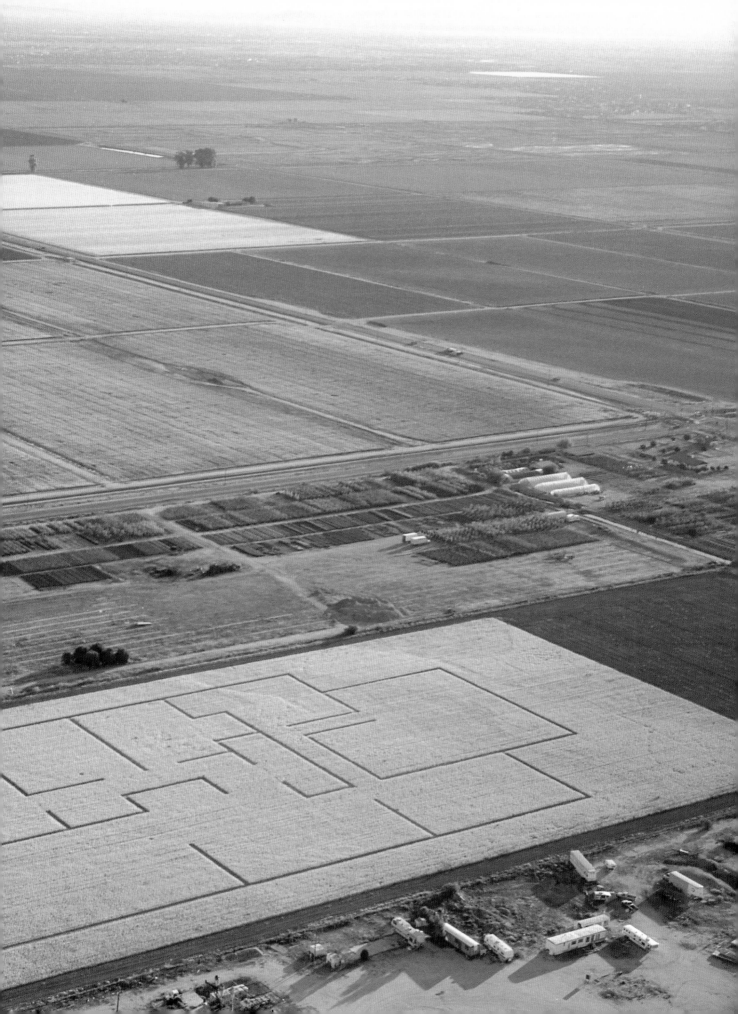

ROTATIONS IS A SERIES OF EARTHWORKS ABOUT
THE FUTURE OF MUCH OF THE AGRICULTURAL
LAND THROUGHOUT THE GREATER PHOENIX
VALLEY. *SINGLE FAMILY RESIDENCE* IS AN
ENLARGED FLOOR PLAN OF A COMMON SUBURBAN
HOME, SET INTO AN AGRICULTURAL FIELD AND
HAND HOED OVER THE COURSE OF FOUR MONTHS.
MOORE ESTATES IS AN EXACT REPLICA AT A THIRD
SCALE OF THE FIRST DEVELOPMENT TO BE BUILT
ON MY FAMILY'S LAND. THE HOUSES ARE PLANTED
IN SORGHUM TO REPRESENT THE REDDISH TONES
OF THE TILED ROOF AND THE ROADS HAVE BEEN
PLANTED IN AN ORNAMENTAL BLACK-BEARDED
WHEAT TO SUGGEST ASPHALT.

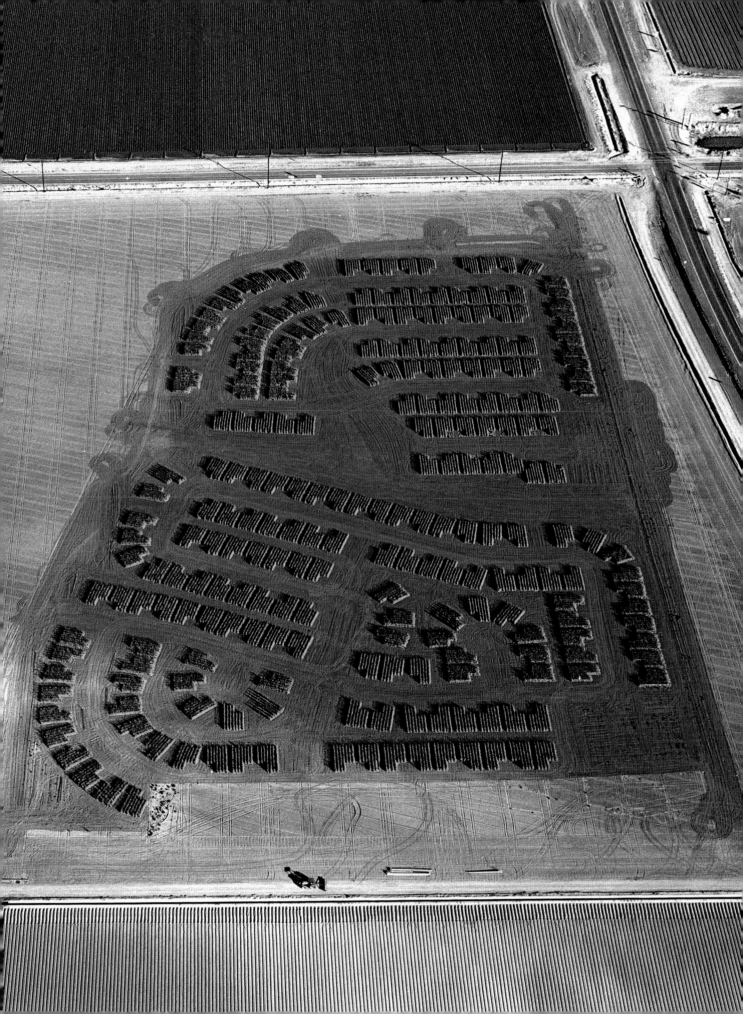

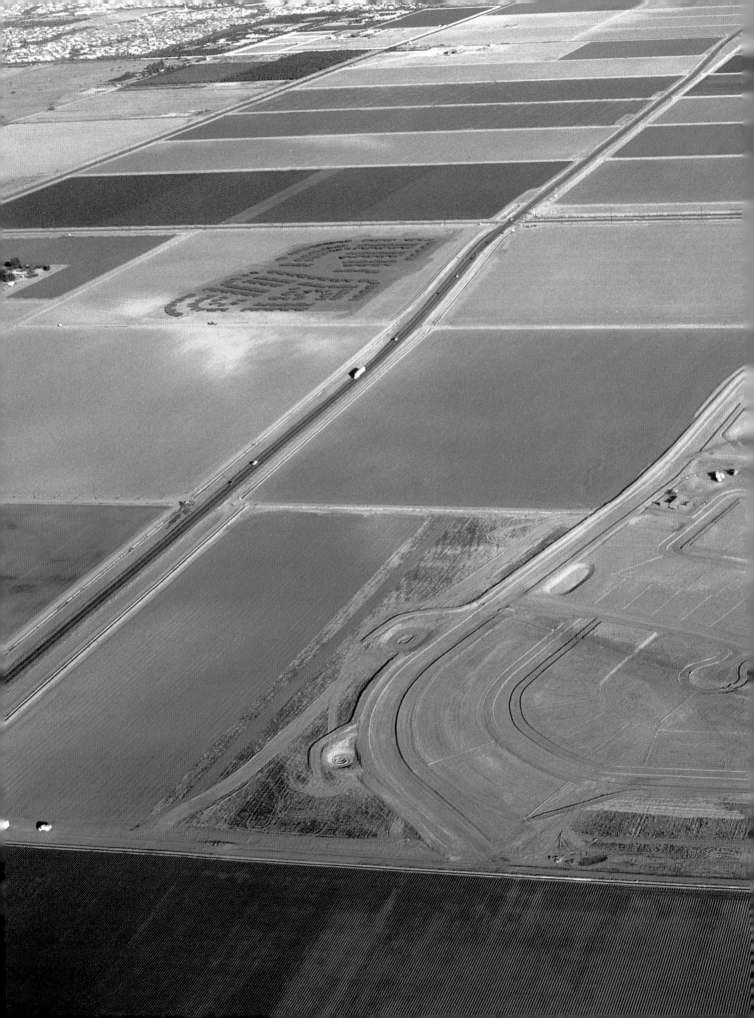

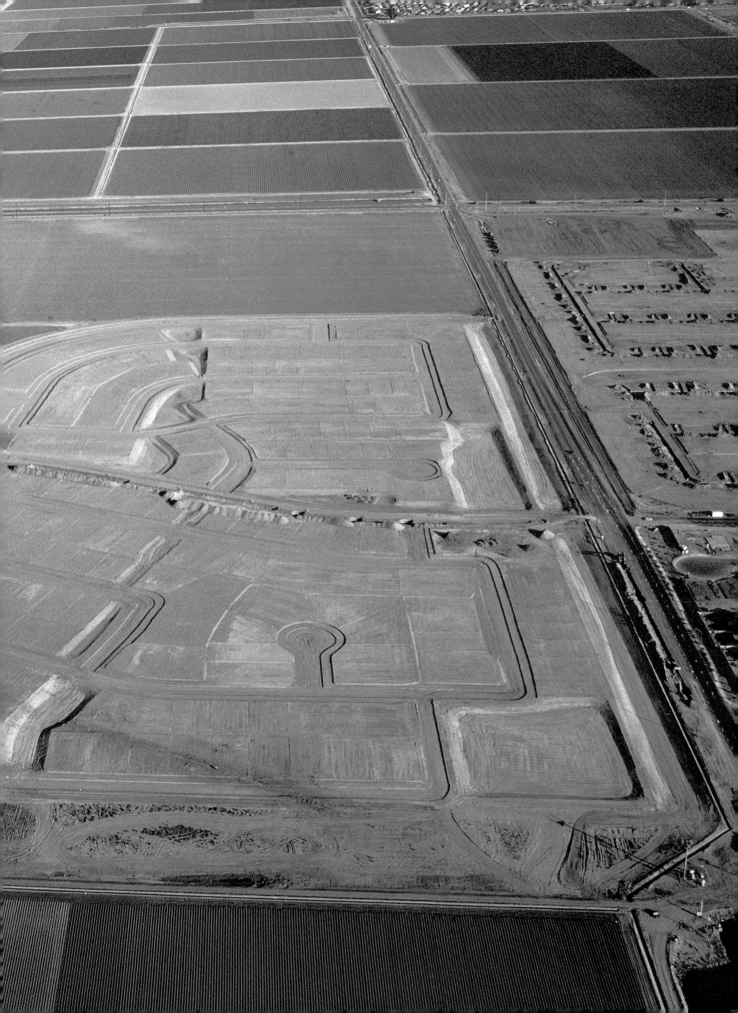

| P.090+091 | ANTONIO LAROSA · LAROSA DESIGN & CONSULTING

| CUBIX | 2003 | 30 X 75 X 25 INCHES | WOOD FRAME, POLISHED

CHROME BASE AND ANILINE-DYED LEATHER |

ALL MY DESIGNS INCLUDE ELEMENTS THAT ENCOURAGE HUMAN

RELATIONSHIPS. IN THIS PARTICULAR PROJECT, THE POSITION OF

THE CHAIRS MAKES IT EASY FOR PEOPLE TO FACE EACH OTHER,

ENCOURAGING THE USERS TO SOCIALIZE.

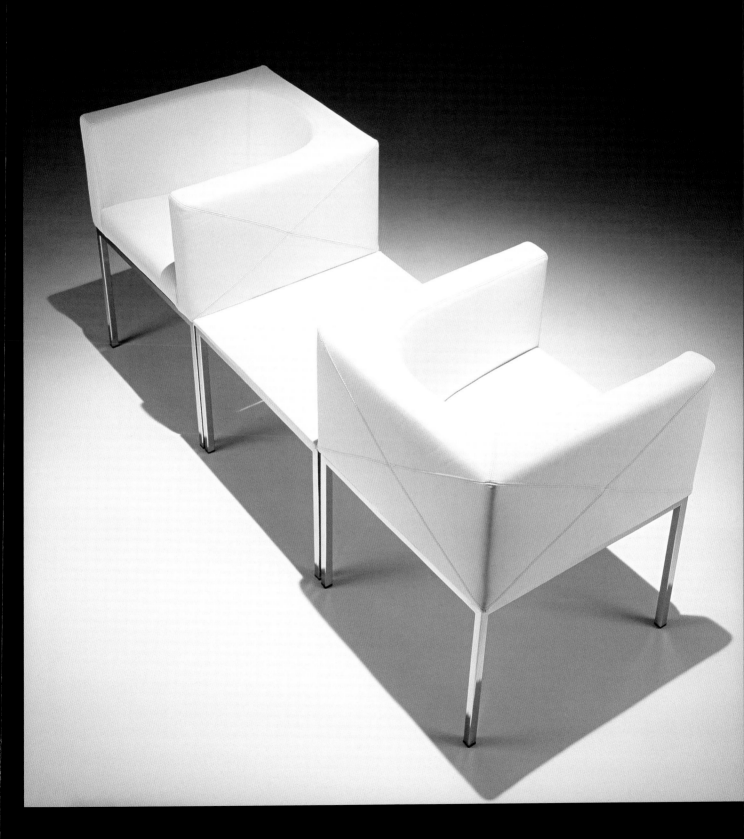

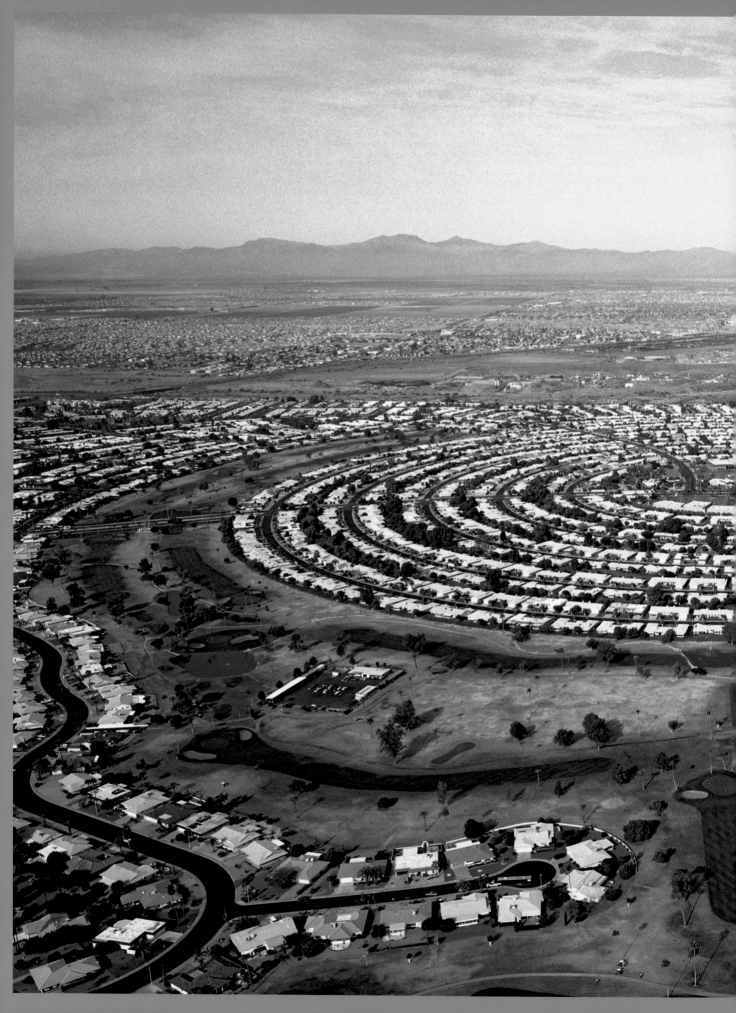

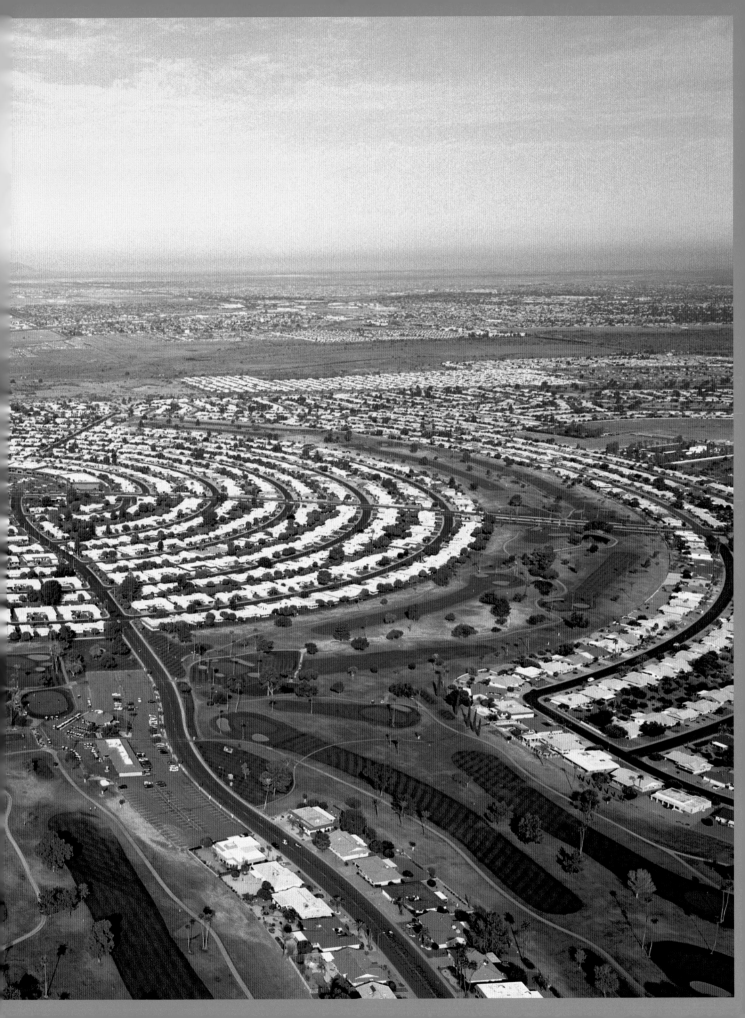

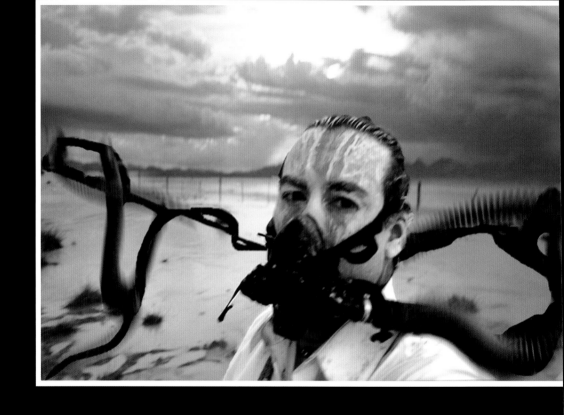

WILLIAM WILSON | AUTO IMMUNE RESPONSE #5 | 2005 | 44 X 110

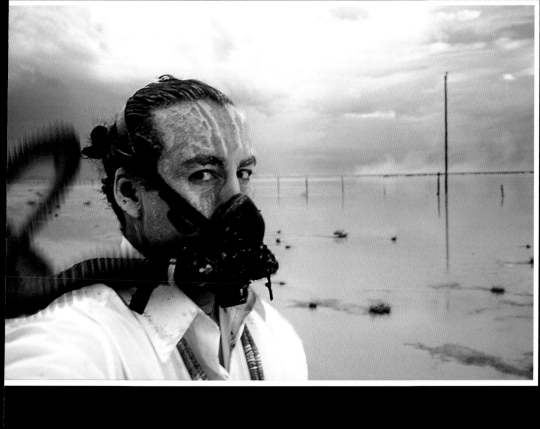

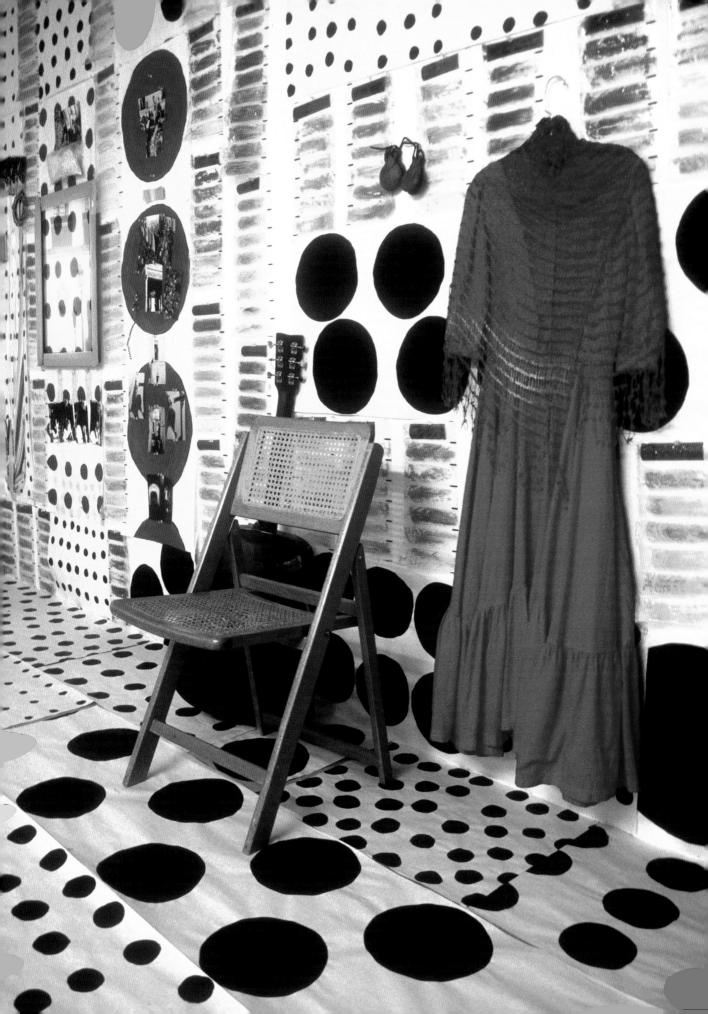

MY WORK OCCUPIES THAT POINT OF CONTACT BETWEEN MYSELF, IDEAS AND MATERIALS, CONCENTRATING ON MAKING THAT CONTACT DRAMATICALLY CLEAR AND COMPOSITIONALLY COMPLETE. DEVELOPING THE IDEA INVOLVES A PROCESS OF DISCOVERY, A STRUCTURING OF A PRESENCE AND WORKING WITH A BREATHABLE SET OF CONDITIONS (SPACE, LIGHT, DIRECTION AND CHANGE). SEMANA SANTA, SPAIN (FLAMENCO) IS ABOUT THE INTEGRATION OF THE CORPOREAL WITH THE TRANSITORY DURING HOLY WEEK IN SPAIN.

MY WORK SPEAKS OF THE EMOTIONAL AND PSYCHOLOGICAL TENSIONS THAT RESULT FROM LIVING IN A CITY IN EXPLOSIVE TRANSITION. EVERYTHING IS CAUGHT IN AN UNEASY BALANCE. IN A WAY, IN PHOENIX, WE ARE CONSTANTLY TRYING TO BALANCE OUR HUMANITY AGAINST THE FORCES OF MARKETING, CAPITAL AND GROWTH.

| P.100 | JEREMY M BRIDDELL | STEPPED TOWERS | 2003 |

11 X 5.5 X 2.75 INCHES | PORCELAIN AND WALNUT |

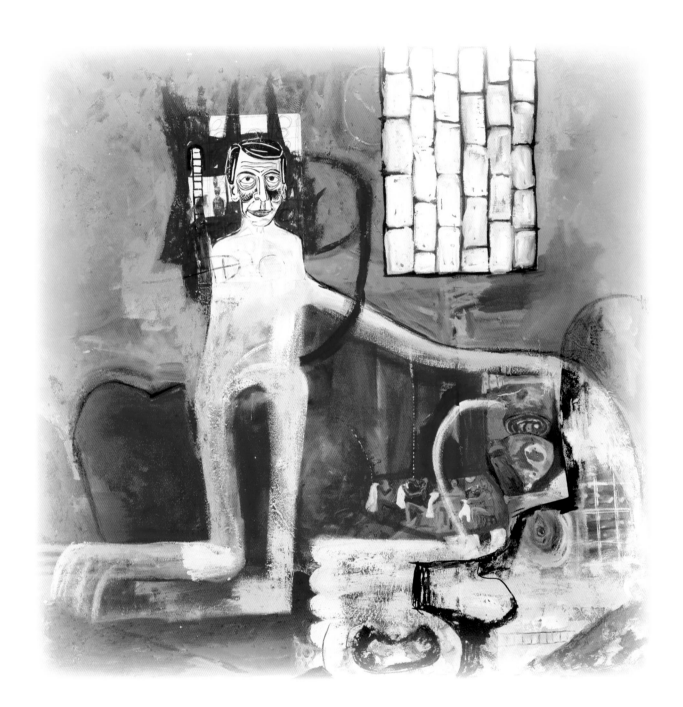

MY WORK IS INFLUENCED BY IMMIGRATION, CHANGE, CONSERVATIVES, BORDER STATE, CORRUPT POLITICS, RED NECKS, INDIANS, MEXICANS, MISCEGENATION AND BY PEOPLE WHO MOVE TO PHOENIX FROM ALL OVER, MAKING IT ONE OF THE FASTEST GROWING CITIES IN THE NATION. THERE IS PLENTY TO BE INFLUENCED BY HERE.

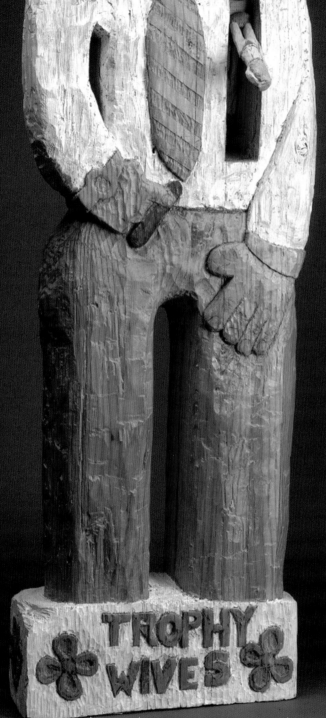

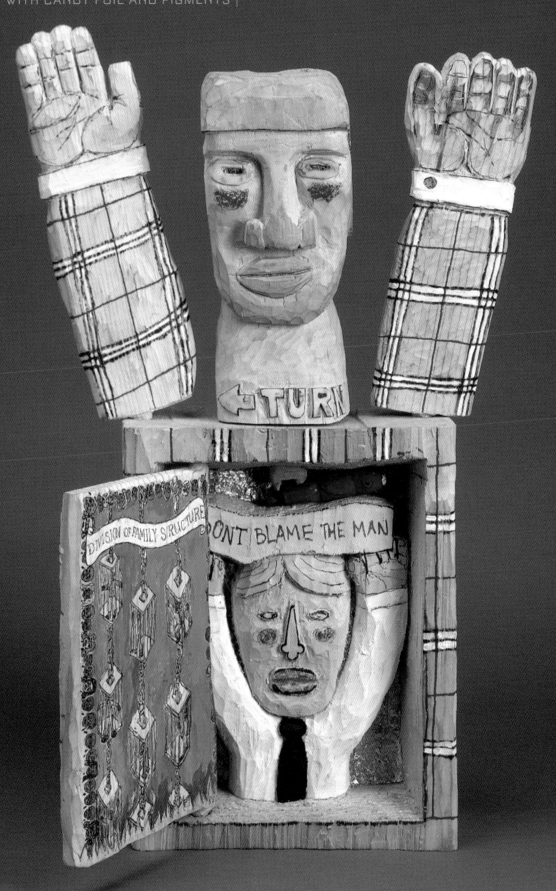

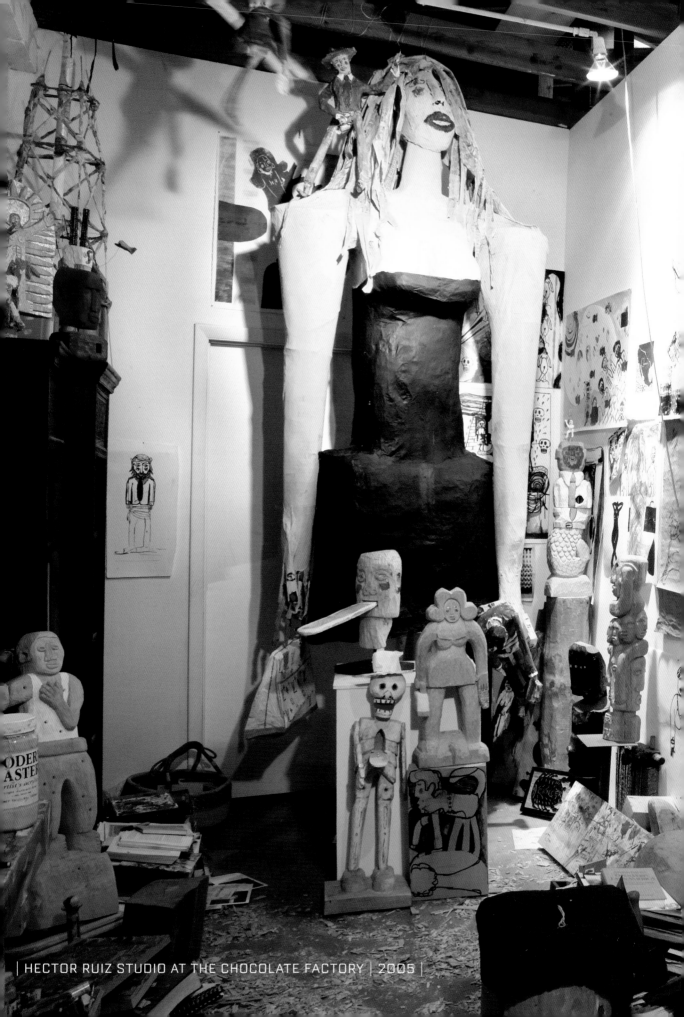

HECTOR RUIZ STUDIO AT THE CHOCOLATE FACTORY | 2005 |

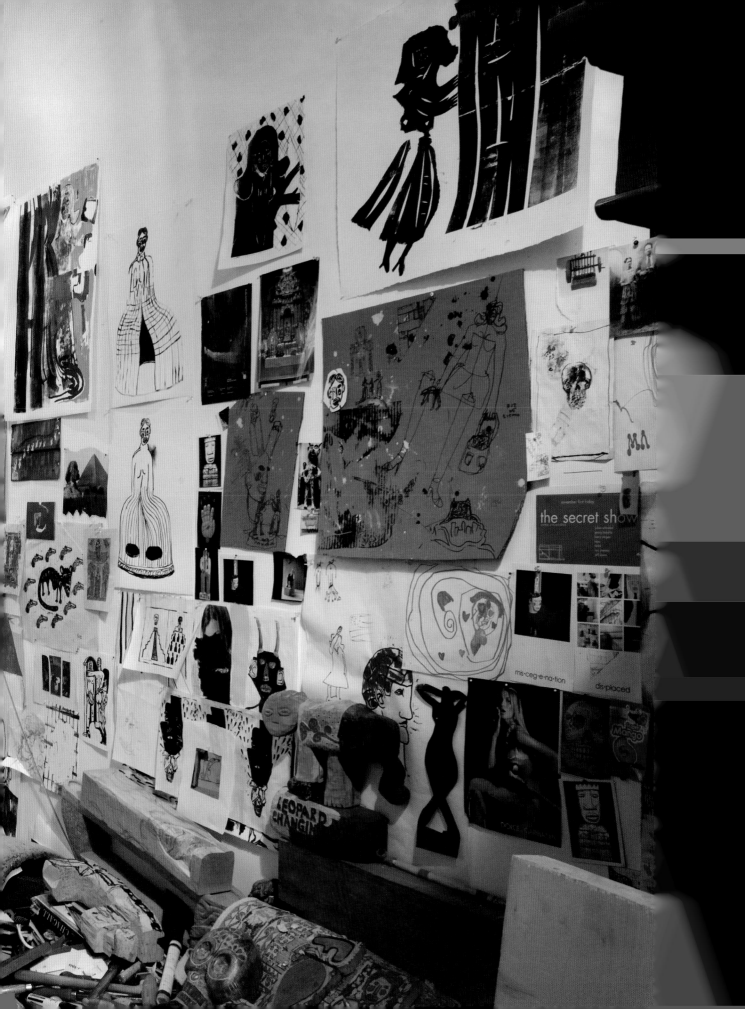

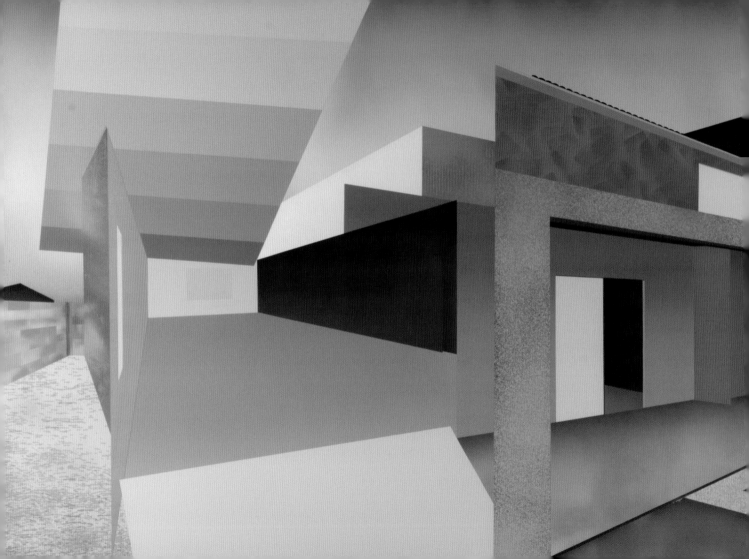

MY WORK IS A DEPICTION OF THE ROMANTIC, ARTIFICIAL NATURE OF BOOMING CITIES IN THE SOUTHWEST. I CONSTRUCT IMAGES THAT PROJECT A SENSE OF THIS PLACE. GROWING UP HERE HAS GIVEN ME AN APPRECIATION FOR THIS VISUAL ENVIRONMENT AND A FASCINATION WITH THE GROWTH AROUND ME. SUBURBAN HOME DEVELOPMENT IS SHAPING THE IMAGE OF THIS REGION. THE CONSTRUCTION AND DESIGN OF TRACT HOUSES IS THE FOCUS OF MY CURRENT WORK. I VISIT HOME DEVELOPMENT SITES THAT ARE UNDER CONSTRUCTION. THIS ALLOWS ME TO BREAK THE HOMES DOWN TO SHAPES AND PLANES, TO LINES AND ANGLES. THESE IMAGES ARE CREATED USING SIGN PAINTING TECHNIQUES.

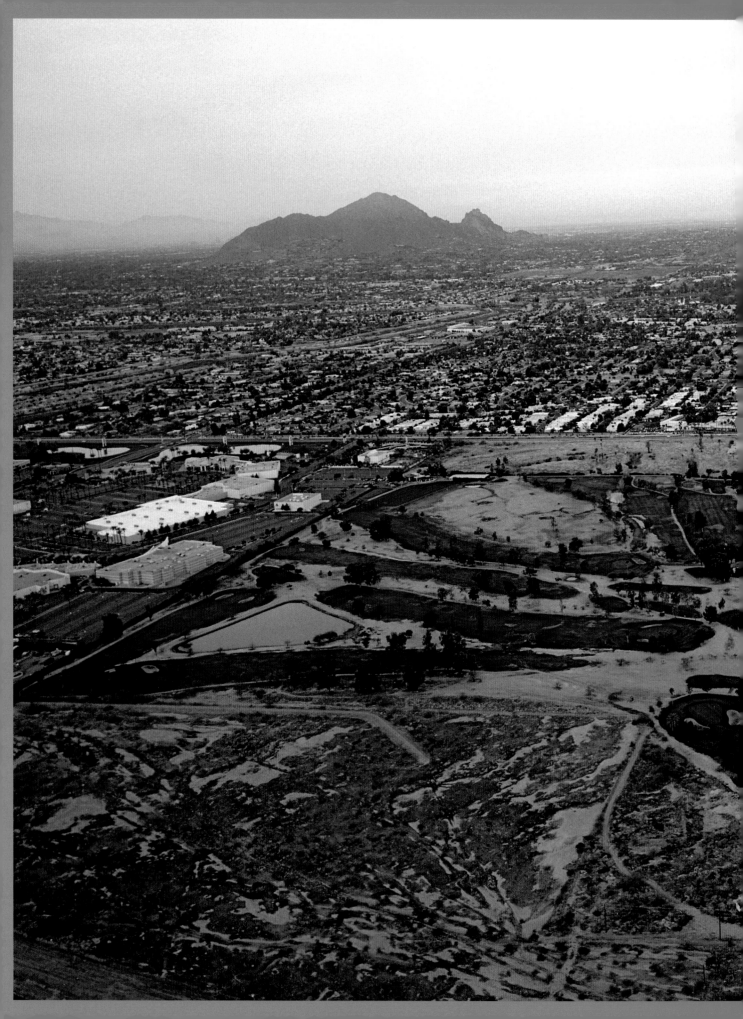

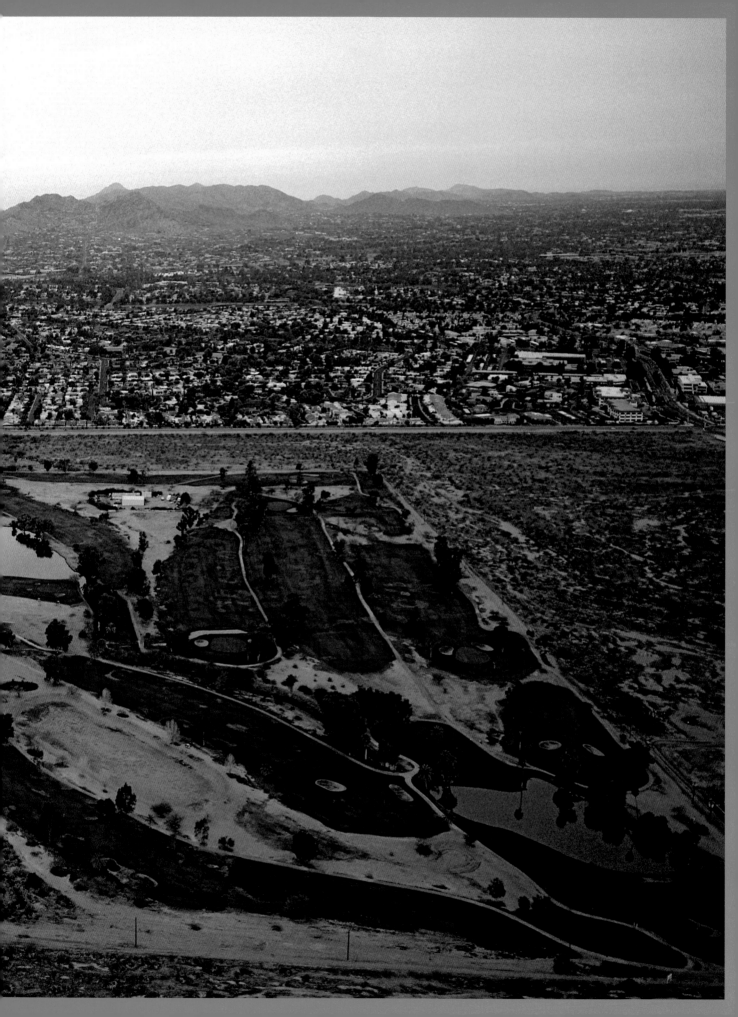

INITIALLY CONCERNED WITH THE FORMAL EXPRESSION OF THE MATERIAL AS A GIFT OF NATURE, I REALIZED OVER TIME THAT THE MATERIAL IS THERE TO ALLOW YOU TO SAY WHAT YOU WANT TO SAY, NOT TO TELL YOU WHAT TO SAY. SO I DECIDED TO USE WHAT I HAD LEARNED ABOUT THE MATERIAL TO EXPRESS SOME IDEAS ABOUT NATURE ITSELF AND MY PLACE IN IT.

| P.114+115 | **THEODORE TROXEL** | **SUBURB** | **2005** | EACH ANIMAL:

28 X 32 X 14 INCHES | WOOD AND ASPHALT ROOFING SHINGLES |

THE RAPIDLY CHANGING ENVIRONMENT HERE HAS EFFECTED NATURAL

HABITATS AND RESOURCES. THIS GROUP OF JAVELINA WERE MADE WITH

MATERIALS OF THE HOUSING INDUSTRY WHICH IS RUNNING RAMPANT IN

THE PHOENIX METROPOLITAN AREA. THE INDIGENOUS CREATURES LOOK

SLIGHTLY OUT OF PLACE WITHIN THE URBAN SETTING. THIS PROJECT

IS A HUMOROUS REMINDER OF THE SMALL COMMUNITIES WE USE FOR

SURVIVAL WITHIN AN URBAN SPRAWL OF COMFORT AND CONVENIENCE.

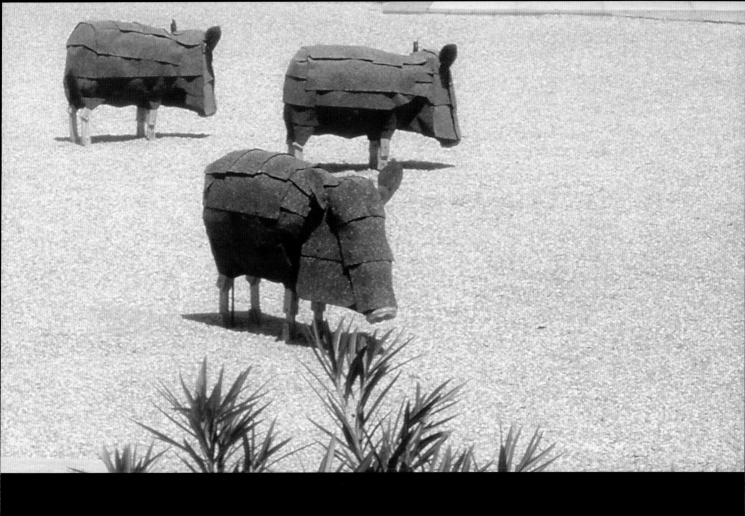

48 X 48 INCHES | ACRYLIC ON BOARD |

THE MINIMALIST INTERPRETATION OF THE COMMON LANGUAGE OF GRAFFITI, POP-CULTURAL,
ICONIC IMAGES AND ARCHITECTURAL SYMBOLS IN MY WORK EMANATES FROM EXPERIENCING
THE DEVELOPING ART SCENE IN DOWNTOWN PHOENIX AS WELL AS THE REVITALIZATION OF
OTHER URBAN LANDSCAPES. WHERE SOME LAMENT A "DISNEYFICATION" OF OUR URBAN CORES,
I ATTEND TO THE UNIQUE EXPRESSIVE MARKS INDIVIDUALS LEAVE ON PLACES.

| P.118-121 | STEVE HILTON | 36, 458...
36,459... 36,460 · ANOMALY | 2005 |
19 INCHES X 16 X 15 FEET | CERAMIC
CAST IN PLASTIC |

AS A "GEOLOGIST" AND CLAY ARTIST, I HAVE DEVELOPED AN

APPRECIATION FOR THE ANOMALIES IN THE MANY FORMS OF LIFE,

CLAY, ROCK AND SOIL COVERING THE LANDSCAPE OF THE EARTH.

I AM INTRIGUED BY THE WAY PLANTS, ANIMALS AND WEATHER

INFLUENCE THE SURFACE OF THE EARTH, BY BOTH EROSION AND

DEPOSITION. THIS FASCINATION, ESPECIALLY WITH THE DESERT

AROUND PHOENIX, HAS BECOME AN INTEGRAL PART OF MY ART.

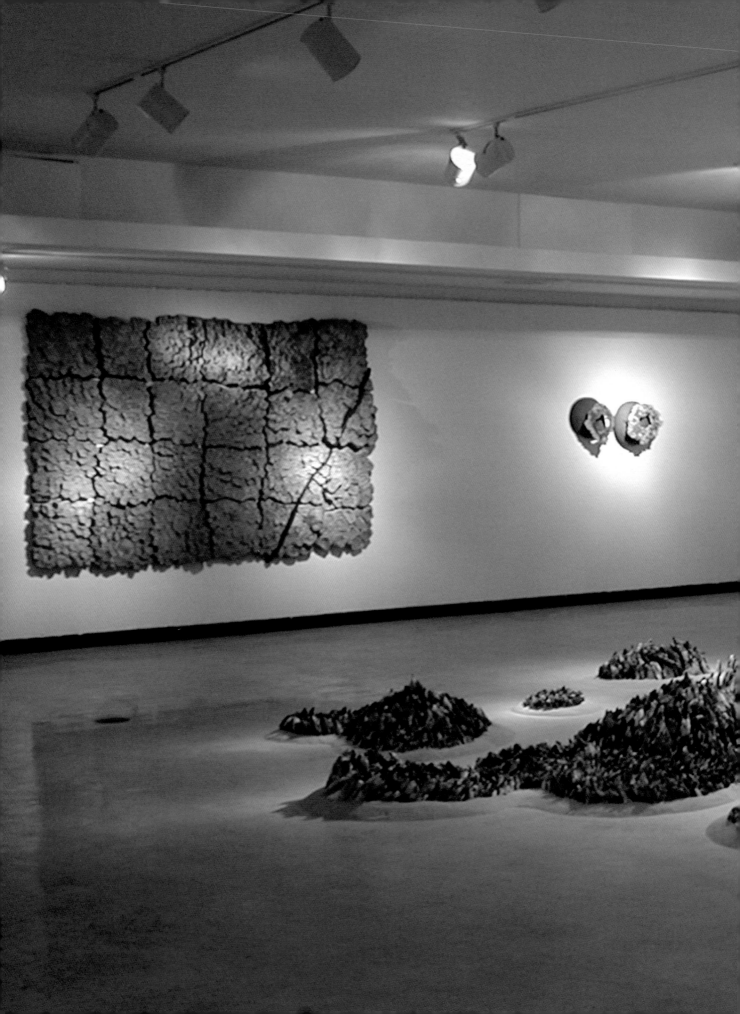

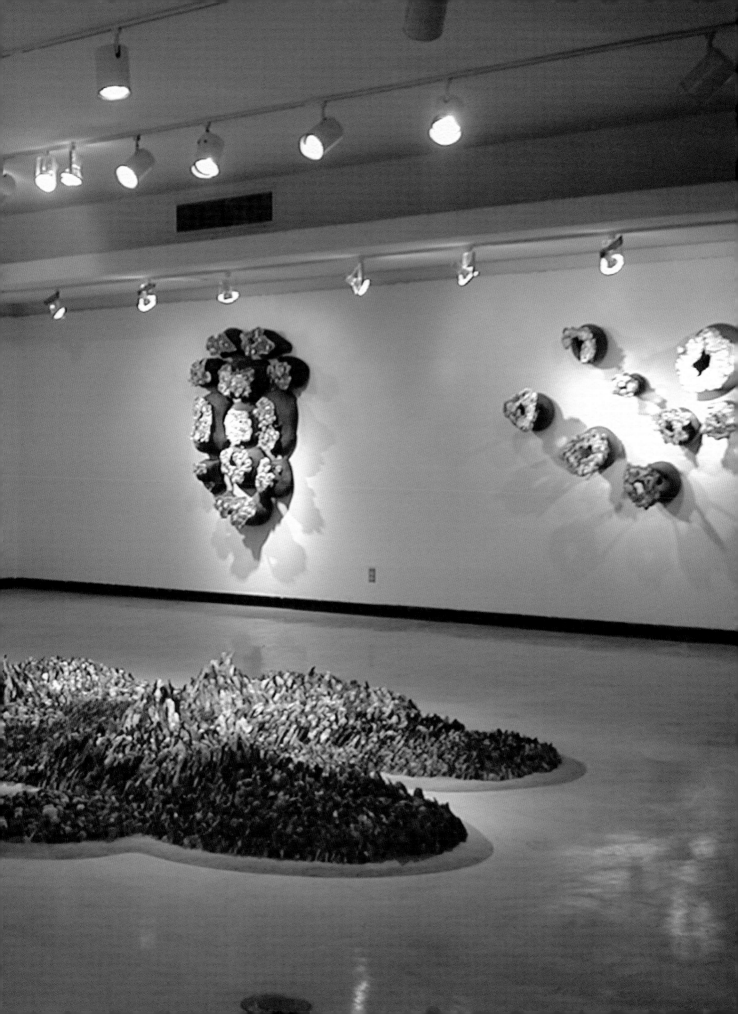

LIVING WITH DIRECT EXPOSURE TO THE EXOTIC NATURE OF THE DESERT
PROVIDES A DAILY ENCOUNTER WITH THE FUNDAMENTALS OF FORM, SPACE,
LIGHT AND AIR. THE VERY SAME VARIABLES ARE CRITICAL IN THE DESIGN
OF ANY BUILDING FROM THE SMALLEST TO THE MOST GRAND. THE 21ST
CENTURY WILL BE THE CENTURY OF DESIGN – NOT ONLY IN TERMS OF STYLE
BUT, MORE FUNDAMENTALLY, TIED TO THE BEAUTY OF PURPOSE, MEANING,
UNPRECEDENTED PERFORMANCE AND HUMAN VALUES.

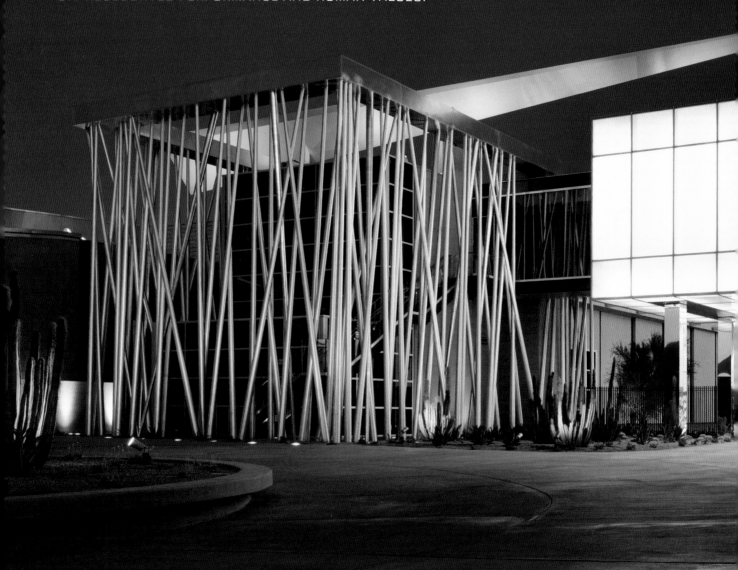

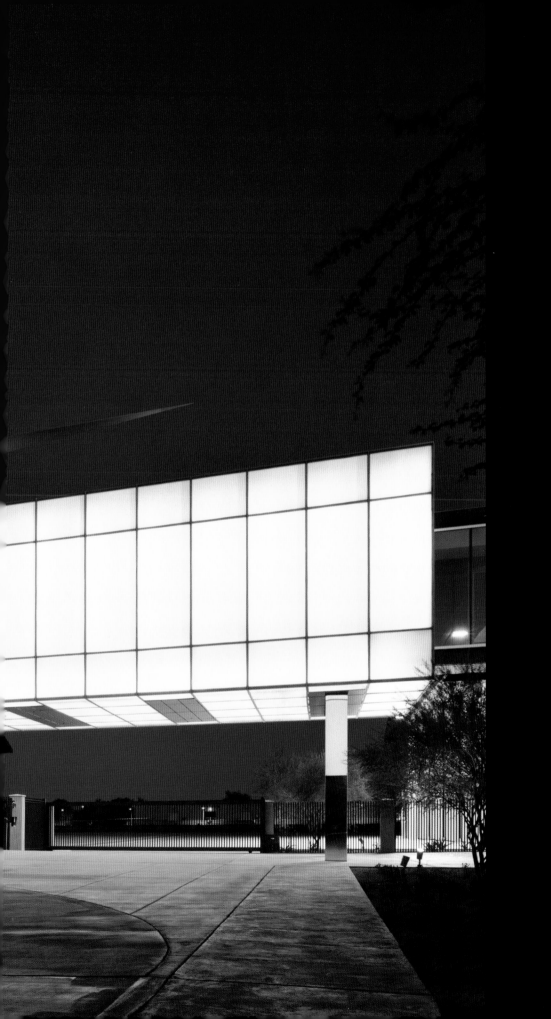

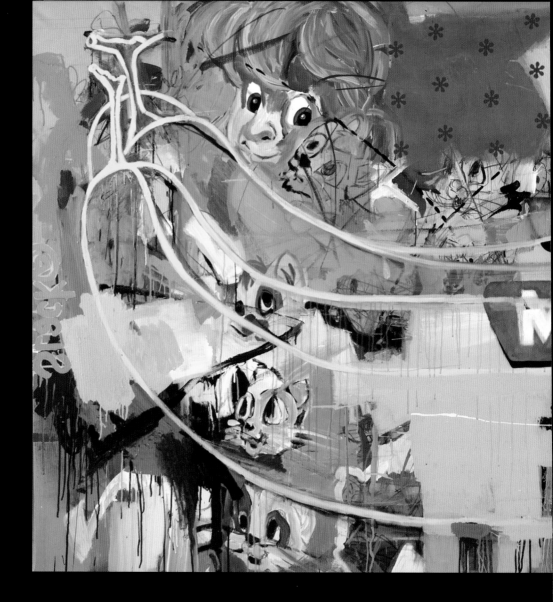

I HAVE ALWAYS HAD AN APPRECIATION FOR THE PHOENIX REGION AND WAS UNAWARE

THAT URBAN RENEWAL WOULD DESTROY AND REBUILD THE SMALL TOWN HISTORY

I HAD COME TO KNOW. MANY MOTEL SIGNS LITTER THE SEEDY, GRAFFITI-FILLED

GRAND AVENUE ON THE WAY TO MY DOWNTOWN STUDIO.

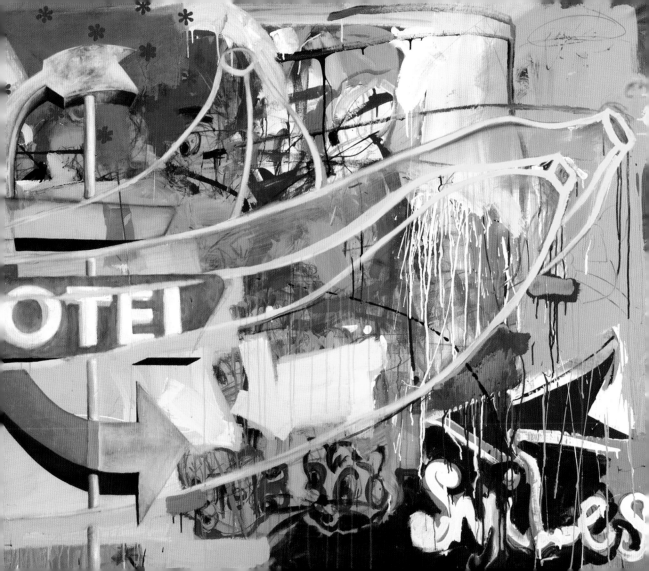

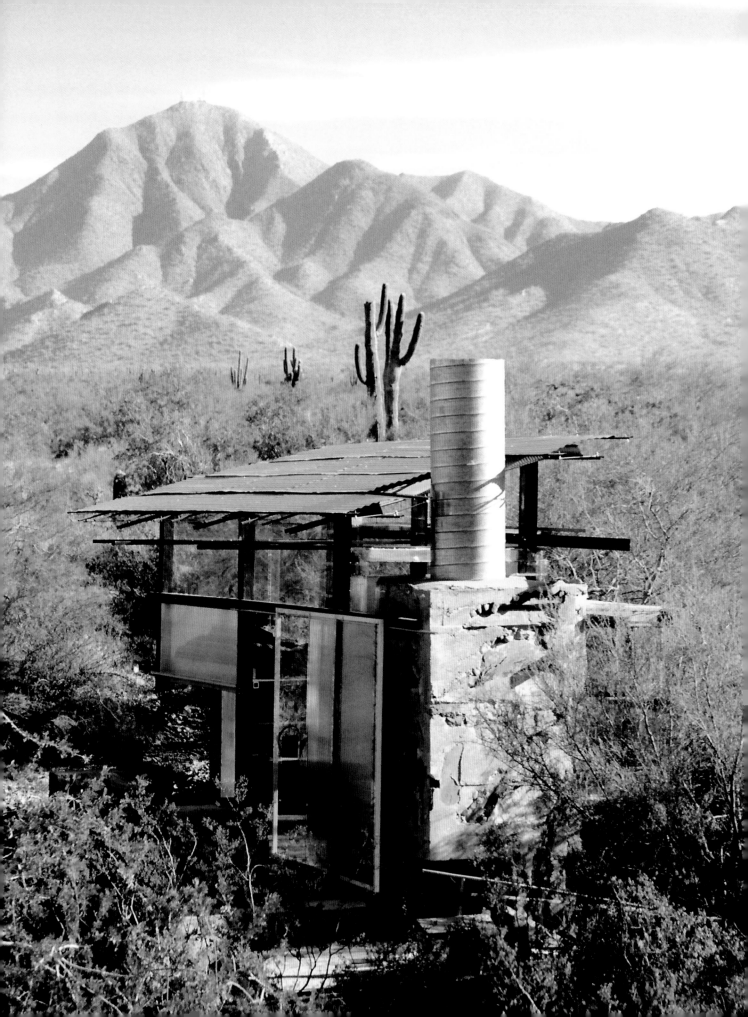

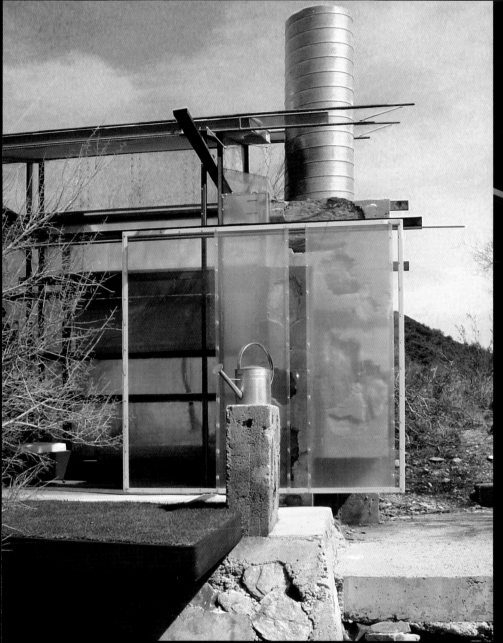

| P.126+127 | **VICTOR SIDY** | **DESERT SHELTER AT TALIESIN WEST** | **2000** | INTERIOR: 144 SQUARE

FEET, EXTERIOR LIVING SPACE: 200 SQUARE FEET | EXISTING CONCRETE AND STONE STRUCTURE

FROM THE 1970S, SANDED OSB-FACED INSULATED PANELS, GALVANIZED CORRUGATED METAL,

POLYCARBONATE, STEEL, GALVANIZED SPIRAL DUCT AND GRASS |

THIS STRUCTURE IS A RESPONSE TO THE RAW ENERGY OF THE ARIZONA LANDSCAPE – BROAD VISTAS,

MUSCULAR LANDFORMS, CLIMATIC CONTRASTS. IT SUPERIMPOSES A COMPOSITION OF LOW-COST

MATERIALS SUCH AS ORIENTED STRAND BOARD, TWIN-WALL POLYCARBONATE, PRIMED STEEL AND

SPIRAL DUCT MATERIAL UPON AN "ARTIFACT" OF CONCRETE AND STONE TO PROVIDE BASIC SHELTER.

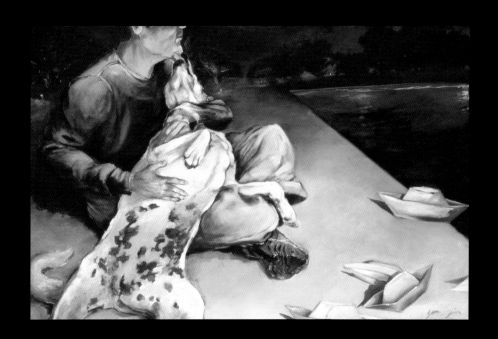

| P.128 | STEVEN J YAZZIE | THE FAREWELL | 2001 | 48 X 72 INCHES |

OIL ON CANVAS |

WITHOUT CONSCIOUSLY REFERRING TO THE PHOENIX EXPERIENCE, THE

CONTEXT OF THE ENVIRONMENT, THE SPRAWLING URBAN EXPERIENCE,

AND ISSUES OF CULTURAL, SOCIAL AND POLITICAL SIGNIFICANCE ARE

INHERENT IN MY WORK.

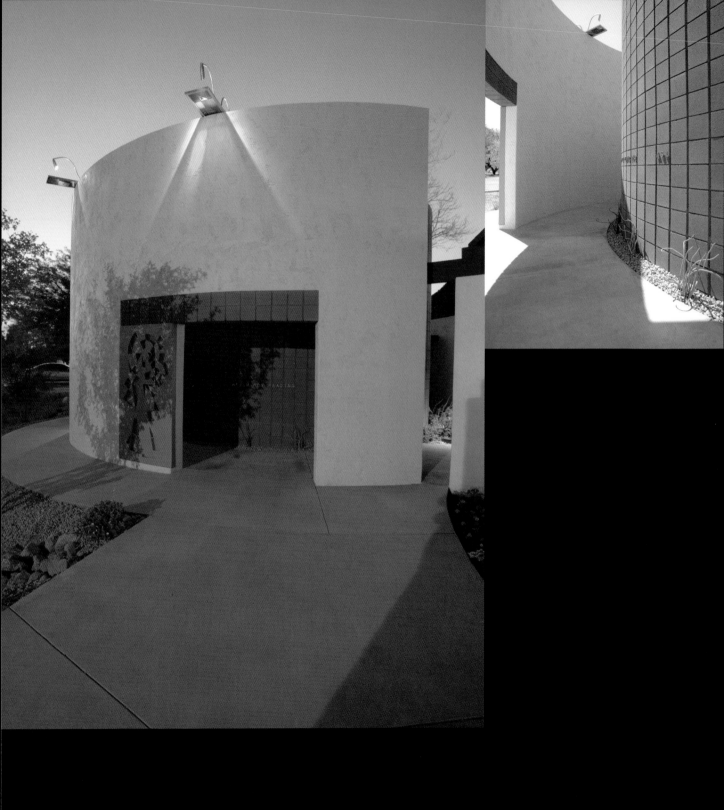

| P.132+133 | MATTHEW & MARIA SALENGER AIA · COLAB STUDIO | ST CLARE BLESSED SACRAMENT CHAPEL | 2004-05 | 240 SQUARE FEET | MASONRY, PLASTER, SOLID WALNUT WOOD, FABRIC AND STAINED GLASS |

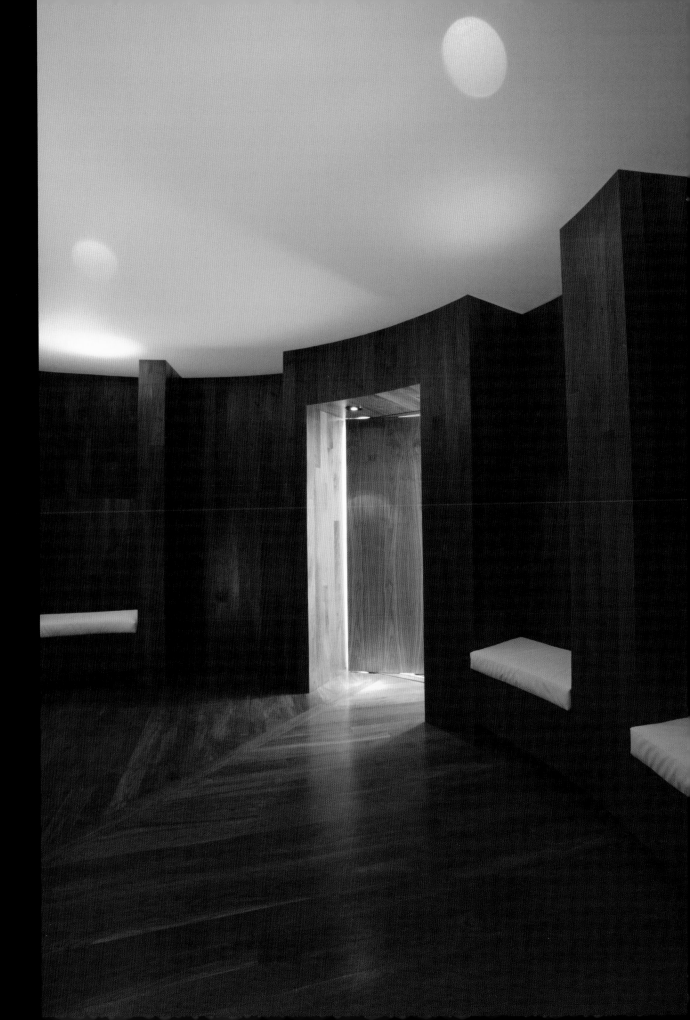

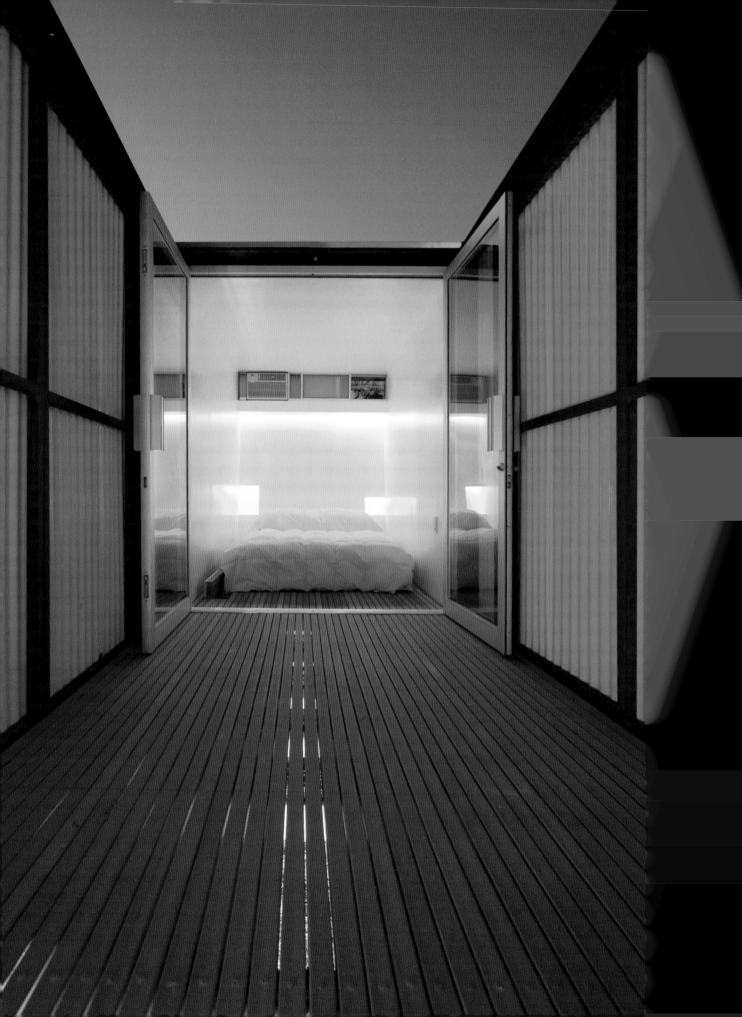

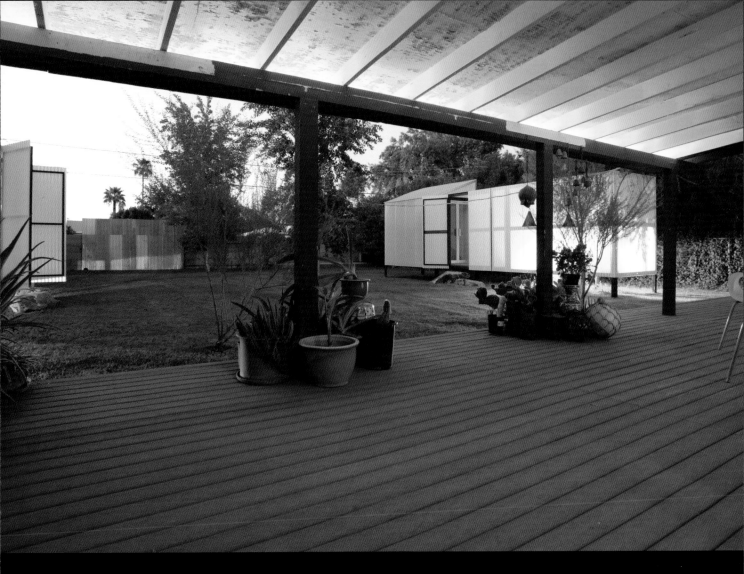

| P.134+135 | MATTHEW & MARIA SALENGER AIA · COLAB STUDIO | CEDAR STREET RESIDENCE |
2000-04 | 1150 SF EXISTING CMU HOUSE BUILT IN 1954, 60 SF SLEEPING PODS CONSTRUCTED
OF STEEL, GLASS, COMPOSITE WOOD, SHEET METAL AND CORRUGATED FIBERGLASS |

COLAB IS A LABORATORY FOR ART AND ARCHITECTURE. MERGING METHODOLOGIES, WE STUDY THE FORCES
THAT GUIDE WHAT IS HAPPENING AROUND US TO CREATE INFORMATIVE EXPERIENCES. LIVING IN PHOENIX
INSPIRES AND INFLUENCES OUR WORK IN EVERY WAY. WE BELIEVE PHOENIX IS THE ENVIRONMENTAL MODEL
FOR MANY DEVELOPING CITIES AROUND THE WORLD.

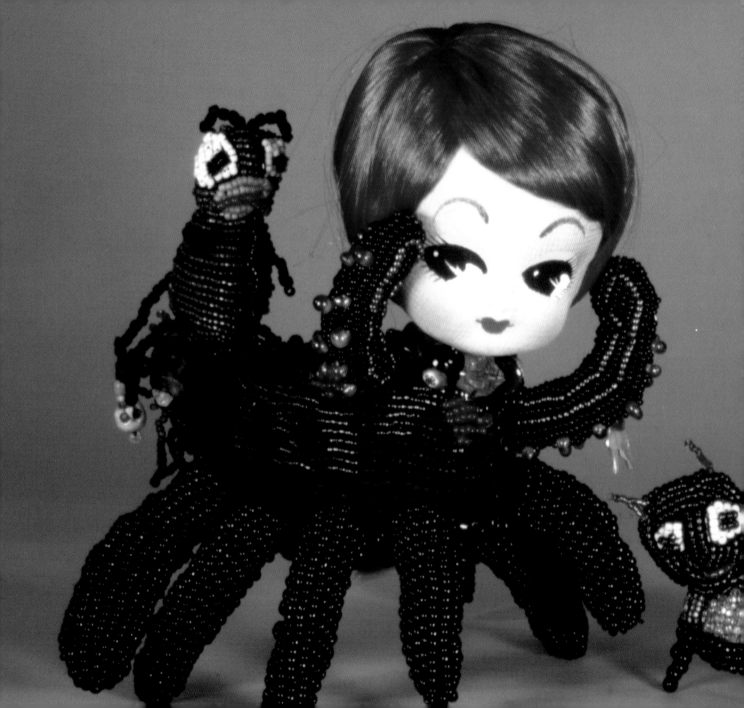

THE SCULPTURES I CREATE TRANSLATE MY REALITY. THEY ARE
PROTECTIVE AND REFLECTIVE. BEAD EMBELLISHMENT ADDS A
HISTORICAL AND RITUAL SIGNIFICANCE TO EACH PIECE. MY CURREN
VISUAL INFLUENCES COME FROM RESEARCH INTO WORLD CULTURES
AND MY EVERYDAY LIFE EXPERIENCES. THE UNIQUE COLORS, PEOPL
BUGS, SMELLS, ETC. THAT PHOENIX HAS TO OFFER IS VAST AND
AMAZING. THE DESERT AND URBAN ENVIRONMENT HAVE DONE
WONDERS FOR MY IMAGINATION.

ON CAMERA THERE WAS AN EVIL, LITERALLY REVEALING ITSELF, ALL AROUND ME.

CHOOSING NOT TO JOIN IT; ALLOWING MYSELF, ASKING REALLY, TO BE SAVED FROM

IT. I HAD A SAVIOR AT THAT POINT, HOLY SPIRIT, ONE I NOW KNEW, PERSONALLY,

THAT CALLED ME BY NAME. NO MORE LONESOME VALLEY. PHOENIX, GROWING UP, FOR

ME, WAS A PLACE OF BUSTLING ISOLATION. BUSTLING IN THE SUNSHINE, AMONGST

OPTIMISM, GROWTH, CITRUS, DESERT AS DESERT AND DESERT AS MOVING VEHICULAR

LANDSCAPE. ISOLATION IN THAT I WASN'T SO SURE HOW I/PHOENIX WORKED/

CONNECTED. FOR A LONG TIME I CAPTURED THINGS ON CAMERA TO UNDERSTAND.

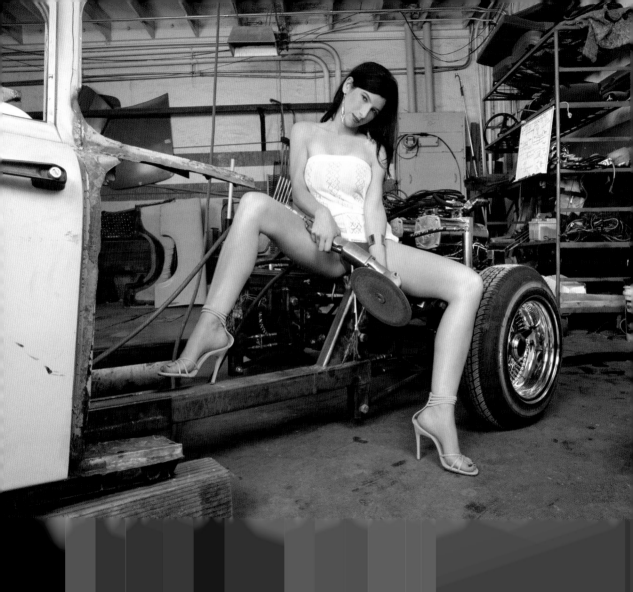

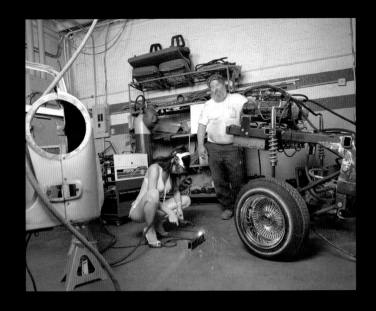

| P.141 | LIZ COHEN | AIR GUN · BODYWORK | 2005 | 40 X 50 INCHES | C-PRINT |

LIKE ANY KID FROM THE VALLEY, I SPENT A LOT OF TIME IN CARS AND SCHOOL BUSES. THESE CARS AND SCHOOL BUSES WERE AN IMPORTANT SOCIAL SPACE IN MY LIFE. I MADE MY CLOSEST FRIENDS ON THE SCHOOL BUS, FOUGHT AND PLAYED WITH MY SISTERS IN THE BACK OF THE CAR AND HAVE HAD SOME OF MY MOST IMPORTANT CONVERSATIONS WITH MY MOTHER IN THE CAR. I GOT MY FIRST CAR WHEN I WAS 16 (I STILL DRIVE IT) AND I OFTEN TALK ABOUT IT AS A PROSTHETIC OR EXTENSION OF MY BODY. OF COURSE, I DO THINK ABOUT THE DARK SIDES OF OUR CAR-DEPENDENT VALLEY AND ITS RELATIONSHIP TO OUR DESIRE FOR OUR "OWN SPACE." I DON'T THINK THAT HIGH SCHOOLERS COULD THROW A DESERT KEGGER AT 104TH ST. AND SHEA THESE DAYS. I HAVE ENJOYED LIVING IN BOTH SAN FRANCISCO AND BOSTON WHERE I DIDN'T NEED TO DEPEND ON THE CAR AS MUCH. I LOOK FORWARD TO THE CITY BUILDING UP AND EXPANDING ITS TRANSPORTATION OPTIONS. FOR NOW, I AM ENJOYING THE TIME IN THE CAR.

| P.144-147 | **MARWAN AL-SAYED | HOUSE OF EARTH AND LIGHT | 2000-04** | MAIN HOUSE: 2400 SQUARE FEET, STUDIO: 1400 SQUARE FEET | EARTH CEMENT, POWDER COATED STEEL, CAST GLASS, CONCRETE, CHERRY WOOD AND KYNAR COATED PVC |

SHADOW AND LIGHT. LUMINOSITY AND INCANDESCENCE OF THE FULL MOON. REFLECTED GLOW OF RISING AND SETTING SUNS ON THE HORIZON. CLOUDS AND SHADE... ATMOSPHERIC EVENTS AFFECTING HUMAN LIFE FILTERED THROUGH BUILDING FORM. ARCHAIC OR MODERN? DOES IT MATTER ANYMORE? EACH BECOMES THE OTHER AND THEN ITSELF AGAIN... AGAIN I ASK MYSELF OUT HERE... ANCIENT OR MODERN...? COURTS ARE WALLS... WALLS ARE LAND... LAND IS LIFE... PHOENIX MAKES ME THINK ABOUT SUCH THINGS IN A WAY MANHATTAN NEVER DID.

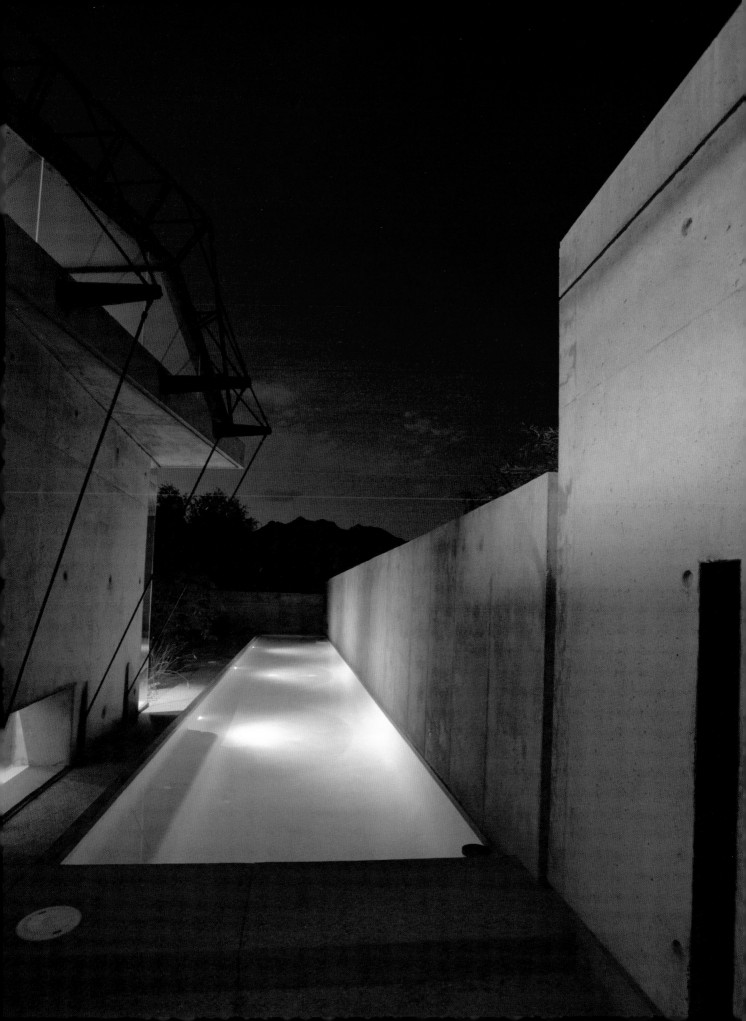

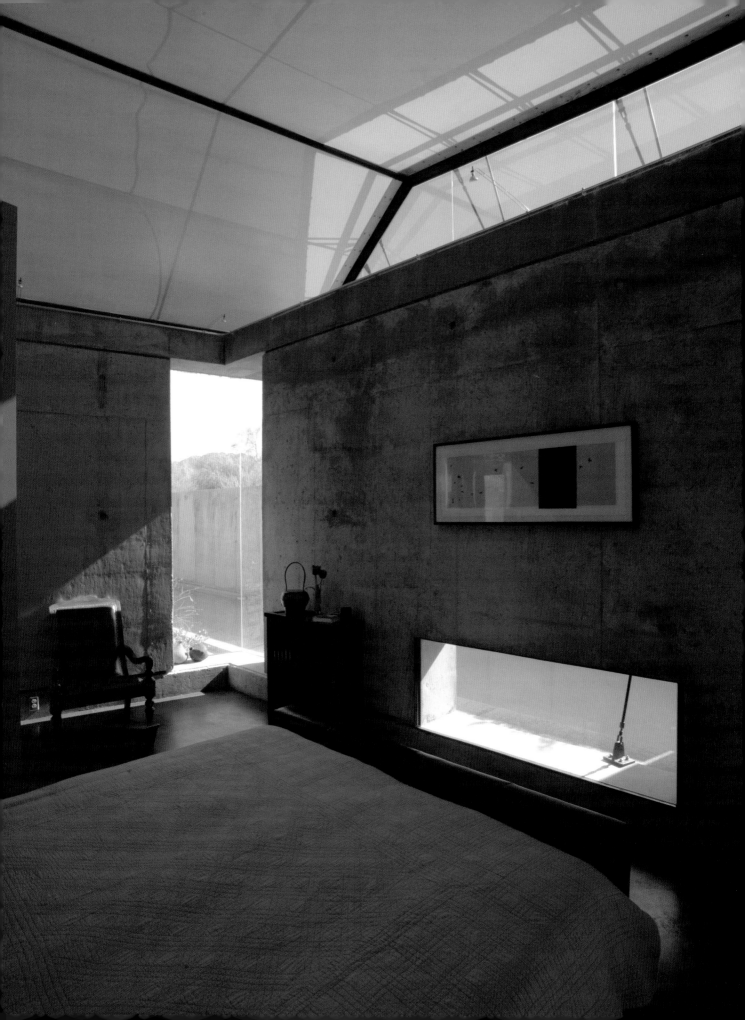

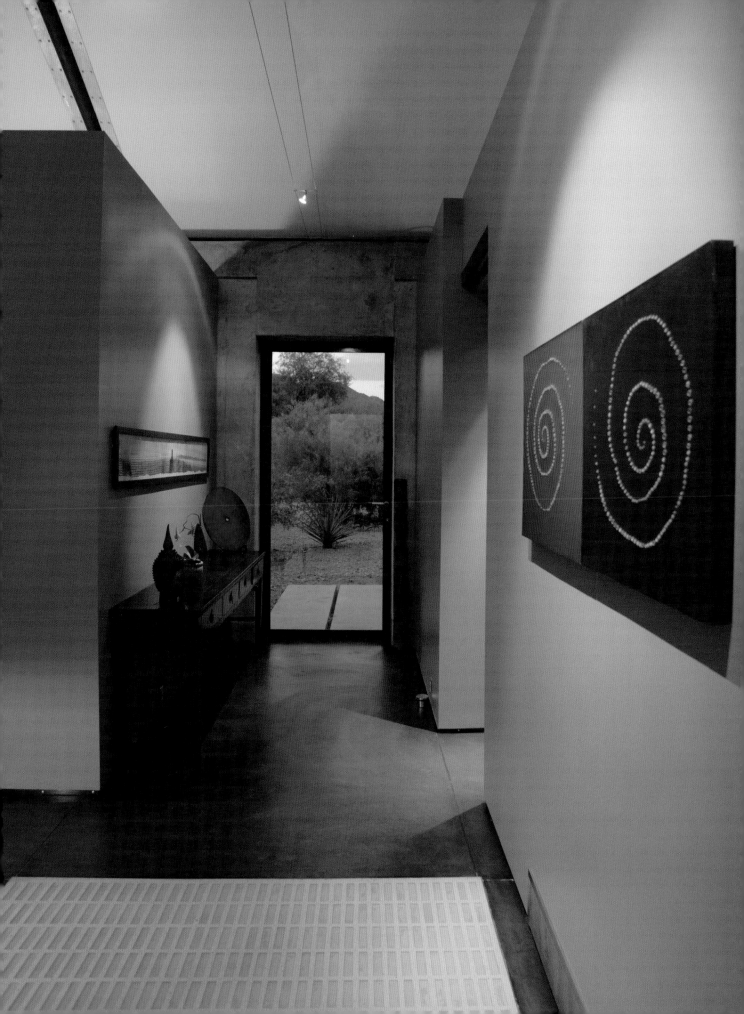

MIES GRYBAITIS | CUSTOM CAST GLASS SINKS – OIA GLASS SINKS · HOUSE OF EARTH AND LIGHT | 2000 | 24 X 20 INCHES | CAST GLASS |

LIVING IN THE CLIMATE AND LIGHT OF ARIZONA HAS INFLUENCED MUCH OF MY RECENT GLASS WORK. GLASS AS A MEDIUM HOLDS ENORMOUS POTENTIAL WITH RESPECT TO LIGHT AND COLOR AND THE EFFECTS OF THE PASSAGE OF LIGHT THROUGH GLASS. THIS HAS INSPIRED BOTH THE WORK ITSELF AND THE DESIGN OF THE HOUSE OF WHICH IT IS A PART.

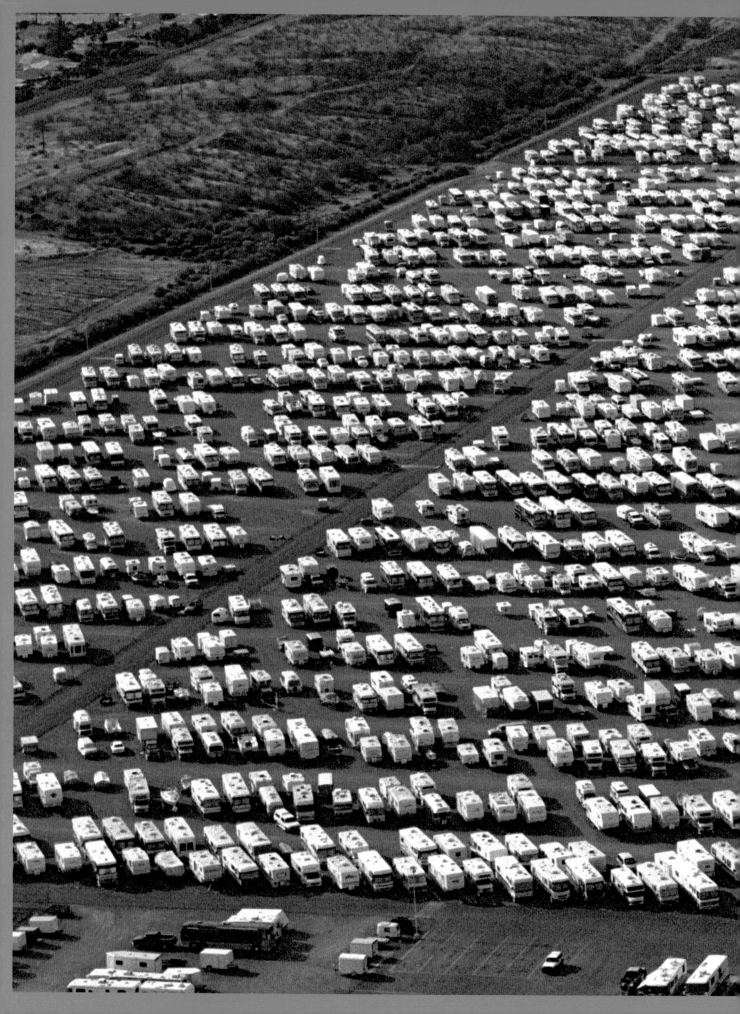

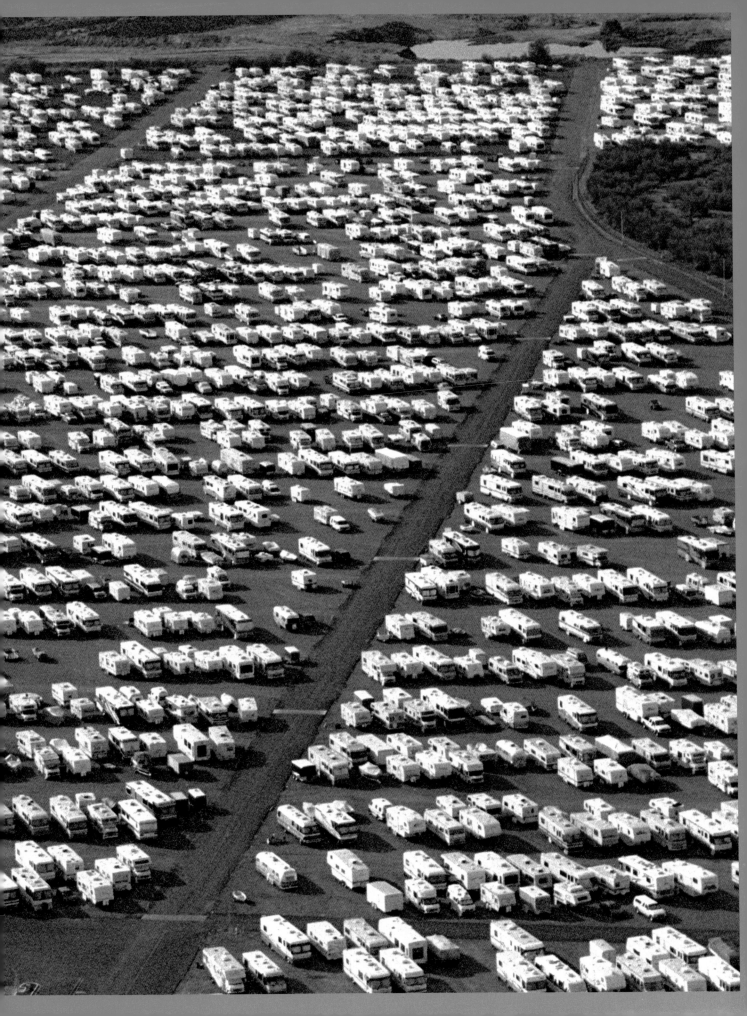

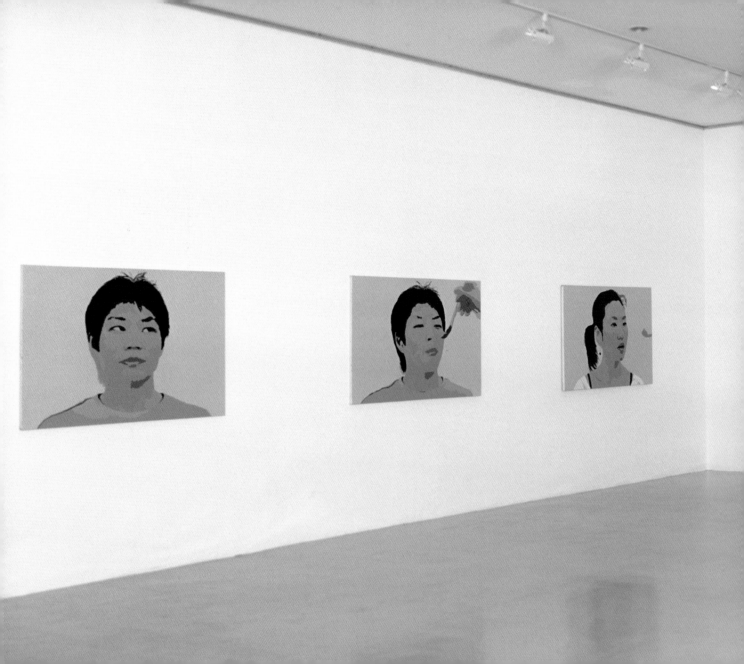

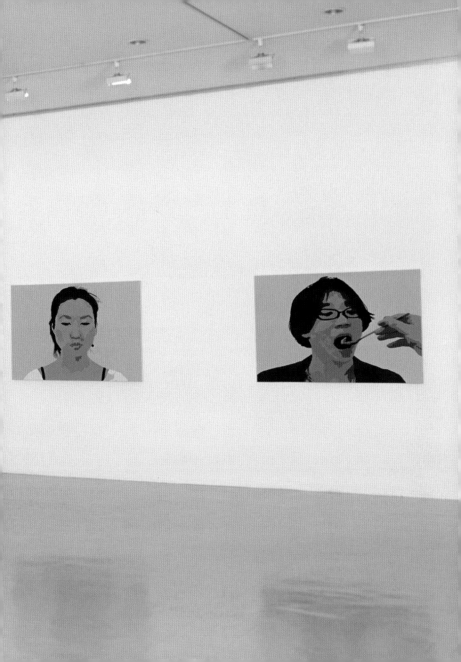

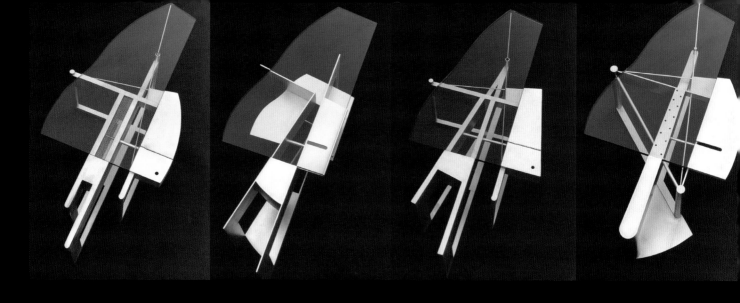

| P.154 | ROBERT WHITTON | ASKEW AXIS TABLE SERIES | 2000-01 |

15 X 56 X 30 INCHES | WELDED ALUMINUM AND GLASS |

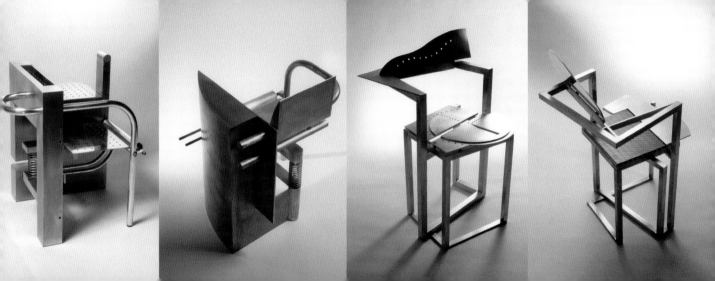

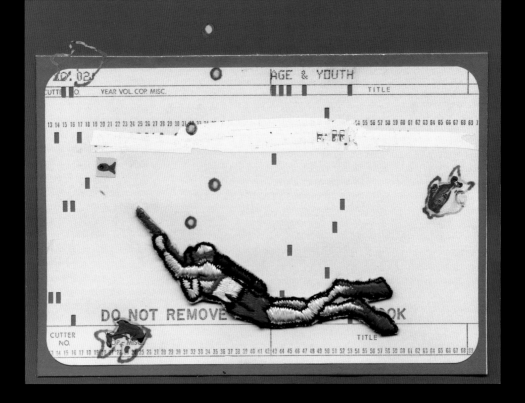

CYNDI COON | SCUBA YOUTH · URBAN PURSUIT | 2005 | 4.25 X 5.5 INCHES | MIXED MEDIA COLLAGE

AS AN ARTIST AND A DESIGNER, I RESPOND GREATLY TO COLOR. PARTICULARLY TO COLOR THAT

THE SOUTHWEST PROVIDES WHICH IS VASTLY DIFFERENT TO THE COLOR OF THE MIDWEST WHERE

I GREW UP. AS A HUMAN, I RESPOND TO COMMUNITY AND UNLIKE OTHER MAJOR CITIES, PHOENIX

IS LIKE A BIG SMALL TOWN WHERE EVERYBODY KNOWS EVERYBODY. THERE IS A SHARED INTEREST

IN SUPPORTING ONE ANOTHER BY PROVIDING FEEDBACK, CRITIQUE AND INSIGHT IN A WAY THAT IS

NOT FOUND IN LA OR NEW YORK. I THRIVE ON THIS NOTION OF COMMUNITY AND CONNECTEDNESS.

2006 | 70 X 60 X 60 INCHES | PLASTER, WOOD AND CONCRETE |

THE ORIGIN OF MAN-AKINS: MISFITS IN UTOPIA DEVELOPED FROM MY SOCIAL ACTIVISM

IN DOWNTOWN PHOENIX AND MY DESIRE TO SEE PHOENIX BECOME A DYNAMIC

ARTISTIC AND CULTURAL CENTER. I GREW UP IN PHOENIX AND HAVE WATCHED IT

GO THROUGH MANY TRANSITIONS; REPEATED CYCLES OF BOOM AND BUST THAT,

IN RETROSPECT, WERE JUST GROWING PAINS. PHOENIX IS EMERGING FROM ITS

ADOLESCENCE AND NOW HAS THE OPPORTUNITY TO BECOME A UNIQUE AND EXCITING

CITY IF WE VALUE, CELEBRATE AND PRESERVE OUR DIVERSITY AND HISTORY. IT'S

THE MISFITS IN A SOCIETY THAT MAKE A PLACE UNIQUE AND INTERESTING.

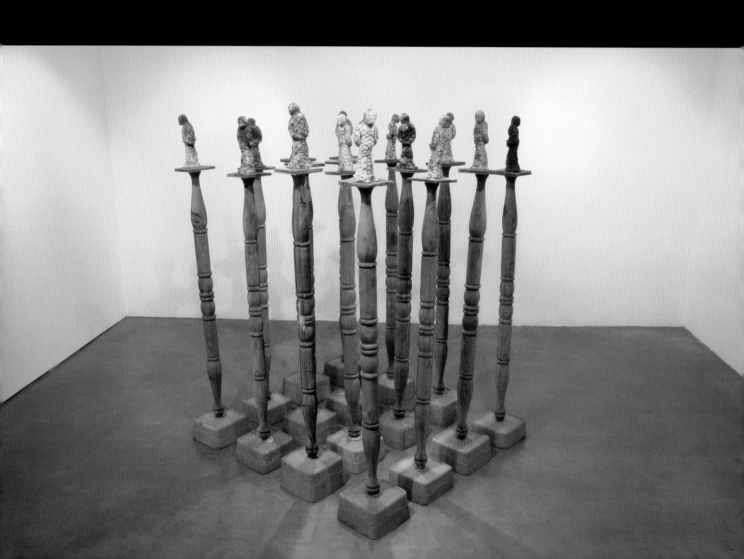

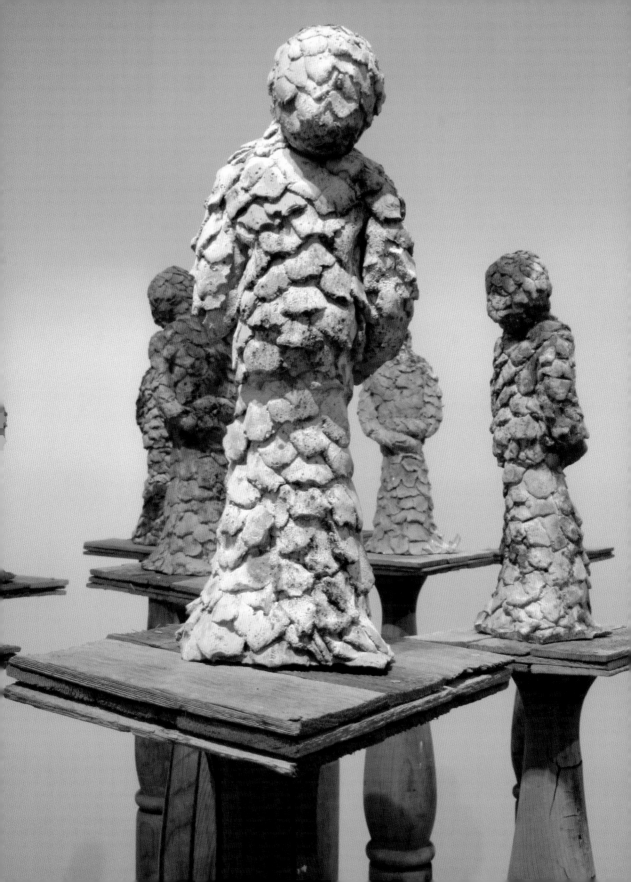

THE TWO-STORY CORRUGATED METAL VOLUME WAS A FOUND OBJECT. AN INSERTED WHITE BOX CARVES OUT AND SLIPS PAST THE EXISTING ONE, INTRODUCING A FLOOR AND CREATING A NEW SPACE. THREE-DIMENSIONALLY, THE SPACE AND EVERYTHING IN IT ARE BASED ON A 4 X 8 FOOT MODULE FOR ECONOMY OF MATERIALS AND TO MINIMIZE WASTE. STRUCTURALLY, IT IS COMPLETELY ISOLATED AND SELF-SUPPORTING SO THAT THE INTEGRITY OF THE HISTORIC WAREHOUSE, INTO WHICH IT IS BUILT, IS NOT COMPROMISED. EVERY OUNCE OF STEEL (STAIR, WALL, FLOOR, TRIM, ETC.) COMES FROM A SALVAGE YARD. A SMALL PIVOT WINDOW IS SLIPPED INTO A LONG BRICKED-OVER OPENING IN THE OLD WALL, BRINGING IN ENOUGH NATURAL LIGHT TO SENSE THE PASSING OF THE DAY. ALL OF THE FURNISHINGS ARE ON WHEELS AND ALLOW THE SPACE TO BE TRANSFORMED BASED ON NEED OR WHIM. BELOW THE STAIRCASE RESTS A BED OF MESQUITE PODS, BRINGING A SMALL PIECE OF THE DESERT LANDSCAPE INSIDE.

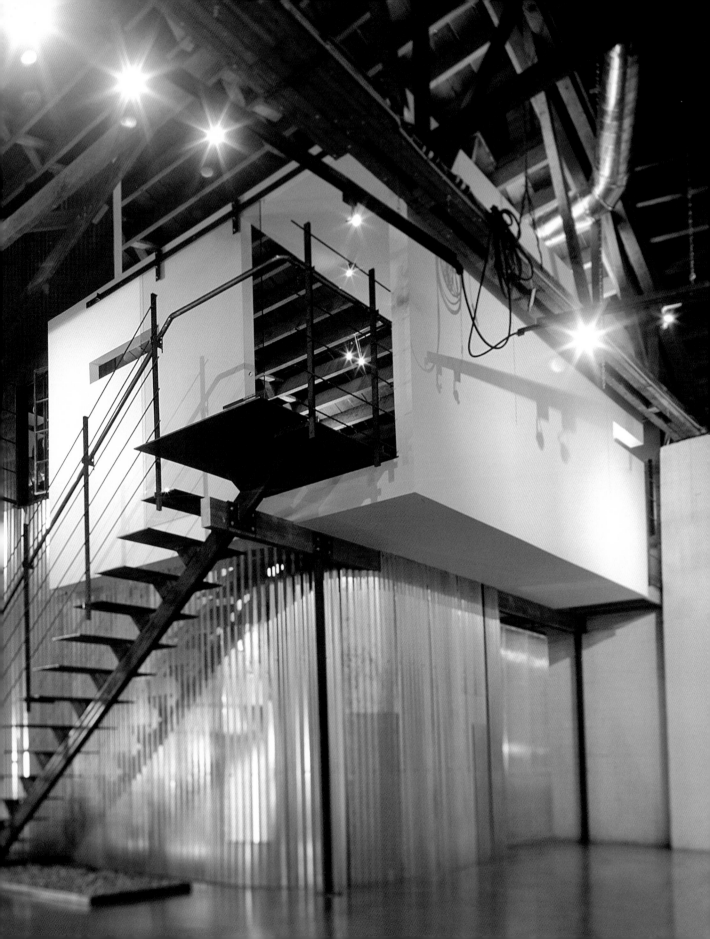

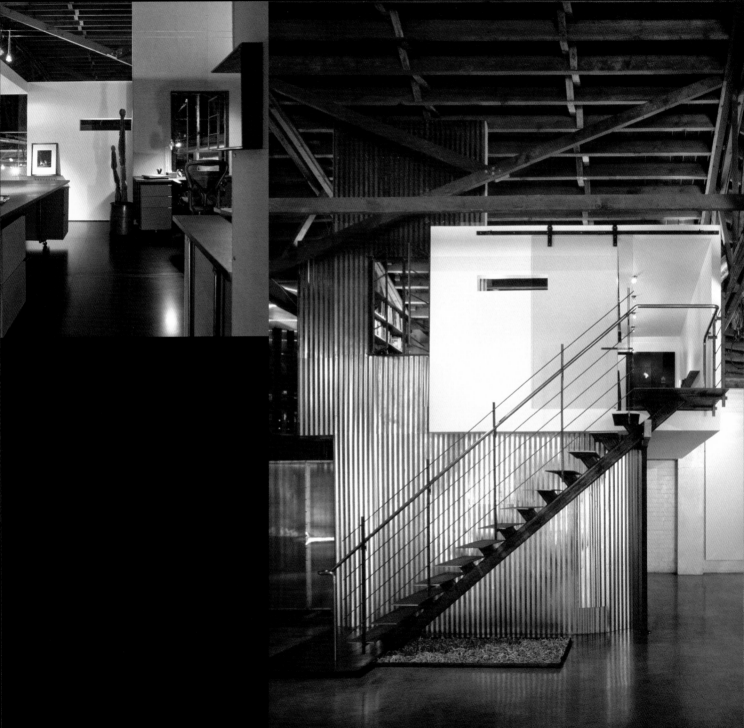

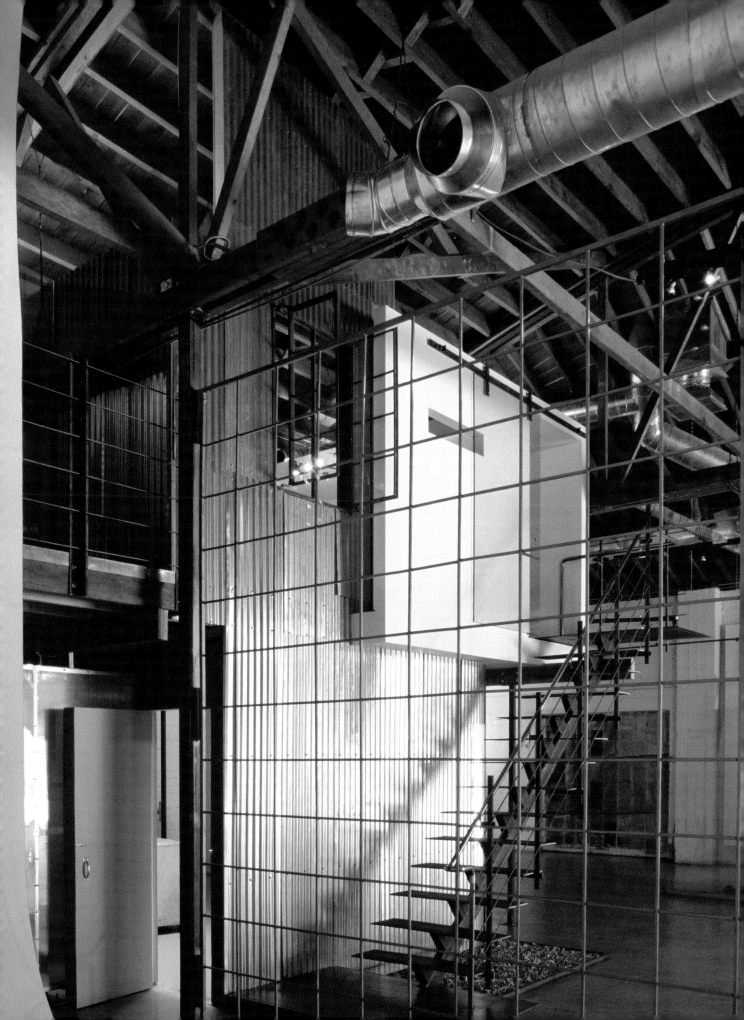

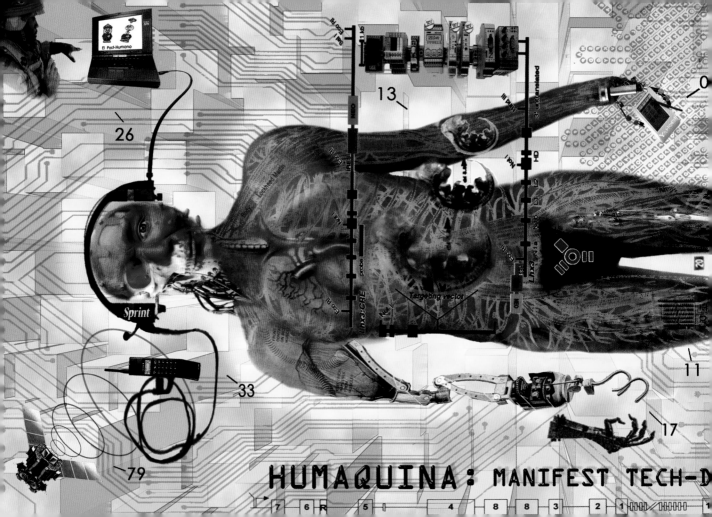

HUMAQUINA: MANIFEST TECH-D

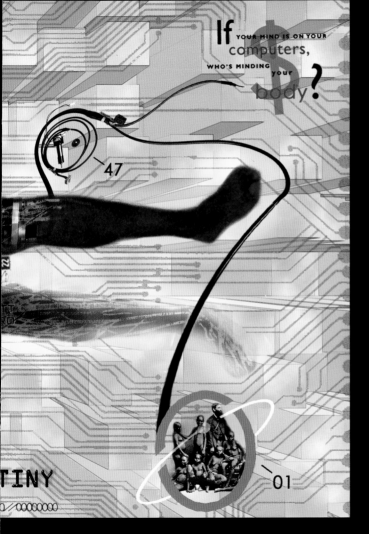

If **YOUR MIND IS ON YOUR** **computers,** **WHO'S MINDING** your $?
body?

47

01

TINY

MUCH OF MY WORK HAS BEEN CENSORED, TAKEN DOWN AND/OR SEEN AS "TOO POLITICAL" LEAVING THE PHOENIX ART SCENE AN IDEOLOGICAL AND DEPOLITICIZED "SAFE-ZONE." AT THE SAME TIME, MEXICAN, NATIVE AND XICANO POPULATIONS ARE CONTINUOUSLY MARGINALIZED AND RENDERED INVISIBLE. THIS CONTEXT INSPIRES MY PRACTICE OF DOCUMENTING SILENCED HISTORIES AND DISRUPTING FIXED IDEOLOGICAL DISCOURSE SUSTAINED BY CONSENT, NEGLECT AND AMNESIA.

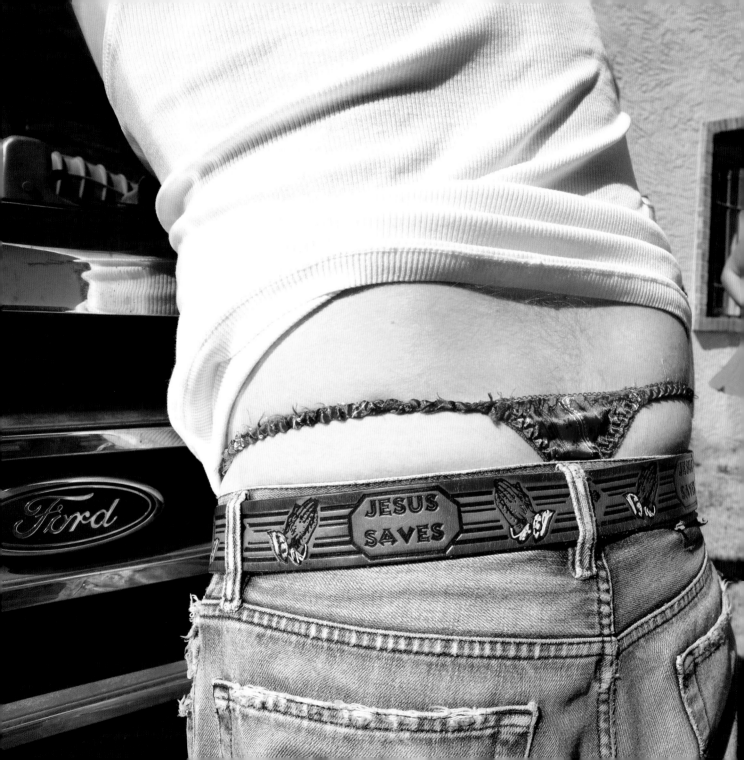

JESUSSAVES · WHITE TRASH SERIES

2005 | 36 X 54 INCHES | C-PRINT |

JESUSSAVES IS PART OF A SERIES

THAT EXPLORES THE SOCIALLY

ACCEPTABLE IDEAS OF THE

MODERN "THONG."

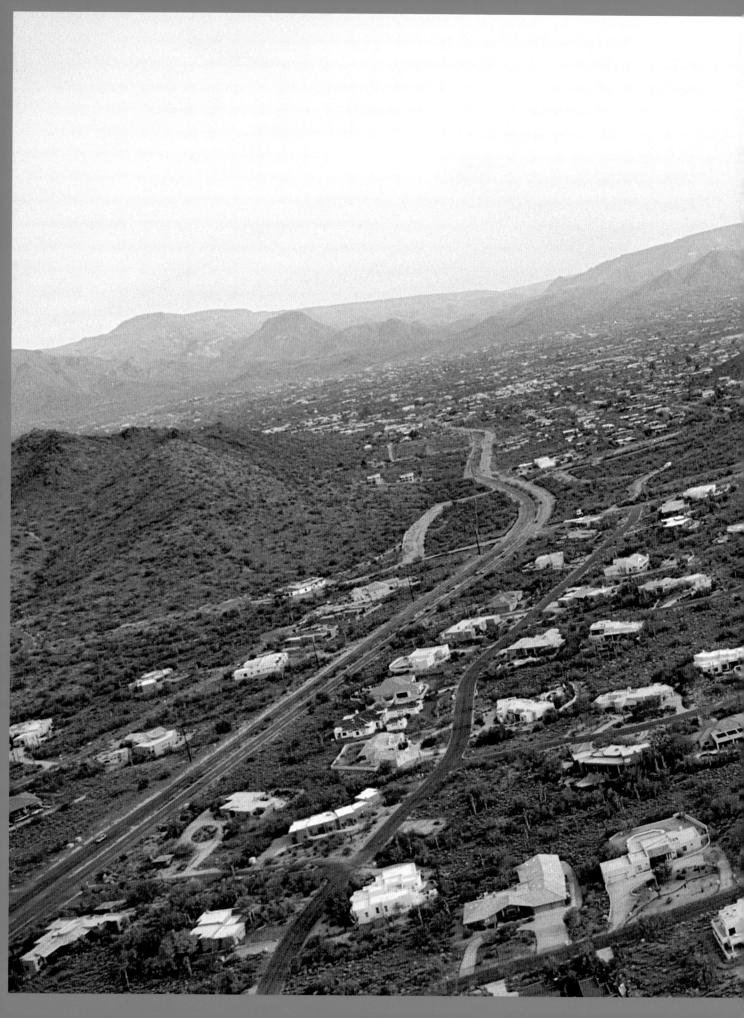

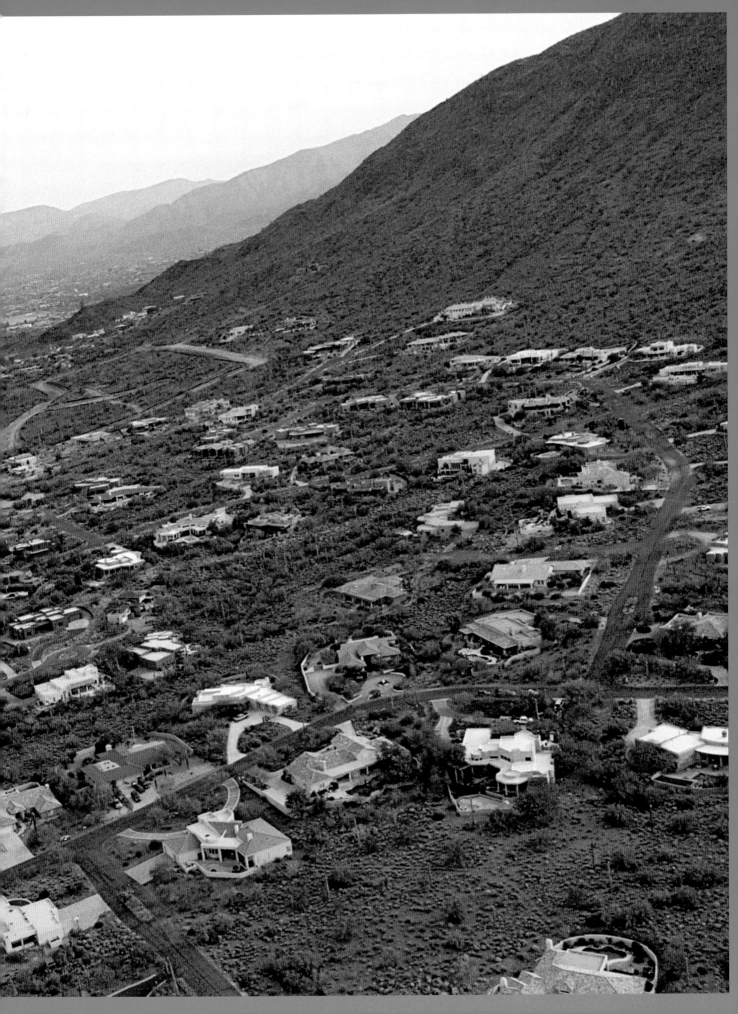

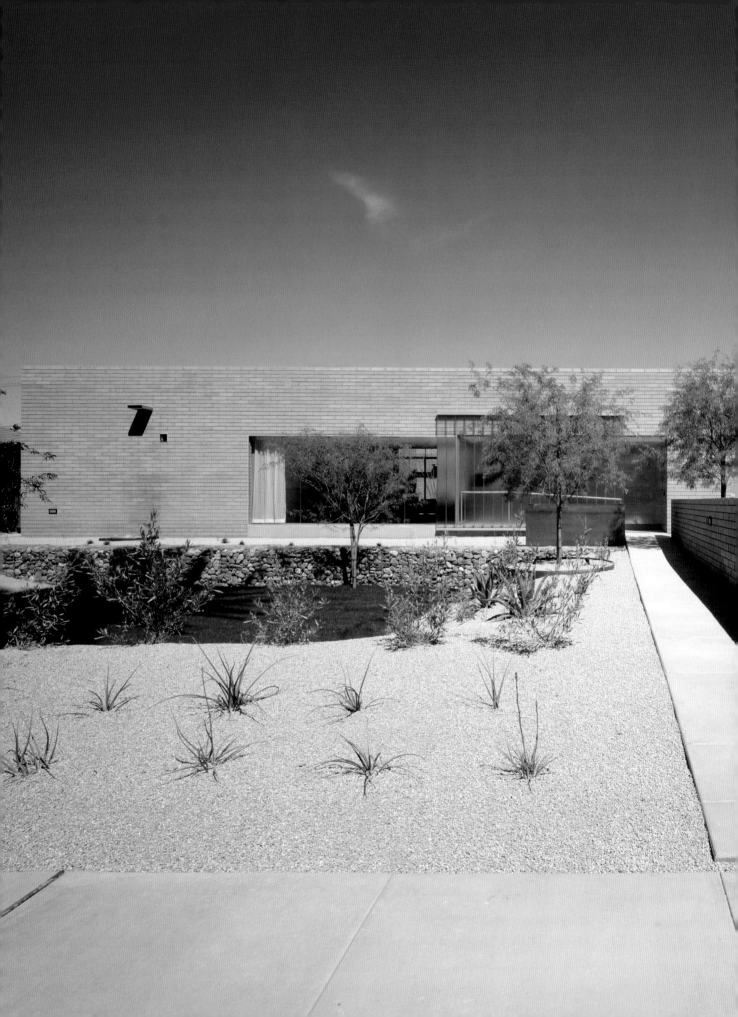

DEBARTOLO 3 AIA · DEBARTOLO ARCHITECTS LT[

| MARIPOSA RESIDENCE | 2003 | COMMON HOUS[

2,800 SQUARE FEET, DWELLINGS: 6,350 SQUAR[

FEET | EXPOSED, PAINTED STRUCTURAL COLUM[

GLASS, CHANNEL GLASS, TREX, BLACK RESIN, [

GRANITE, CONCRETE, GALVANIZED HAT CHANNE[

MILL FINISH STEEL AND CONCRETE MASONRY U[

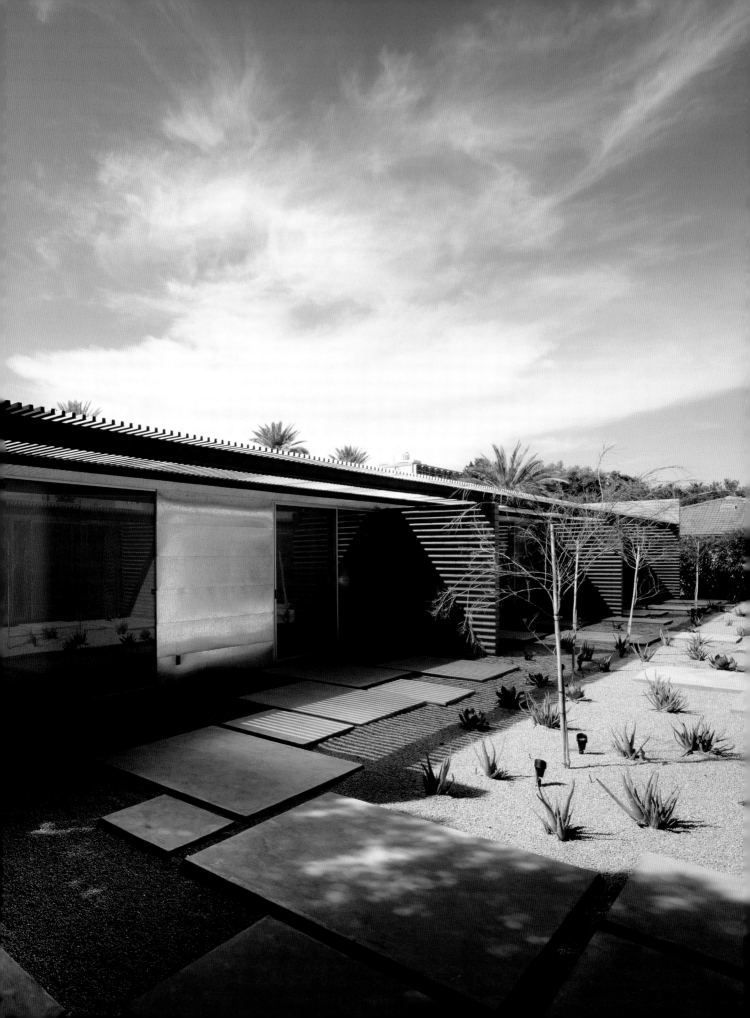

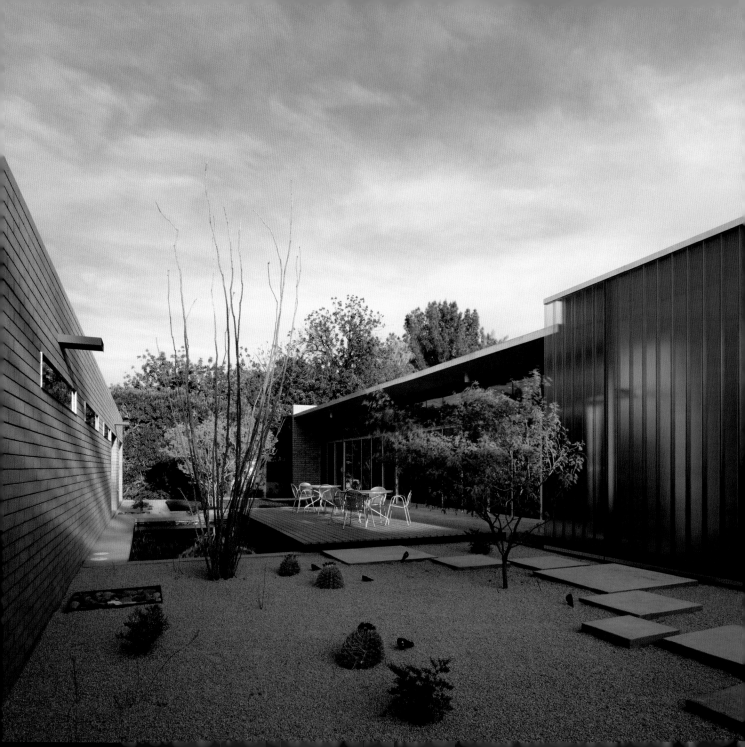

DEBARTOLO ARCHITECTS IS INSPIRED BY THE CLARITY

OF THE DESERT ELEMENTS: SUNLIGHT, HEAT, SHADE AND

DRYNESS. THE SIMPLICITY OF THE DESERT ELEMENTS

INSPIRES AN ARCHITECTURE OF CLARITY AND SIMPLICITY.

THIS NEW RESIDENCE FOR THE JESUIT PRIESTS PERMITTED

US TO UNITE THE MANDATES OF SITE AND DESERT CLIMATE

WITH THE RELIGIOUS AND LIVING REQUIREMENTS OF THE

JESUIT COMMUNITY, YIELDING A HOUSE THAT RESPONDS TO

THE DESERT AND FACILITATES THE REDUCTIVE LIFESTYLE

OF THE COMMUNITY.

OVER THE YEARS I PURSUED OTHER AREAS TO LIVE AND WORK BUT ALWAYS RETURNED TO

PHOENIX, MY HOME. INSTEAD OF LOOKING TO OTHER PLACES FOR INSPIRATION I DECIDED

TO DEEPEN MY ROOTS AND TAKE NOTICE OF THE SURROUNDINGS. I FIND INSPIRATION IN THE

DESERT (EXOTIC PLANT FORMS), ANTIQUE SHOPS AND LIBRARIES. THIS AREA, BECAUSE OF ITS

ARID CLIMATE (PERFECT FOR KEEPING MY MEDIA, WOOD, STABLE) AND LONG WORK SEASON

HAS EVERYTHING THAT I NEED TO ACCOMPLISH MY PROFESSIONAL GOALS.

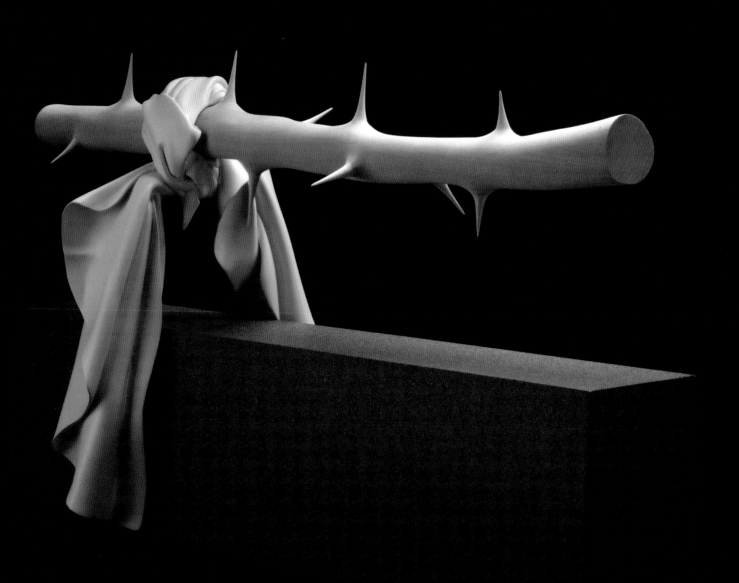

I AM REALLY PROCESS-ORIENTED WHEN I MAKE ART. I THROW MYSELF UNQUESTIONINGLY INTO MATERIALS AND WAYS OF MAKING ART THAT ARE UNFAMILIAR TO ME. IF I WORK ONLY WITH MATERIALS OR PROCESSES THAT I HAVE A MASTERY OF, I DO NOT GET OUTSIDE OF MY CONSCIOUS BRAIN. I BELIEVE IN LOSING CONTROL AS A RESULT OF THE NEW AND UNFAMILIAR, EXAMINING THE MISTAKES AND ACCIDENTS, AND MAYBE EMBRACING THEM. THIS IS A POINT OF ACCESS FOR ME BETWEEN THE CONSCIOUS AND THE UNCONSCIOUS, AND BETWEEN THE INTELLECT AND SPIRIT. TEN YEARS AGO A NORTH AFRICAN GRADUATE STUDENT WHO HAD STUDIED IN EUROPE AND NEW YORK SAW MY WORK AND ASKED WHAT I WAS DOING IN PHOENIX... I RESPONDED THAT "IF I COULD MAKE IT HERE, I COULD MAKE IT ANYWHERE."

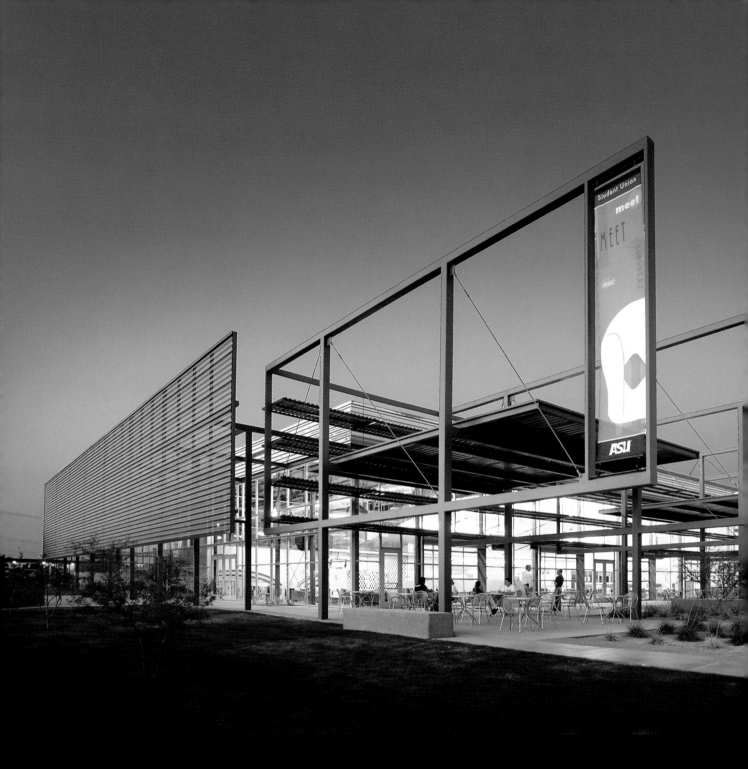

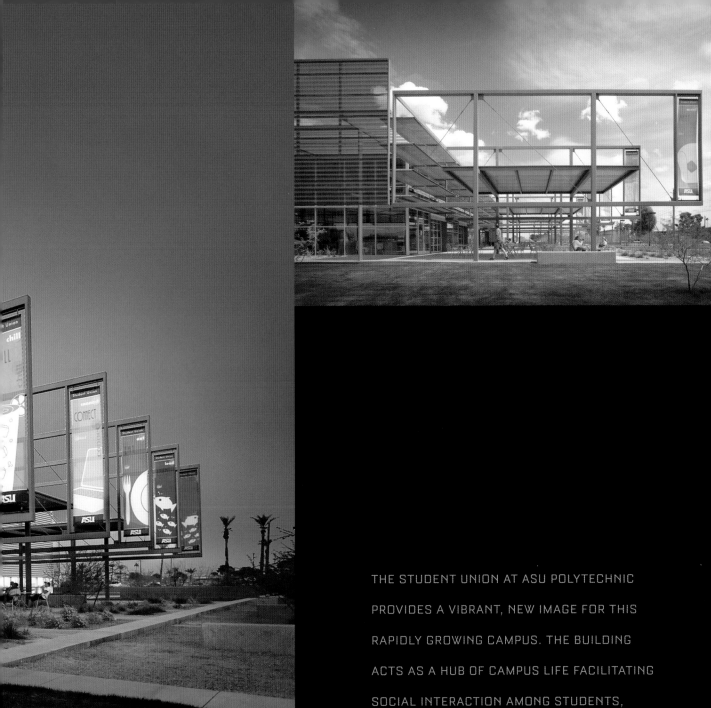

THE STUDENT UNION AT ASU POLYTECHNIC
PROVIDES A VIBRANT, NEW IMAGE FOR THIS
RAPIDLY GROWING CAMPUS. THE BUILDING
ACTS AS A HUB OF CAMPUS LIFE FACILITATING
SOCIAL INTERACTION AMONG STUDENTS,
FACULTY AND THE COMMUNITY.

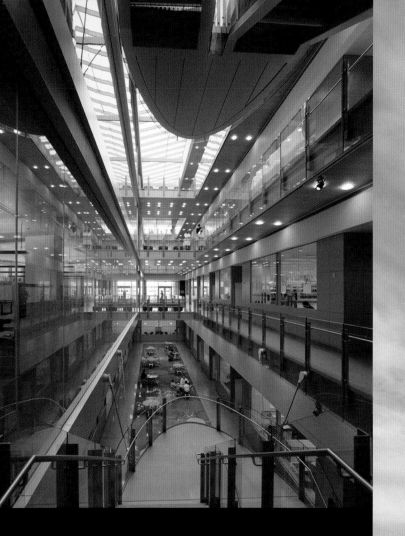

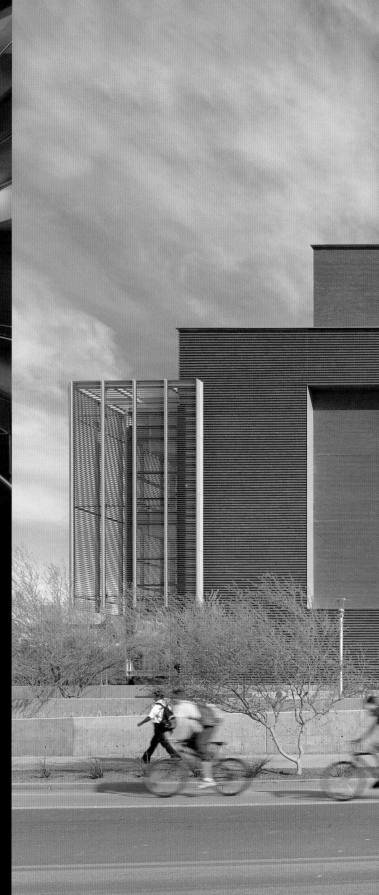

THE *BIODESIGN INSTITUTE* IS A STATE-OF-THE-ART RESEARCH FACILITY THAT HOUSES THE VANGUARD OF CONTEMPORARY SCIENCE, BRIDGING ACROSS DISCIPLINES, INDUSTRY, GOVERNMENT AND ACADEMIA. THE INSTITUTE IS DEDICATED TO INTERDISCIPLINARY RESEARCH AND THE COLLABORATIVE PARTNERSHIPS OF BIOTECHNOLOGY, NANOTECHNOLOGY AND INFORMATION TECHNOLOGY.

PHOENIX PALO VERDE BRANCH LIBRARY · MARYVALE COMMUNITY CENTER | 2006

| BRANCH LIBRARY: 16,000 SQUARE FEET, COMMUNITY CENTER: 27,000 SQUARE

FEET | ORIENTED STRAND BOARD, RUBBER AND MAPLE FLOORING, CARPET TILE,

PERFORATED ALUMINUM, MILL FINISH STAINLESS STEEL, GLASS AND MASONRY |

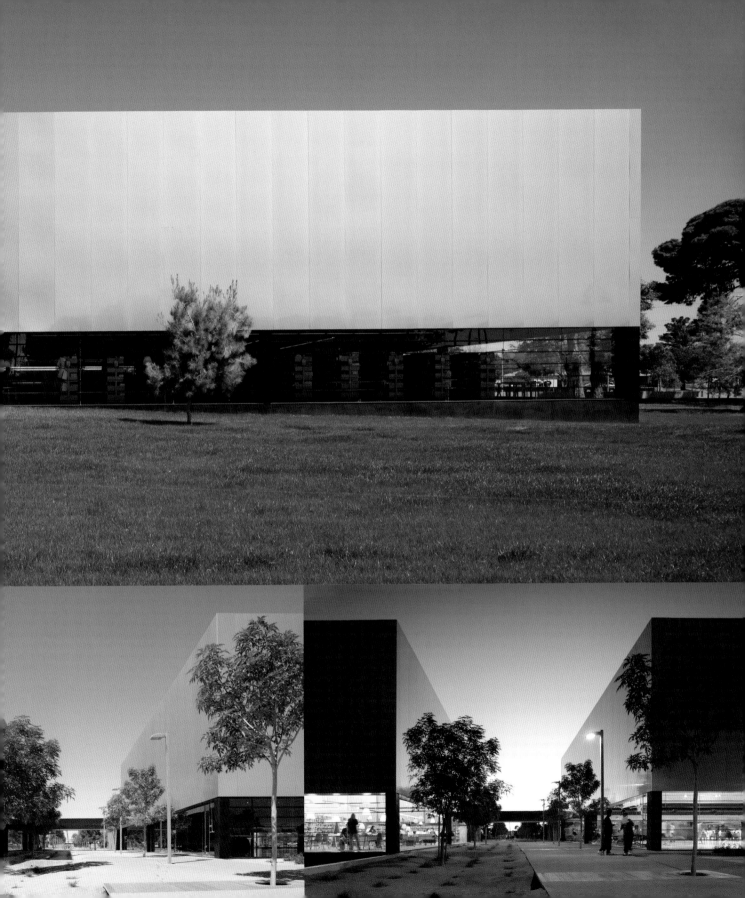

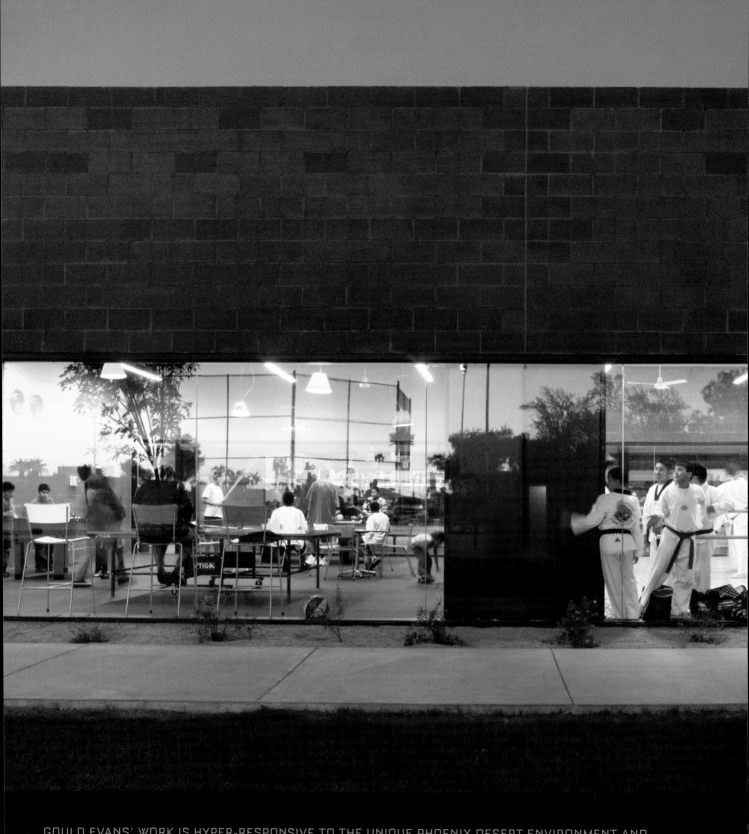

GOULD EVANS' WORK IS HYPER-RESPONSIVE TO THE UNIQUE PHOENIX DESERT ENVIRONMENT AND

ENRICHES THE COMMUNITIES IT SERVES. THE EXTREME HEAT OF THIS DESERT METROPOLIS ALONG WITH

THE APPRECIATION OF SHADE AND WATER, THE BEAUTY OF THE MOUNTAINS THAT SURROUND THE CITY,

AND THE ROOTS IN ANCIENT CULTURES - ALL INSTILL IN THE STUDIO'S WORK THE NEED FOR THOUGHTFUL

CONSIDERATION OF HOW WE INTERACT WITH THE PHYSICAL AND CULTURAL ENVIRONMENT.

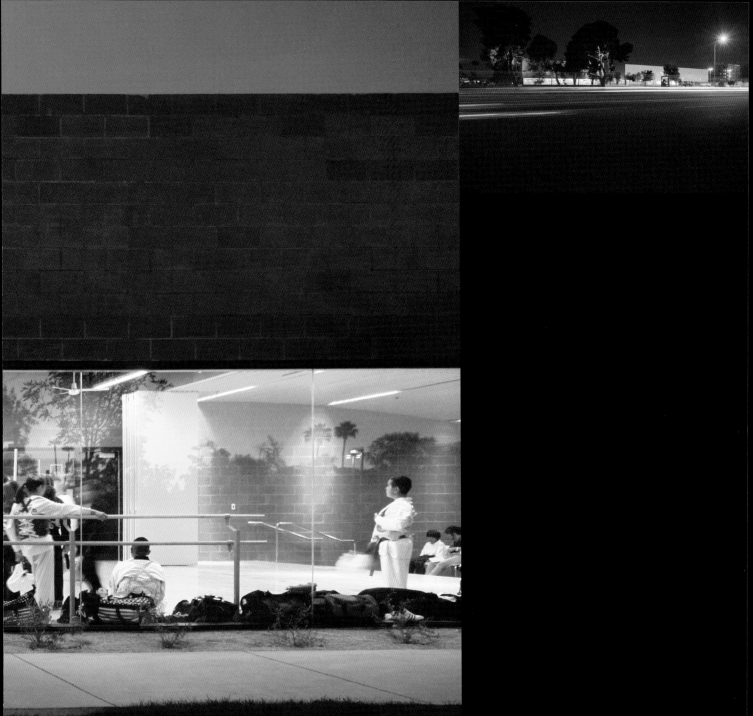

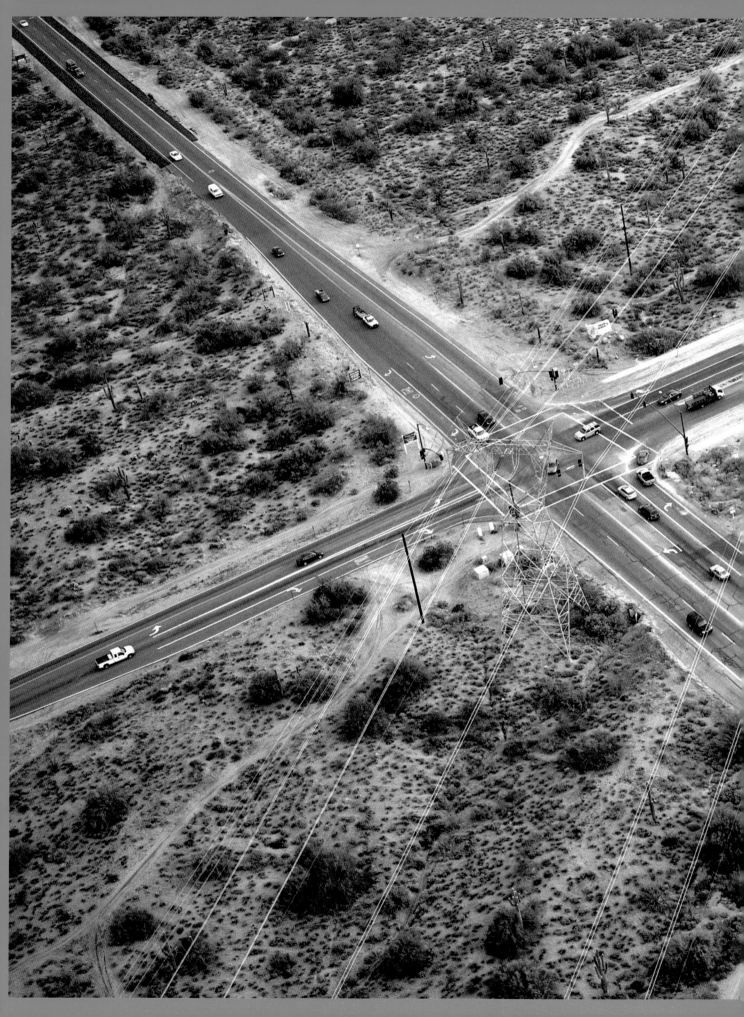

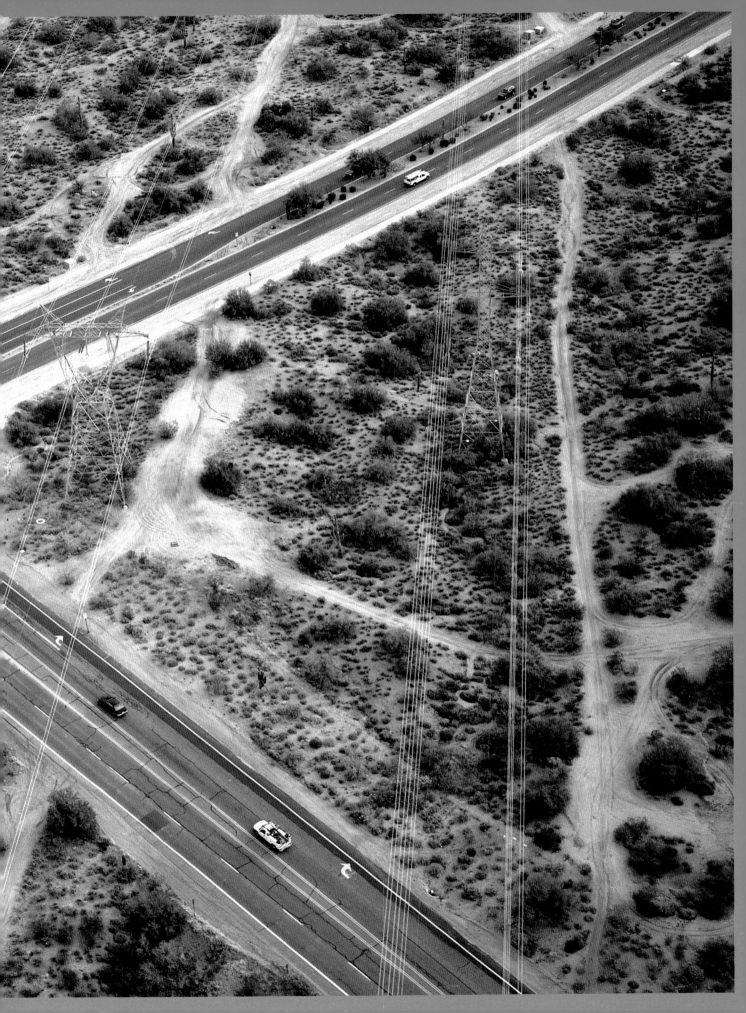

| FAMOUS LAST WORDS · COMIC SCHEME | 2005 |

DIGITAL IMAGE |

GROWING UP IN PHOENIX HAS HAD A BIG IMPACT ON MY WORK. THE EMPTINESS, BOTH PHYSICAL AND CULTURAL, THAT HAS GRADUALLY BEEN FILLED WITH FEATURES GENERIC TO ALMOST ANYWHERE IN AMERICA, EXPRESSES ITSELF IN MY APPRECIATION FOR MEDIATED EXPERIENCE, A WEARINESS WITH TRADITIONAL IDEAS OF BEAUTY AND THE FEELING THAT NOWHERE IS EVERYWHERE.

FAMOUS LAST WORDS

CHICAGO, 1992-- BETH LUNCHES WITH DANA AND JANIE AT DANA'S HEALTH CLUB...

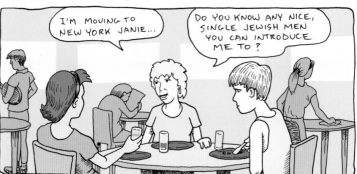

I'M MOVING TO NEW YORK JANIE...

DO YOU KNOW ANY NICE, SINGLE JEWISH MEN YOU CAN INTRODUCE ME TO?

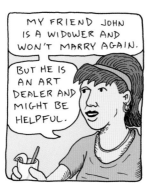

MY FRIEND JOHN IS A WIDOWER AND WON'T MARRY AGAIN.

BUT HE IS AN ART DEALER AND MIGHT BE HELPFUL.

SOMETIME LATER, AT BETH'S NEW YORK APARTMENT...

HELLO, MY NAME IS BETH. JANIE SUGGESTED I CALL YOU. I'M AN ARTIST..

I'M NOT INTERESTED IN SEEING ANY ARTIST'S WORK.

WELL, THAT'S NOT REALLY WHY I CALLED...

OH.

AH...

...LET ME THINK ABOUT IF I WANT TO MEET YOU...

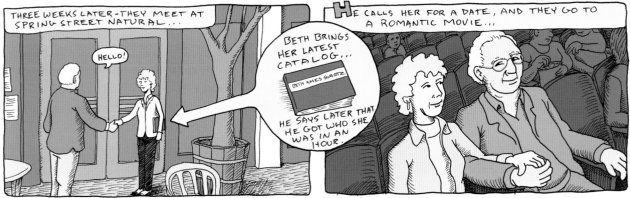

THREE WEEKS LATER-THEY MEET AT SPRING STREET NATURAL...

HELLO!

BETH BRINGS HER LATEST CATALOG...

BETH AMES SWARTZ

HE SAYS LATER THAT HE GOT WHO SHE WAS IN AN HOUR.

HE CALLS HER FOR A DATE, AND THEY GO TO A ROMANTIC MOVIE...

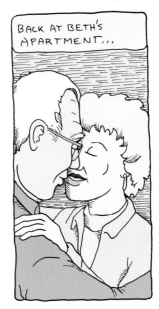

BACK AT BETH'S APARTMENT...

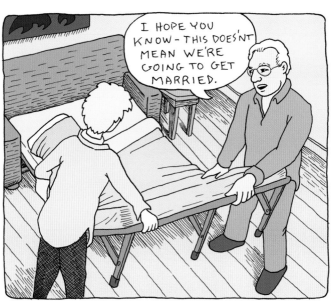

I HOPE YOU KNOW - THIS DOESN'T MEAN WE'RE GOING TO GET MARRIED.

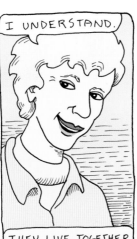

I UNDERSTAND.

THEY LIVE TOGETHER STARTING IN 1993 AND ARE MARRIED IN 1998. ♡

| P.194 | JON HADDOCK | ACTIVIST · EMBEDDED | 2004 | 2 X 5 X 10

INCHES | POLYURETHANE RESIN, PAINTED WITH ACRYLIC |

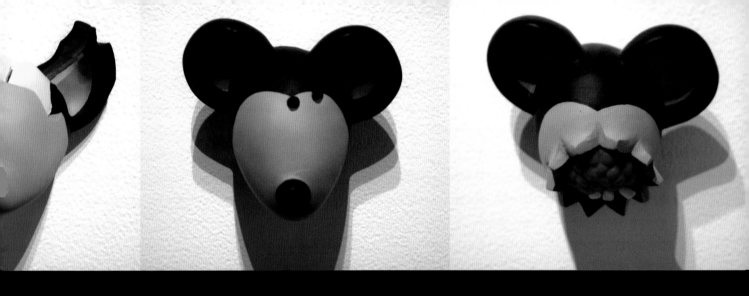

JON HADDOCK | GUNSHOT, SHRAPNEL,

AND COMPRESSION WOUNDS TRANSPOSED ONTO

THE HEADS OF CARTOON MICE | 2004 | 2 X 5 X 10

INCHES | POLYMER CLAY PAINTED WITH ACRYLIC |

| P.197 | JON HADDOCK |

JONG215.JPG · INTERNET SEX

PHOTOS | 1999 | DIGITAL IMAGE |

WHEN I BECAME AWARE OF THE LARGE AMOUNT OF AMATEUR PORNOGRAPHY ON THE INTERNET,

I WAS FASCINATED BY THE TYPE OF PERSON THAT WOULD PARTICIPATE IN SOMETHING LIKE

THIS. LOOKING AT THE PEOPLE IN THE PHOTOS PROVIDED VERY FEW CLUES - THEY WERE

GENERALLY NAKED AND EMOTIONALLY VACANT. AT ONE POINT I NOTICED A COPY OF ULYSSES

ON A BOOKSHELF IN THE BACKGROUND AND REALIZED THAT I COULD LEARN ABOUT THE

PEOPLE THROUGH STUDYING THEIR SURROUNDINGS. BY COPYING BITS OF THE INTERIORS AND

GRADUALLY COVERING THE BODIES, I WAS ABLE TO ELIMINATE THE EXTRANEOUS INFORMATION

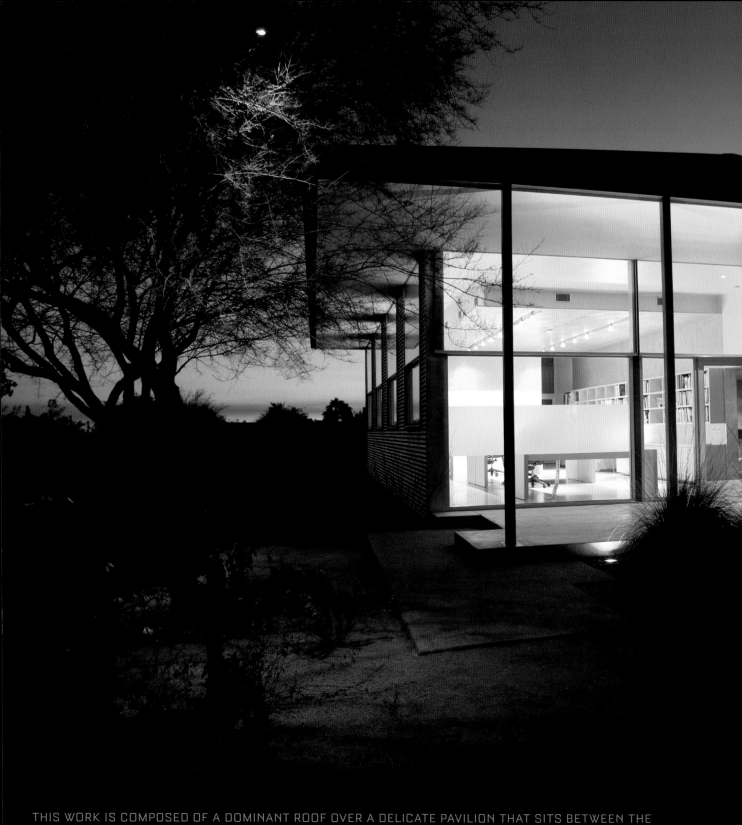

THIS WORK IS COMPOSED OF A DOMINANT ROOF OVER A DELICATE PAVILION THAT SITS BETWEEN THE

NATURAL LANDSCAPE AND DESERT GARDENS. THE ROOF PROVIDES BROAD AND PRECISE PROTECTION

FROM THE SUMMER SUN AND EMBRACES THE WINTER SUN. THE PRIMARY MATERIALS, GALVALUME

AND CONCRETE BLOCK, HAVE A NATURAL COMPATIBILITY WITH THE DESERT AND ARE PART OF A

STRONG REGIONAL VOCABULARY OF MODERNISM.

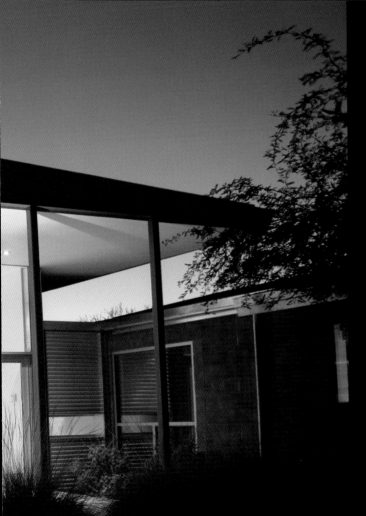

| P.198-203 | MCCOY AND SIMON ARCHITECTS WITH
TEN EYCK LANDSCAPE ARCHITECTS INC | GARDEN HOME
STUDIO | 2004 | 1,200 SQUARE FEET | STRUCTURAL
STEEL, CONCRETE, GALVALUME, STAINLESS STEEL,
SANDED MILL FINISH ALUMINUM, GLASS AND MAPLE |

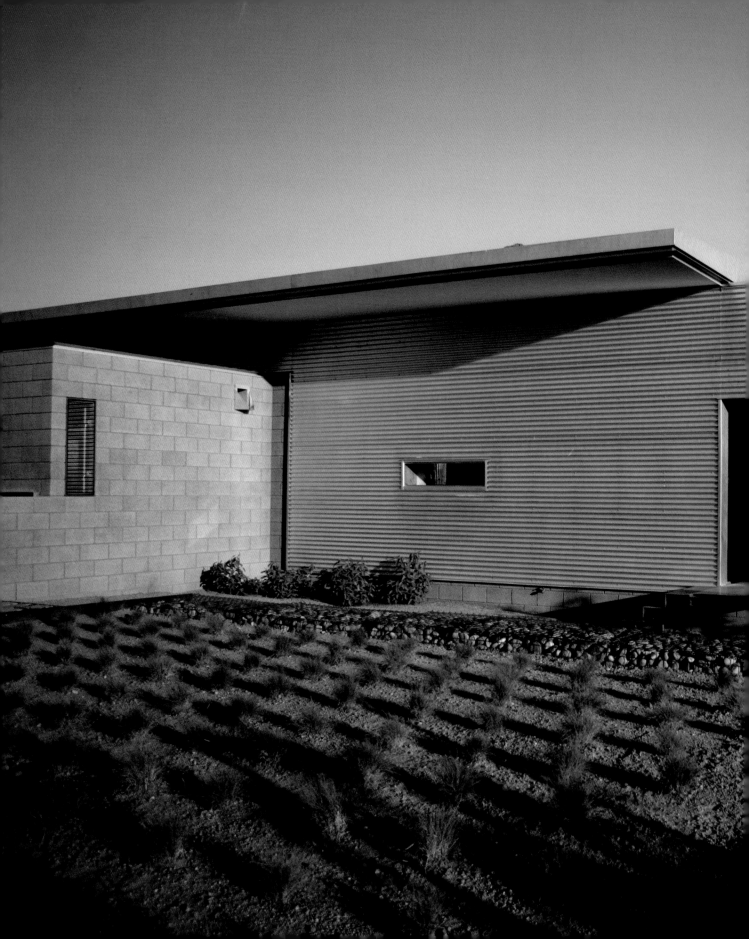

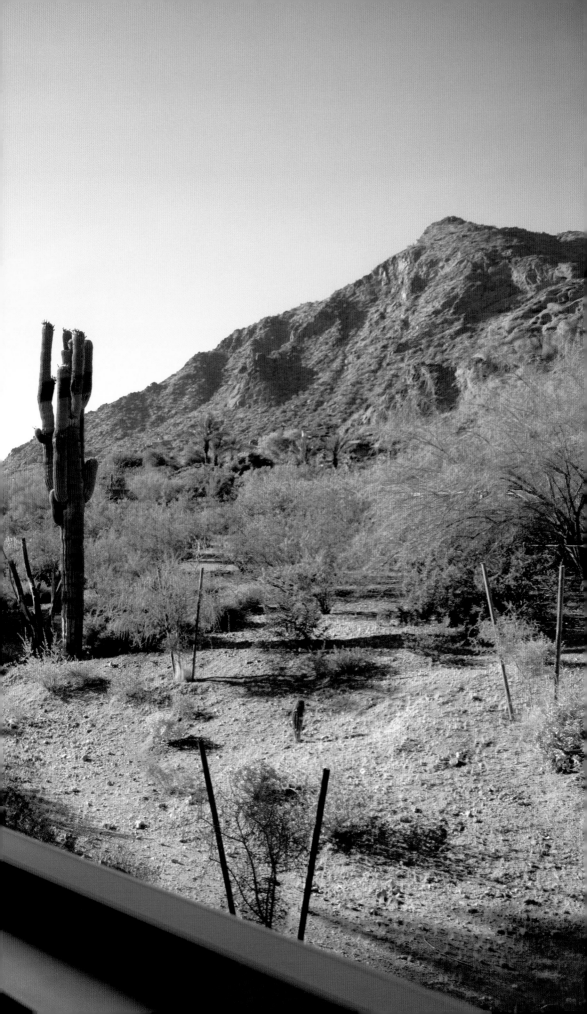

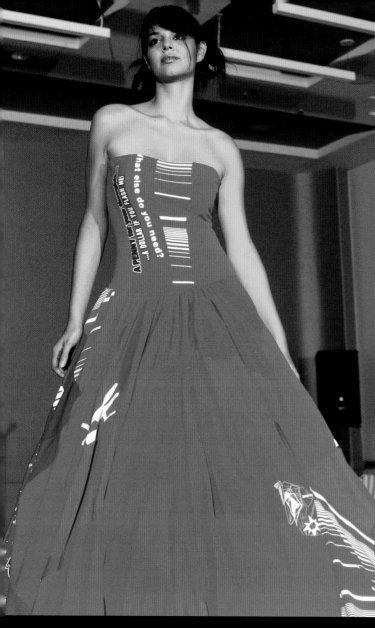

| P.204 | ANGELA JOHNSON | RED T-SHIRT BALL-GOWN | 2004 |

CUSTOM MADE, FULL LENGTH | RECYCLED T-SHIRTS |

| P.204 | ANGELA JOHNSON | WHITE T-SHIRT BALL-GOWN |

2002 | SAMPLE, FULL LENGTH | RECYCLED T-SHIRTS |

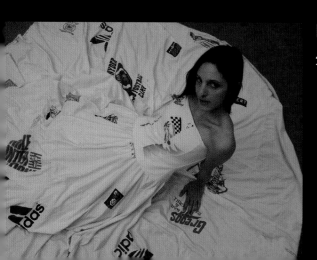

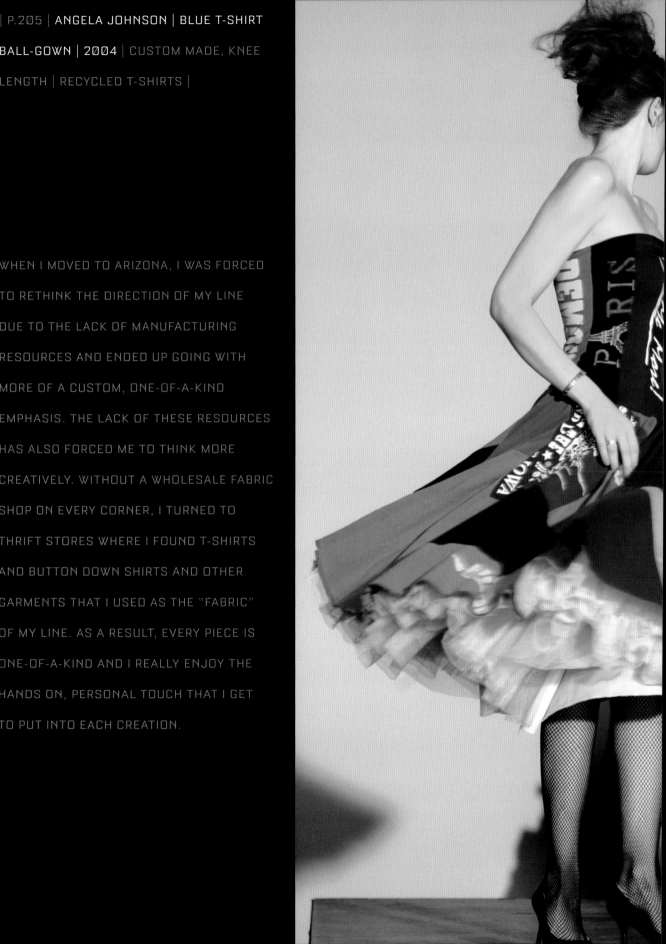

WHEN I MOVED TO ARIZONA, I WAS FORCED TO RETHINK THE DIRECTION OF MY LINE DUE TO THE LACK OF MANUFACTURING RESOURCES AND ENDED UP GOING WITH MORE OF A CUSTOM, ONE-OF-A-KIND EMPHASIS. THE LACK OF THESE RESOURCES HAS ALSO FORCED ME TO THINK MORE CREATIVELY. WITHOUT A WHOLESALE FABRIC SHOP ON EVERY CORNER, I TURNED TO THRIFT STORES WHERE I FOUND T-SHIRTS AND BUTTON DOWN SHIRTS AND OTHER GARMENTS THAT I USED AS THE "FABRIC" OF MY LINE. AS A RESULT, EVERY PIECE IS ONE-OF-A-KIND AND I REALLY ENJOY THE HANDS ON, PERSONAL TOUCH THAT I GET TO PUT INTO EACH CREATION.

THE ARCHITECTURE PRODUCED BY JONES STUDIO INC IS A DIRECT RESPONSE
TO HEAT MITIGATION, LONGEVITY, SITE FORCES, PROGRAM AND CULTURE.
ALTHOUGH EACH DESIGN IS GROUNDED IN RESOURCE EFFICIENCY AND ENERGY
CONSERVATION, WE EXPECT THE ESSENCE OF SUSTAINABILITY IS ACHIEVED
THROUGH A COMMUNITY'S PRIDE OF OWNERSHIP.

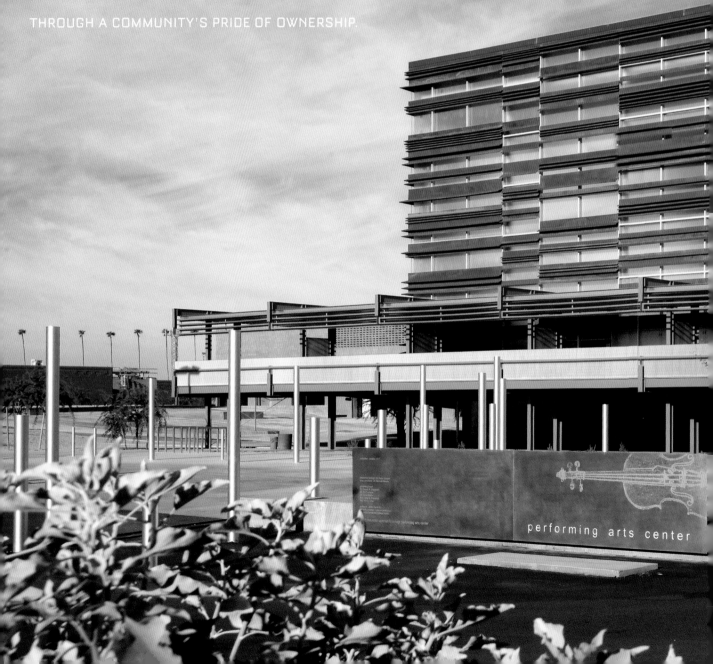

performing arts center

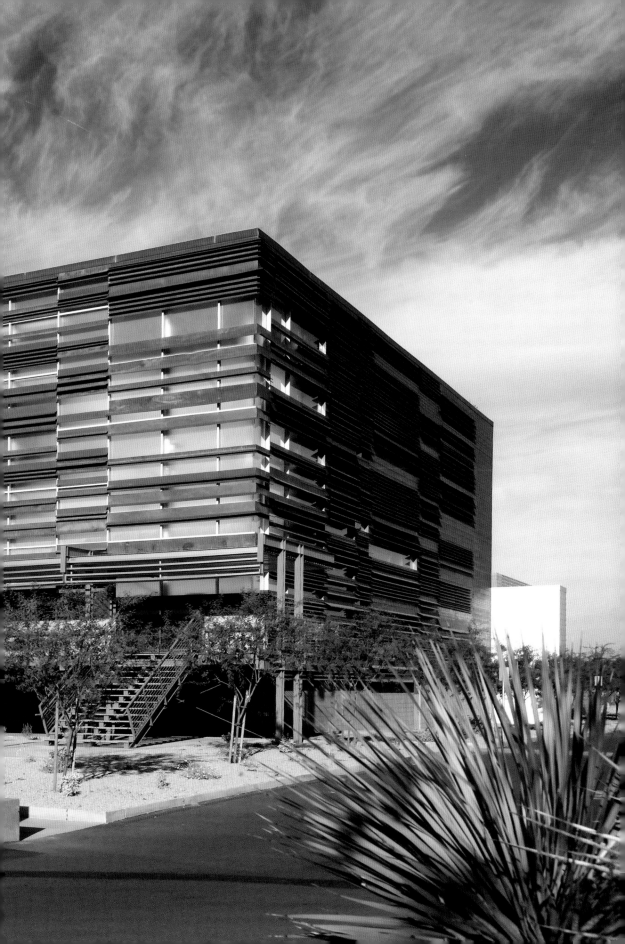

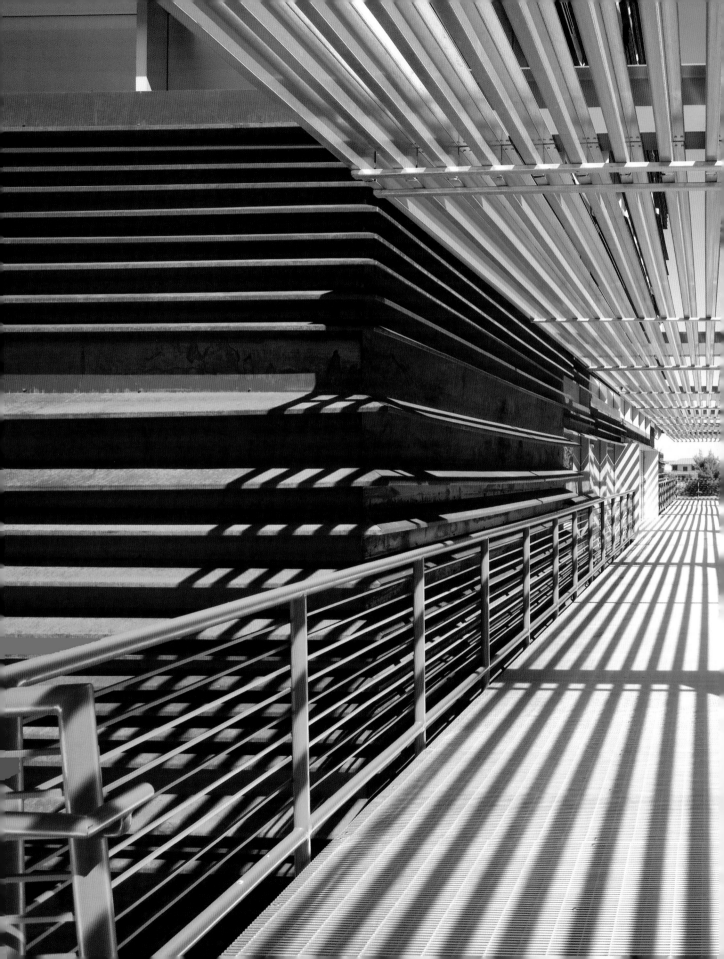

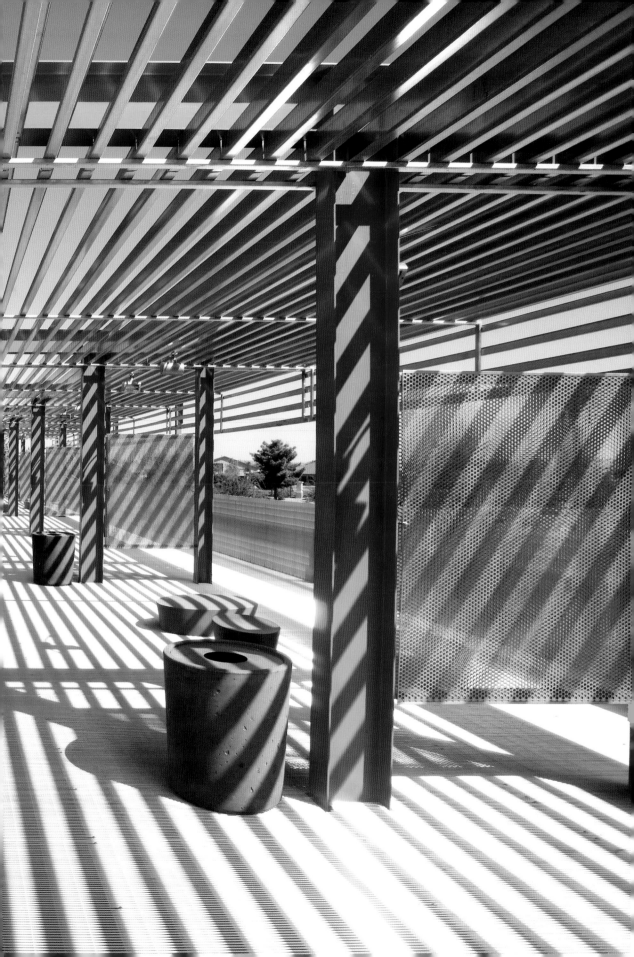

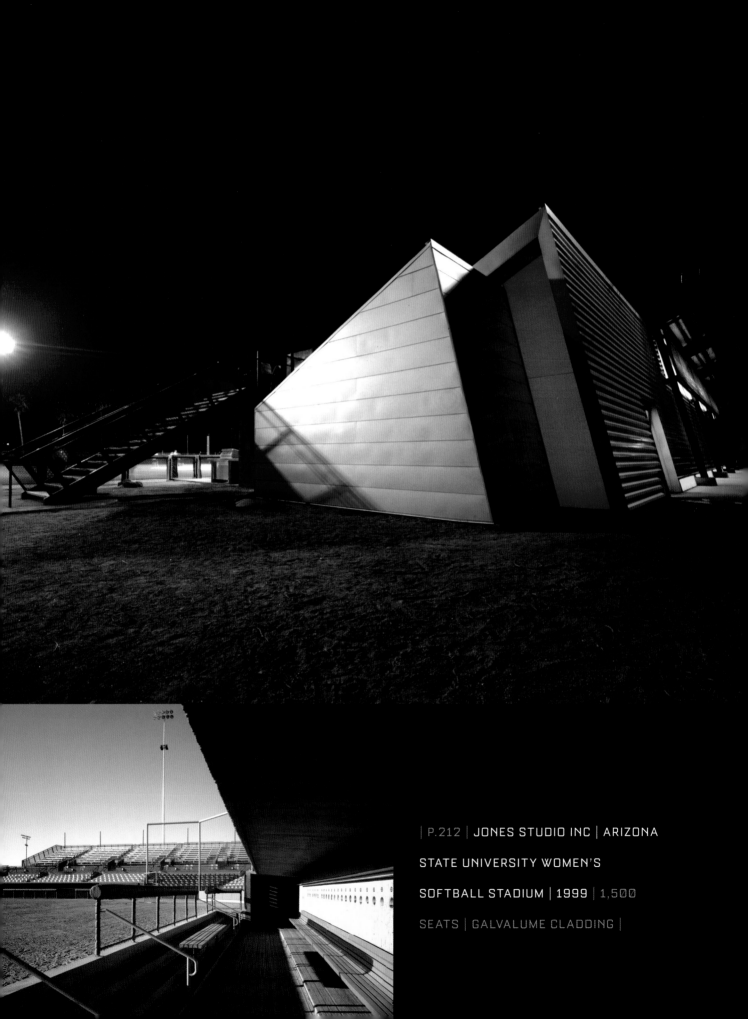

| P.212 | JONES STUDIO INC | ARIZONA
STATE UNIVERSITY WOMEN'S
SOFTBALL STADIUM | 1999 | 1,500
SEATS | GALVALUME CLADDING |

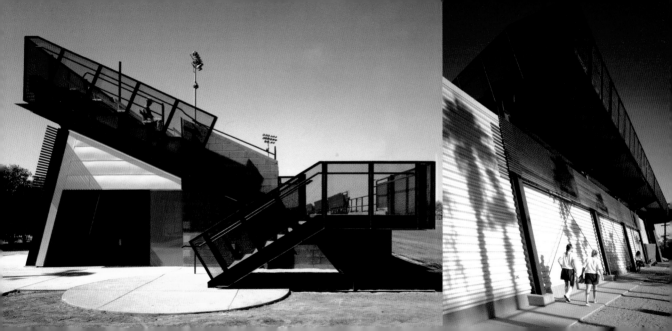

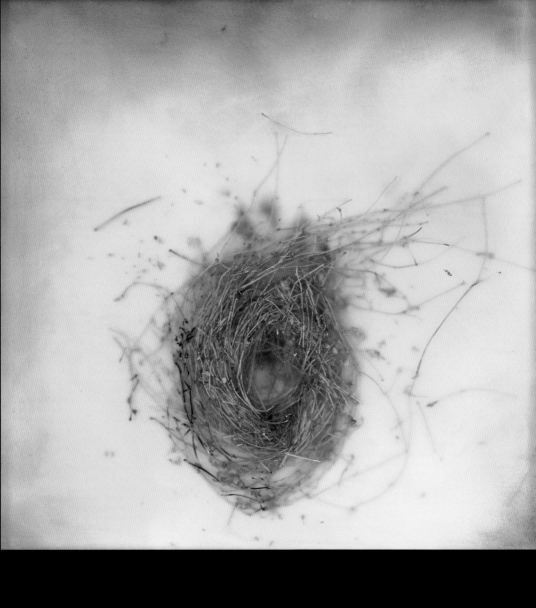

| MAYME KRATZ | KNOT (1) | 2002 | 11 X 11 INCHES | RESIN, WEED AND WOOD

DENIS CLAUDE GILLINGWATER | **MIXED MEDIA/MIXED MESSAGES** | **1998** | DIMENSIONS VARY | INSTALLATION USING CLOSED CIRCUIT TELEVISION SYSTEMS, AUDIO SYSTEMS AND PHOTOGRAPHIC IMAGES |

OVER THE COURSE OF THE 20TH CENTURY, CITIES EVOLVED FROM HOUSING 3% OF THE WORLD'S POPULATION TO OVER 60%. MY WORK EXPLORES THE ACCELERATING MANIPULATION OF THESE LANDSCAPES AND ITS EFFECT ON THE HUMAN PSYCHE, ESPECIALLY ISSUES OF ALIENATION, DISPLACEMENT, AGGRESSION, CONSUMPTION AND CONTROL. THINKING METAPHORICALLY, I KNOW OF NO BETTER CITY THAN PHOENIX FOR REPRESENTING THESE ISSUES.

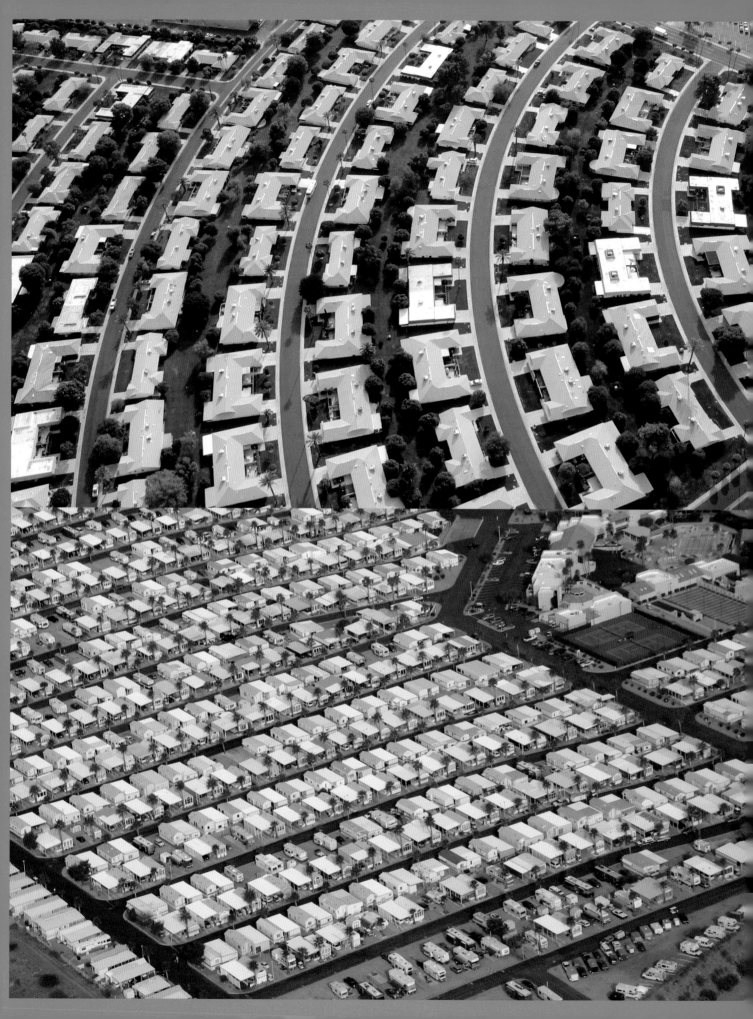

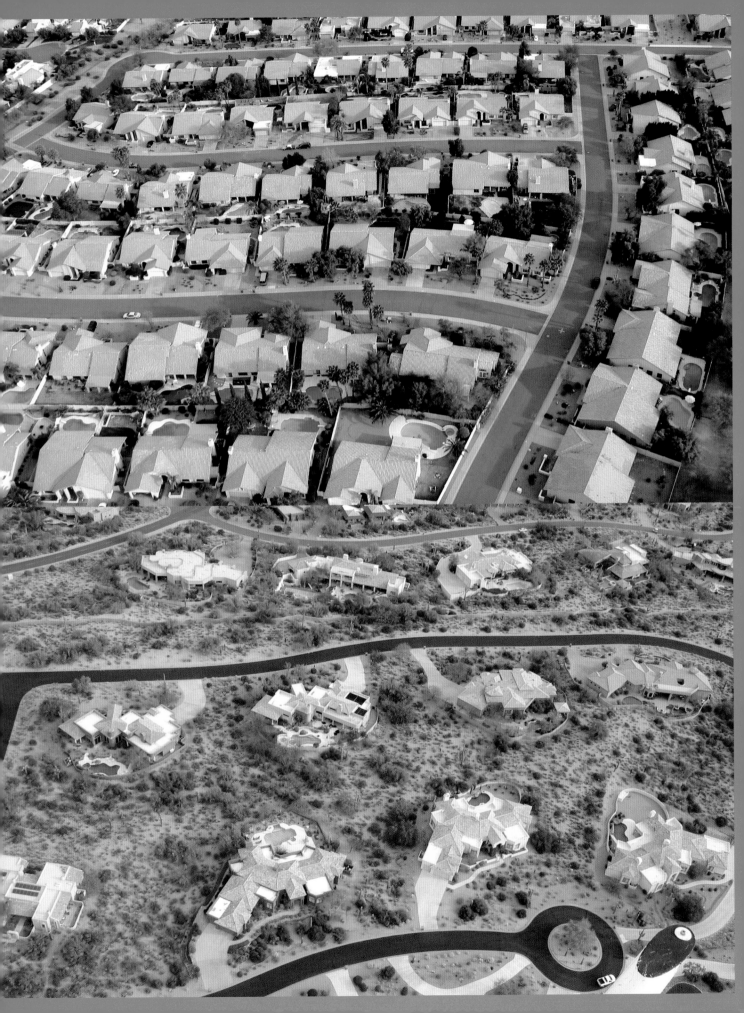

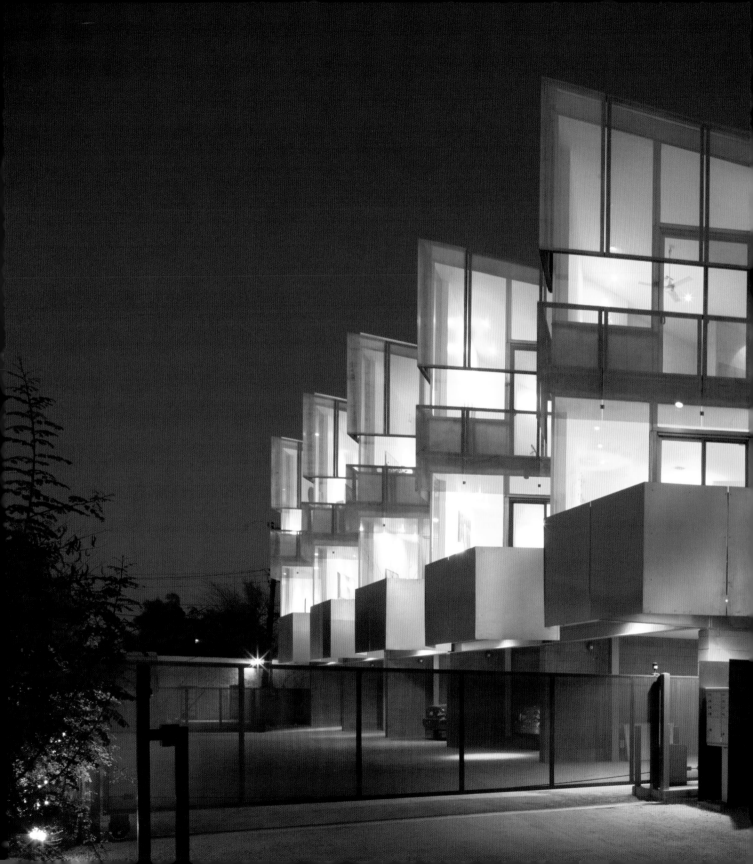

| 9,000 SQUARE FEET | MASONRY, STRUCTURAL

STEEL, WOOD FRAME, EXPOSED SANDBLASTED

CONCRETE BLOCK, CUSTOM RANDOM STANDING

SEAM ZINC METAL CLADDING, CORRUGATED

WEATHERED STEEL, PERFORATED GALVANIZED

METAL SUN SCREENS, GREEN PLASTER, GYPSUM

WALLBOARD, MAPLE VENEERED CABINETS,

CONCRETE, CERAMIC AND CARPET FLOORS,

STAINLESS STEEL PLATE COUNTERTOPS |

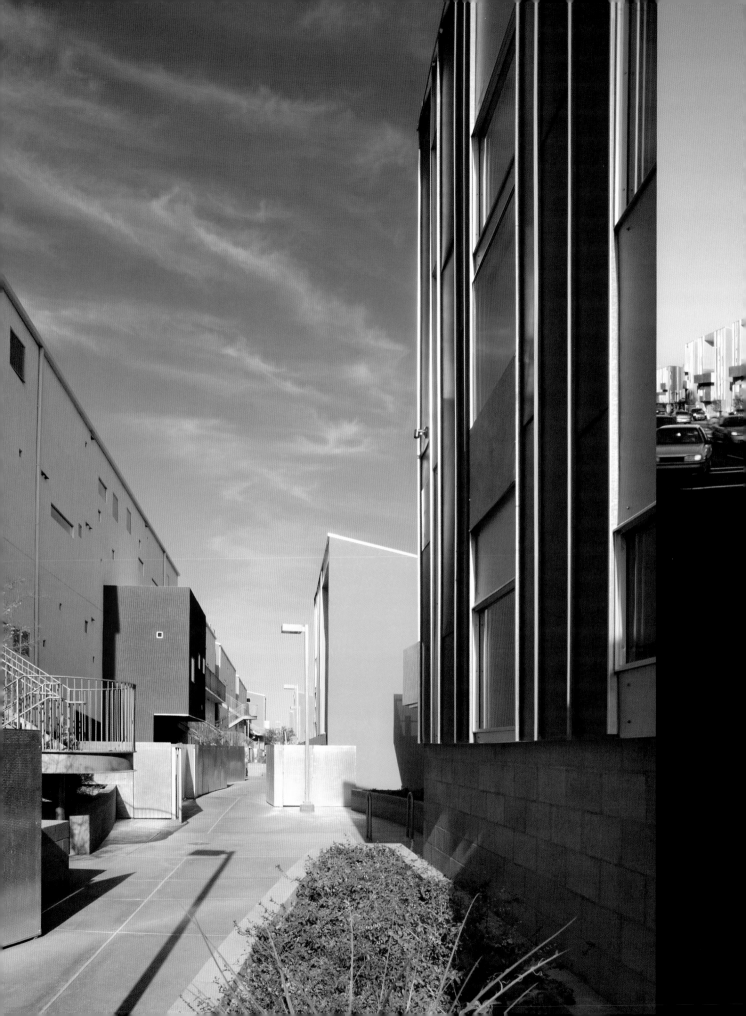

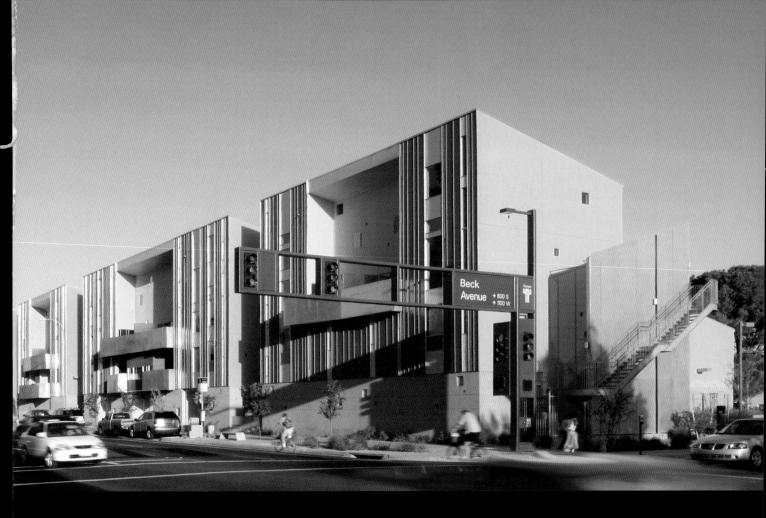

| P.224-225 | **WILL BRUDER** | **THE VALE** | **2005** | 69,330 SQUARE FEET | PAINTED GYPSUM WALLBOARD, CUSTOM CABINETRY IN CHERRY, MAPLE AND COLORED PLASTIC LAMINATE, CARPET, CERAMIC TILE, THREE COAT STUCCO WITH INTEGRAL CUSTOM, STANDING SEAM METAL CLADDING, CONCRETE BLOCK WITH VARIED SANDBLASTED TEXTURES, CUSTOM FIBERGLASS BALCONY DIVIDER PANELS WITH CUSTOM STEEL ATTACHMENT AND GAUGE GALVANIZED PERFORATED METAL SHEET BALCONY SCREEN |

MY ARCHITECTURE IS A RESPONSE TO THE DRAMATIC SUNLIGHT AND SHADOWS THAT DYNAMICALLY ANIMATE THE SURREAL LANDSCAPE OF THE DESERT OF THE AMERICAN WEST. WITH A MATERIALITY THAT COMPLEMENTS THE GEOLOGY AND THE LANDSCAPE, MY WORK GROWS FROM THEIR SITES, REACHING TO "KISS" THE SKY WITH SCULPTURAL SIMPLICITY. AS THIS CITY GROWS TO BECOME A REAL COMMUNITY – IN CELEBRATION OF ITS "PLACE" – MY WORK IS BECOMING MORE FOCUSED ON THE SPACES BETWEEN BUILDINGS AND HOW THE ARCHITECTURAL FABRIC EVOLVES TO MAKE A LIVABLE PLACE OF MEMORY.

| P.226+227 | KAROLINA SUSSLAND | SOME DRAWINGS | 2004 | 6 X 13 FEET |

DRAWING INSTALLATION |

I STARTED THESE DRAWINGS AFTER DOING A SERIES OF COWBOY PAINTINGS USING

STILLS FROM BLAZING SADDLES. THE REASON FOR USING BLAZING SADDLES IS

THAT THERE IS A LOT OF COWBOY ART AROUND AND, LIVING HERE, IT IS HARD TO

SEE WHERE IT ORIGINATES. I MEAN THE AMERICAN INDIAN BABE WEAVING BASKETS

IS NOWHERE TO BE SEEN EXCEPT IN ART OR MOVIES. IT SEEMED NECESSARY TO

USE A MOVIE THAT IS A STEP REMOVED FROM THE "ACTUAL", SINCE I FEEL A BIT

REMOVED FROM THE COWBOY WAY OF LIFE.

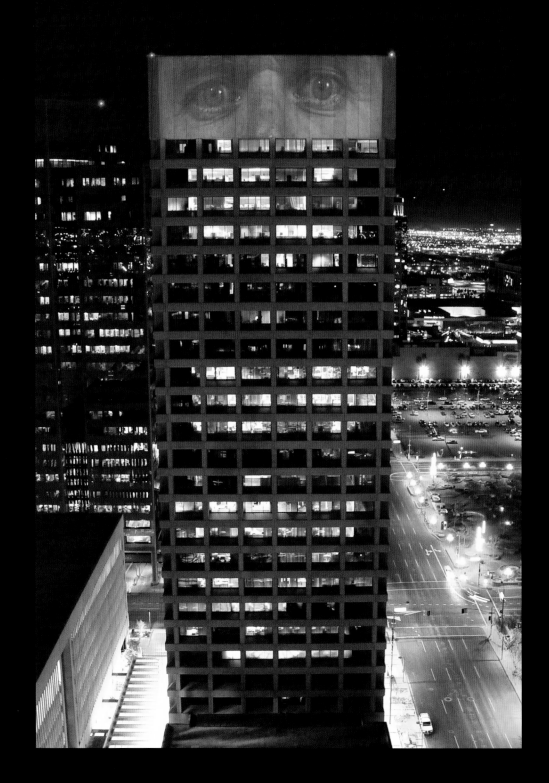

THROUGH THE ARTISTS' INITIATIVE TEMPORAR'

PUBLIC ART PROGRAM BY PHOENIX PUBLIC ART

ALQUIST RECORDED VIDEO IMAGES OF THE

EYES OF VARIOUS PHOENIX CITIZENS AND THE

PROJECTED THIS FOOTAGE ONTO THE FAÇADE

OF THE BUILDING NEXT TO PHOENIX CITY HALL

THE ANIMATED BUILDING LOOKED AROUND,

BLINKED, AND ALLOWED CITIZENS TO "KEEP

WATCH" OVER CITY HALL FOR TWO NIGHTS,

IN CONJUNCTION WITH PHOENIX'S ANNUAL

DOWNTOWN ART DETOUR 2004.

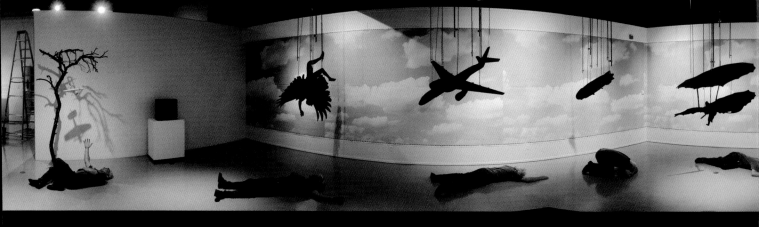

DAN COLLINS | RETURN TO THE GARDEN | 2003-04 | 12 X 50 X 50 FEET |

WEBCAM INSTALLATION WITH COMPUTER-CUT PARTS AND MIXED MEDIA |

THIS INSTALLATION UTILIZED A NETWORKED VIDEO CAMERA SITUATED IN THE MIDST OF

A SEA OF FLOATING SILHOUETTES OF AIRCRAFT PARTS. A VIEWER TAKING CONTROL OF

THE CAMERA – EITHER ON SITE IN THE MUSEUM OR FROM ANY WEB BROWSER – COULD

FRAME VARIOUS VIEWS OF FAMILIAR AIR DISASTERS THAT "ASSEMBLE" VIA VIDEO. THE

SILHOUETTE OF ICARUS, AS SEEN IN THE IMAGE OF THE MONITOR, WAS ONE OF THE SIX

EXPLODED IMAGES THAT APPEARED "WHOLE" ONLY FROM THE POINT OF VIEW OF THE

CAMERA. THE PANORAMA IMAGE ASSEMBLES A 360 DEGREE VIEW OF THE INSTALLATION

FROM THE POINT OF VIEW OF THE CAMERA.

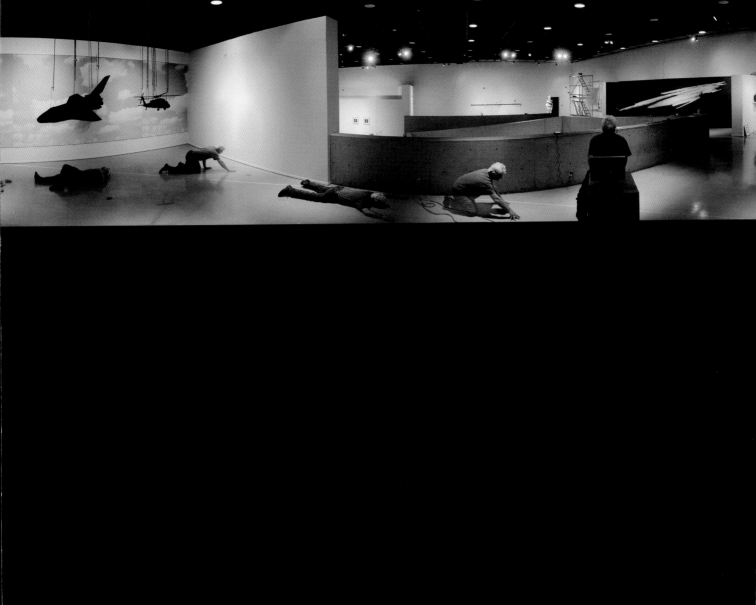

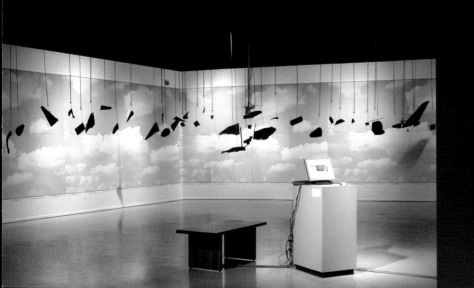

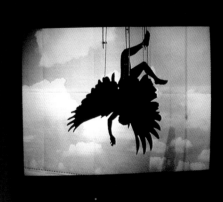

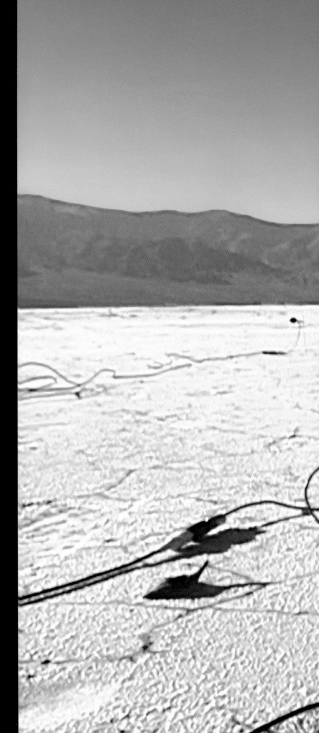

THE DESERT OF THE SOUTHWEST UNITED STATES

HAS GREATLY INSPIRED AND INFLUENCED MY WORK.

I HAVE WORKED IN THE PRISTINE DESERT, IN URBAN

DESERTSCAPES AS WELL AS THE EXTREME DESERT

OF DEATH VALLEY. I SEEK TO GATHER SOUND/VIDEO

TO RECORD PLACE. FOR *BIOPSY*, I PLUNGED NEEDLES

INTO THE SALT FLATS OF DEATH VALLEY, CONNECTED

THEM WITH SUTURE THREAD AND RECORDED THE

WIND BOWING THE THREAD AND THE NEEDLES IN THE

SALT PAN. THIS IMAGE REPRESENTS ONE MONTH IN

THE CYCLE OF TWELVE THAT I GATHERED.

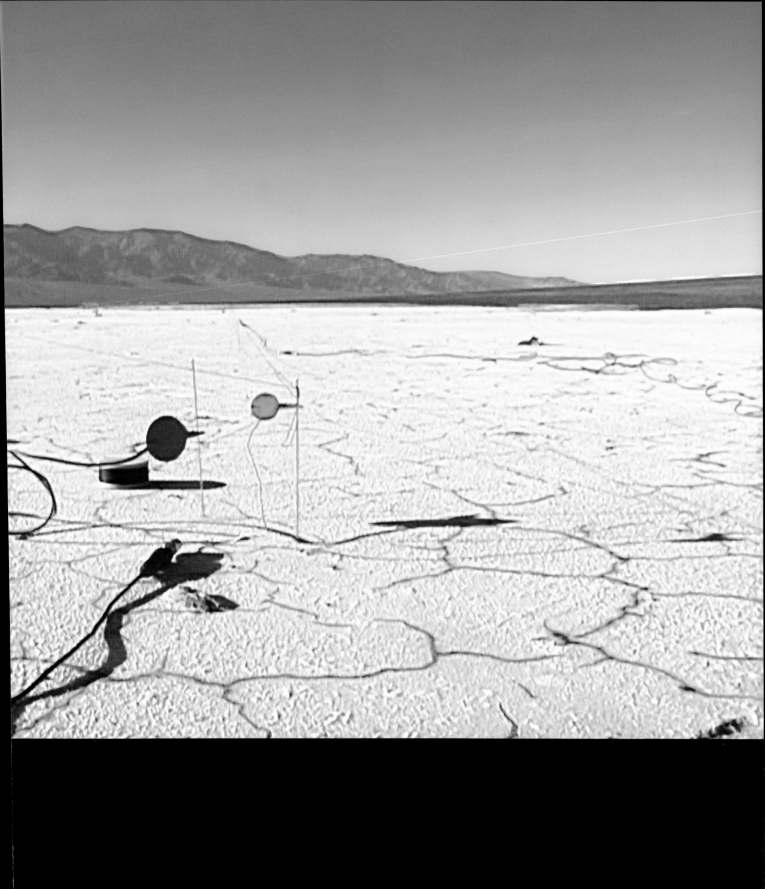

Artist, filmmaker and influential Professor of Art at Arizona State University, Lew Alquist (1948-2005) combined skills as an electrician and videographer with a dynamic artistic vision and humor. Alquist frequently employed industrial and scientific equipment in his work, exploring the intersections of technology and culture. He found early success in Chicago but became well known as an inspiring leader of the Grassroots Arizona arts movement; his works included Hot Pots - a series of kinetic pieces that combined fiestaware dishes with Geiger counters - and temporary video projections on buildings slated for demolition. Alquist's work is represented in collections including the San Francisco Exploratorium, the Arizona State University and University of Arizona Art Museums.

Marwan Al-Sayed studied Art History and Architecture at Vassar College and Columbia University before practicing for 12 years in New York City. He is extensively traveled and his journeys inspire his architectural work. In 1995 the Architectural League of New York recognized his work by awarding him the Young Architects Prize for his 5th Avenue Penthouse renovation as well as the Emerging Architects award in 2001. His work has been featured in the Smithsonian/Cooper Hewitt Museum Design Culture Now 2000 exhibition. Most recently, in 2006, he was awarded the Academy Award in Architecture by the American Academy of Arts and Letters. His firm is currently involved in residential and luxury resort projects in Arizona, Utah, New York and Dubai.

James Angel was raised and resides in the metro Phoenix area. After completing his education and a brief stint as a contributor to the emerging downtown art scene, Angel pursued his dream and innate talent to become a self-supporting artist. Through the development and implementation of a prolific art portfolio, he has worked as a full-time artist for the past two decades. He first gained recognition as a founding member of 3carpileup, an artist collective and major contributor to a then emerging "downtown" art scene. This collaborative experience was the launching pad for his "Homespun-Urban-Pop" approach.

Linda Foss Asakawa is a visual artist working in mixed media installation, painting and photography. She received an MFA in Visual Art from the University of California, San Diego, in 1974, after receiving a BA from San Diego State College in 1972. Since 1975 her work has been exhibited in venues across the United States including the exhibition American Women Artists at the Museu de Arte Contemporânea da Universidade de São Paulo, Brazil, in 1980. She is a recipient of the Visual Arts Fellowship from the Arizona Commission on the Arts 1995 as well as other awards. Travel linked to her work includes the United States, France, Spain, Canada and Japan.

Melinda Bergman graduated from Konstfack University College of Arts, Crafts & Design, Stockholm, in 1996 with an Masters in Fine Arts, followed by a residency at the International Artist Studio Space in Stockholm (IASPIS). She has participated in numerous solo and group shows in Sweden and Phoenix. Bergman was co-creator and coordinator of the Phoenix urban community garden, El Jardin de la Gente.

Carrie Bloomston was born and raised in Birmingham, Alabama. She left the South to study Painting and Glass-blowing at the Rhode Island School of Design. During this time she held numerous internships including an assistantship to artist Kiki Smith as well as an internship at the Gagosian Gallery in New York City. After receiving her BFA in Painting in 1994, she headed West to pursue her career as a painter in Phoenix, Arizona, where she has since been included in many group and solo shows. The desert provides the perfect backdrop for her contemplation and exploration of qualities of light and space as well as emotional temperatures and tones.

Jeremy M Briddell was born and raised in St. Louis Missouri. As a student he spent time in Pennsylvania, Colorado, California and Nebraska. He was a studio assistant to fellow ceramists John Balestreri, Jun Kaneko and the late Ken Ferguson. He received a Bachelors of Fine Arts from Kansas City Art Institute, followed by an Masters in Fine Arts from Arizona State University, specializing in Ceramics. Briddell was the recipient of an American Crafts Council grant in 2002. His work has been shown nationally and resides in prestigious private collections. His ceramic work is currently represented by Costello Childs Gallery in Phoenix, Arizona.

Self-trained as an architect, Will Bruder holds a Bachelors of Fine Arts, Sculpture, from the University of Wisconsin, Milwaukee. Licensed as an architect in 1974, his 20-person studio has created "place-making" architecture across America. Known for inventive cultural buildings, mixed-use urban infill projects and concern for the quality of life in the contemporary urban fabric, his firm has won more than 80 design awards and has been published extensively around the globe. Bruder is winner of the Rome Prize, Chrysler Design Award. He holds the Spring 2006 visiting Bishop Chair at the Yale University School of Architecture. Through his creative interpretation of program and site, his ability to raise the ordinary to the extraordinary is renowned. He is a craftsman in his concern for detail and building processes, and a sculptor in his unique blending of space, materials and light. Bruder believes architecture is the celebration of listening in service of the human spirit and senses.

Wendell Burnette founded Wendell Burnette Architects (WBA) in 1996 which has since become an internationally recognized architectural practice. Based in Phoenix, Arizona, its portfolio includes a wide range of private and public projects. The specific focus of the practice is concerned with space and light, context and place, and the environment and landscape in which we live. The architecture of the firm responds to the specifics of site and client needs, is resourceful with regards to budget, takes a pro-active approach to the craft of building and strives to create spaces that engage people. Wendell Burnette Architects' design philosophy is grounded in listening and distilling the very essence of a project to create highly specific architecture that is at once functional and poetic. The firm's design approach is to take note of all aspects of a particular building program and develop a consensus of approach with client, design team members and potential contractors. Through the integration of this process, Wendell Burnette Architects delivers architecture that is both uniquely appropriate and timelessly valuable to the client and/or user.

Born in Plainview, Texas, Sue Chenoweth now lives and works in Phoenix, Arizona. In 1998 she graduated from The Katherine K Herberger College of Fine Arts at Arizona State University with an MFA. Her paintings and installations have been shown in New York (The Cue Foundation), Tucson (Tucson Museum of Art, the Tucson Museum of Contemporary Art), Scottsdale (The Scottsdale Museum of Contemporary Art) and Phoenix (Eye Lounge). She has received numerous grants and awards including an Arizona Commission on the Arts Project Grant and Studio Space at the Cue Art Foundation. Chenoweth also teaches Drawing and Painting at the Metropolitan Arts Institute, an Arts College Preparatory High School in Phoenix, Arizona.

Liz Cohen was born in Phoenix, Arizona. She graduated with a BA in Philosophy from Tufts University and a BFA from The School of the Museum of Fine Arts, Boston, in 1996. She completed her graduate studies in Photography at California College of the Arts in 2000. She has had solo exhibitions in Paris (Galerie Laurent Godin), Stockholm (Fargfabriken), New York (Modern Culture), San Francisco (San Francisco Arts Commission Gallery, Manolo Garcia Gallery, Spanganga, Detour 888) and has participated in group exhibitions at the Yerba Buena Center for the Arts (San Francisco), Galerie K & S (Berlin) and Galeria de la Raza (San Francisco) among others. She is represented by Galerie Laurent Godin in Paris.

coLAB studio was formed in 1999 by the married duo *Matthew and Maria Salenger*. Both completed undergraduate studies in Architecture at Arizona State University and University of Arizona, respectively, prior to graduate work in London. Maria obtained an MFA at the Slade School of Fine Art, University College London. Matthew graduated with honours from the Architectural Association of London Diploma School. The studio attempts to blur the two disciplines within each project to form experiences that are simultaneously functional and thought provoking. coLAB has completed various projects in studio and public art, as well as residential and commercial architecture in Phoenix.

Dan Collins, Professor of Intermedia, joined the School of Art Faculty at Arizona State University in 1989. In addition to teaching courses in intermedia and foundations, he is founding co-director of the PRISM lab and coordinator of the foundation program in basic art instruction (artCore). He was awarded a Fulbright to Malaysia for Research and Teaching in 1987 and the Herberger College Award for Research and Creative Activity in 2000. His theoretical essays in the areas of art, education and technology have appeared in Leonardo, New Art Examiner, Computer Graphics and the Journal of Social Theory in Art Education among others. His work in sculpture and installation has been exhibited at the Boston Cyberarts Festival, the Basel Art Fair, SIGGRAPH, Scottsdale Center for the Arts, the Phoenix Art Museum, the Tucson Museum of Art and in numerous solo shows in commercial galleries in Arizona and New York.

The Company State (CO.ST) was brought to life by Arizona State University School of Art alumni, *Wesley Cleveland*, in 2005, with the help of a grant from the Arizona Commission on the Arts. Cleveland, joined by part-time collaborator/ writer/voice actor Dustin Mackerman, seeks to draw attention to the problems associated with the merging of corporate and state interests . through commentary, analogy and satire.

Cyndi Coon received a Bachelors of Fine Arts from Kendall College of Art and Design in 1997 followed by an Masters in Fine Arts from Arizona State University in 2000, with a focus in Community Based Art. She studied Painting at the Accademia Di Bella Arti in Perugia, Italy and at the New York Studio Exchange Program through the New School for Social Research. She has received several travel and research grants for her work.

Susan Copeland is a Phoenix native, educated at the Art Students League of New York and Arizona State University. Her work encompasses a variety of media including concrete, plaster, recycled materials, clay and various printmaking techniques. A dedicated social activist, her work has recently taken a political bent, dealing with issues such as incarceration, war, urban sprawl and the environment. She has participated in numerous group exhibitions in Russia and across the US, and has had solo exhibitions at the Scottsdale Performing Arts Center, Valley National Bank's Corporate Gallery, Metropophobobia and the University of Arizona. Her public art projects include integrating the natural environment with the artwork of students. She has been a member of Artists of the Black Community Arizona(ABC/AZ) since 1986.

DeBartolo Architects is the result of a 10-year collaboration between father and son. Working as partners, the elder, Jack DeBartolo Jr, FAIA (former founding partner of Anderson DeBartolo Pan Inc) graduated from the University of Houston and Columbia University and the son, Jack DeBartolo 3 AIA, graduated from the University of Arizona and MIT. Joined by an aggressive and youthful staff of five, the studio has completed works in Arizona, Virginia, New York and Philadelphia. Working to achieve significance, the pair, along with their supportive staff, aim to create unique, finely tuned buildings that respond to the climate, context and client, and achieve architectural excellence.

Tom Eckert received his MFA from Arizona State University, with advanced studies at California State University at Northridge. He uses a wide variety of wood-working techniques in his sculptural pieces, including laminating, bending, carving, turning and painting. Exhibited in over 150 national and international competitive and invitational exhibitions since 1966, his work is shown throughout the United States and, most recently, in the Netherlands. His commissions include McDonald's Corporation, OSI Industries, Arizona Governor's Award and Apple Computer Inc. His work is held in many private and public collections. He received a Visual Arts Fellowship for 3-D media from the Arizona Commission on the Arts twice, and was awarded WESTAF/NEA grants in 1993 and 1989. He is a Professor of Art at Arizona State University.

Joerael Julian Elliott is a conceptual artist, illustrator and muralist living in Phoenix, Arizona. An ex-graffiti artist, Elliott has spent his efforts directing his work into the public view through unconventional methods - usually collaborating with local independent businesses or zines. He leaves his work open for viewing to a diverse range of people. Born in the Southwest, Elliott hopes to bring a new perspective to Southwestern art by illuminating current contradictions of environment, civilization and social issues of the region.

Angela Ellsworth received a BA from Hampshire College and an MFA in Painting and Performance from Rutgers University. Following graduate school, Ellsworth attended Skowhegan on a Fellowship. Other grants and fellowships include Visual and Media Arts from Arizona Commission on the Arts, Contemporary Forum Materials Grant from Phoenix Art Museum, Art Matters and New Jersey State Council on the Arts. Her work has been exhibited in venues throughout the United States including the Museum of Contemporary Art (Denver), Museum of Contemporary Art, (Tucson), Tucson Museum of Art, Arizona State University Art Museum, Highways (Santa Monica) and the Zimmerli Museum and Noyes Museum (New Jersey). She is Assistant Professor of Intermedia in the School of Art at Arizona State University and is represented by Bentley Gallery in Scottsdale.

Denis Claude Gillingwater is an MFA graduate from the University of Cincinnati. The "rust belting" of the United States had a pronounced impact on his work. The subsequent photo/ videography of urban areas within the United States, British Isles and Europe has been the primary means for its ideational development. The imagery manifests itself in various forms; cctv surveillance systems/DVD players/miniature "bill-boarded" photographs in site-specific installations, wall works and monoprints. He has had numerous solo exhibitions and installations, most notably at the New Museum of Contemporary Art (New York), The Irish Museum of Modern Art (Dublin), The Center for Contemporary Art of Santa Fe, Slade Art Academy and Bartlett School of Architecture (London), University College London, Phoenix Art Museum and the Arizona State University Art Museum.

Gould Evans Phoenix is rooted in an agenda of NO WALLS and a belief in the power of great design. NO WALLS refers to the studio's design process, collaborative approach and office space. As "creative provocateurs," it is willing to explore the unknown in order to solve complex problems beautifully through space and form.

Jason Grubb (AKA Jehu) graduated from Kent State University with a degree in Commercial Photography. He has been a photographer in Phoenix since moving to the valley in 1994. In 1999, with a business partner, he set up his commercial photography studio, Camerawerks, and entered the downtown Phoenix art scene in 2000. He has his own original and eclectic take on photography, mixing socially acceptable and unacceptable situations, using his own analytical and humorous approach. He is currently part-owner of a downtown studio art space, Legend City. His personal and commercial photographs appear in magazines, national ad campaigns, art shows and personal collections.

Mies Grybaitis studied Art and Design at the Australian National University, majoring in Glass Sculpture. Her glass art and design work has won several international awards and has gained worldwide recognition with exhibitions in Australia, the United States, Denmark and China. In 1997, she co-founded Marwan Al-Sayed Architects with architect husband, Marwan Al-Sayed. Their collaborative work on residences has led to her work in product and interior design.

Jon Haddock has exhibited widely throughout the United States and in Europe. His work has been shown at the Whitney Museum of American Art (New York), the Arizona State University Art Museum, the Yerba Buena Art Center (San Francisco), Pace Wildenstein Gallery (New York), the Laguna Art Museum (Laguna Beach, CA), Roberts & Tilton Gallery and CherrydelosReyes Gallery in Los Angeles. He is twice the recipient of grants from the Arizona Commission on the Arts and his work is in the collections of the Whitney Museum of American Art and the Arizona State University Art Museum among many others. He received his Bachelors of Fine Arts in 1986 from Arizona State University, and his MA in Fine Arts in 1991 from the University of Iowa. He currently lives and works in Tempe, Arizona.

The art of Lee Hazel offers a window into her intricate dreams, as well as her passions and interests. Raised in Austin, Texas, the daughter of an engineering professor, she was often surrounded by foreign students and cultures. Opportunities led her to travel and study Art History, and ultimately acquire a love of the old masters, eventually landing at an art school in Paris. She then returned to Austin and began formal studies of art, obtaining a Bachelors of Fine Arts from the University of Texas. Her work exercises two realms of her creativity: impressionist works in oil on canvas and her personal work, a reflection inspired by medieval realism in "old world paintings." Also known for her exceptional portraits and murals, she lives and works in downtown Phoenix.

Heidi Hesse was born in Germany, raised in South Africa and Germany, and has lived in the United States for most of her adult life. She obtained a Masters in Fine Arts from the Ohio State University, where she studied with Sandy Skoglund and Ann Hamilton. She has been a resident artist at Bemis Contemporary Art Center in Omaha, Nebraska, the National Museum of Contemporary Art in Seoul, Korea and the City of Phoenix Light Rail. Solo exhibitions of her work have been held at the Tucson Museum of Contemporary Art, Studio Lodo (Phoenix) and PH Gallery (New York). Hesse is the recipient of numerous awards including the Artist Fellowship from the Arizona Commission on the Arts, the Phoenix Art Museum's Contemporary Forum Artist grant and the City of Phoenix Commission on the Arts artist grants. Her work is included in the Tucson Museum of Contemporary Art as well as numerous private collections.

Steve Hilton has recently finished his MFA in Ceramics at Arizona State University. He also holds an MS in Art Education and a BS in Geology. He has taught Astronomy, Oceanography, Environmental Studies, Ceramics, Sculpture, Drawing, Graphic Design and Optical Art at secondary and post-secondary levels. In 2005-06, his work, a fusion of hand built (sculptural) and wheel thrown (sometimes functional) components, has been placed in the permanent collections of museums in China and Canada. During the same time, he has been juried into one international and 11 national exhibitions in conjunction with three regional solo shows in the Southwestern United States. He is currently a member of the Ceramics and Art Education Faculty at Midwestern State University in Wichita Falls, Texas.

Angela Johnson creates directional, women's apparel from recycled T-shirts and other "thrifted" items. She is also the founder of Arizona's Fashion Directory and resource guide, Arizona Fashion Foundation / LabelHorde Fashion. She has over 10 years experience in design and production which started at The Beastie Boys' and Sonic Youth's, X-Large Clothing and X-Girl, respectively, and eventually led to the creation of her own line, "monkeywench", a girl's street wear line which she shared with Days of Our Lives actress, Christy Clark. Today, Johnson designs under her own name and has received The Scottsdale Cultural Council's Artist of the Year award and Fashion Group International's Rising Star award.

Jones Studio Inc is an eleven-person office, widely recognized as one of the pivotal players in the new "Arizona School" of architecture. Led by brothers Eddie and Neal Jones, the studio specializes in design for the Sonoran desert environment. The recipient of over 145 national and regional design awards, Jones Studio has received international recognition for its knowledge and experience in providing environmentally sensitive architecture, all with the common theme of design excellence. The architecture of Jones Studio Inc reflects two primary traditions: the site-integration of Frank Lloyd Wright and the visionary organicism of Bruce Goff.

Mayme Kratz was born in San Diego County, California, and has lived in Phoenix since 1986. Self-educated and focused on her creative life at an early age, she apprenticed with artist James Hubbell in her early twenties. Her previous solo exhibitions were held at institutions such as the Tucson Museum of Art and the Tacoma Museum of Glass and she has participated in group exhibitions at the Scottsdale Museum of Contemporary Art, Phoenix Art Museum and Blue Star Art in San Antonio Texas. Kratz was a visiting artist at Pilchuck Glass School in Stanwood Washington and held a residency at the Museum of Glass in Tacoma Washington. She is represented by and exhibits regularly

at Lisa Sette Gallery (Arizona), Anne Reed Gallery (Idaho), William Lipton Ltd (New York) and Hayes George Gallery (North Carolina).

Born and raised in Italy, Antonio Larosa studied Architecture and Design at Milan Polytechnic University in Italy. He also studied City Planning at the University of Calabria and Archaeology at the University of Milan. Following graduation, Larosa moved to the United States to work as a design consultant for several design companies before starting his own business as an independent architect-designer. For the past 20 years, he has worked on a wide range of projects from architecture and interior design to furniture and product design, and urban planning. He has designed collections of furniture and accessories for the residential and contract markets, manufactured in United States and Europe, and marketed worldwide. Larosa has taught Furniture Design and Interior Design in Italy and at Arizona State University.

Los Cybrids - René Garcia, John Jota Leaños and Praba Pilar - is a junta of poly-ethnic cultural diggers of the Latino sort dedicated to the critique of cyber-cultural negotiation via tecno-artistico activity. The group brings to the fore the mythologies of emergent digital technologies and, lending barrio perspectives to high tech rhetoric, they pierce utopian/dystopian paradigms and promises that accompany the marriage of capital and new technology. Los Cybrids detonate reality bombs through performance, burla, high-tech and installation art, infiltrating public media spaces that disturb the alarmingly uncritical, passive acceptance of emerging technologies of the internet and post-IT boom.

Sound artist Richard Lerman works in music, media, installation and performance, often constructing functional microphones from diverse materials. These transducers amplify sounds too soft for our ears alone, allowing the sonic flavor of each material to be heard. Recent installations with audio and video include Fences-Borders, gathered from fences along the Mexico/United States border, Biopsy, gathered from windharps and needles plunged into the salt at Death Valley and Relocation: Alaska, a collaboration with Mona Higuchi concerning the forced relocation of the Aleut People during WW2. He has received grants from the Guggenheim Memorial Foundation, the Asian Cultural Council and the NEA amongst others, and has performed and presented his work internationally and nationally. He is Professor of Media and Digital Arts at Arizona State University.

Laurie Lundquist holds an MFA in Sculpture from Arizona State University, a BFA from the Maine College of Art and attended The Skowhegan School of Art as a recipient of the Langlais Fellowship. She has completed more than a dozen public art commissions and participated in several planning efforts for the Phoenix metro area. Her work is concept driven and responsive to the aesthetic

and environmental conditions of a given site. Lundquist has received national recognition for projects that use water as a lens to examine the interface between mechanical and natural systems at work in the desert.

Jeff Lyon was raised in Hallowell, Maine, and now lives in Scottsdale, Arizona. Growing up he took several years of drawing classes and was deeply influenced by his father's engineering drawings of bridges and structures. He holds a BS from the University of Maine and an MS from Arizona State University, both in Mechanical Engineering. After working in the aerospace industry for several years, Lyon returned to Arizona State University to continue his artistic studies in drawing and painting. As an emerging artist in the Phoenix community, he has had several private and group shows. Lyon's work was also included in the Phoenix Art Museum's 2006 Building a Collection exhibition.

McCoy and Simon Architects was founded by Ron McCoy and Janet Simon in Los Angeles in 1985. Ron McCoy graduated with a Masters in Architecture from Princeton University and was on the Faculty at the Southern California Institute of Architecture (SCI-Arc) from 1985-1995. He served as Director of the School of Architecture and Landscape Architecture at Arizona State University, and is currently Professor and University Architect. Janet Simon graduated with an MA in Architecture from SCI-Arc and received the Dinkleoo Prize for Architecture in 1992.

Sloane McFarland is beta testing a being entity named "Martha + Mary." "Martha and Mary" were sisters to Lazarus, the man who died and was brought back to life by Jesus. Martha has come to be known as a worker bee, Mary as one more spiritually oriented. Projects have been created in video, performance, real estate development, hospitality and goods/services.

Sherrie Medina is a practicing artist and independent curator. Born in Anchorage, Alaska, she has lived in the Phoenix metropolitan area since 1995. Medina attended the Cornish Institute for the Applied Arts, received a BFA at the Art Institute of Chicago and an MFA in Sculpture from Arizona State University. She has shown her work from California to Seoul, Korea, and has focused her curatorial efforts in Phoenix. She continues her investment in Phoenix and its growth as a great city by contributing to the evolution of the College of Design at Arizona State University.

Leigh Merrill grew up in Albuquerque, New Mexico. In 2001 she graduated from the University of New Mexico with a BFA in Photography. She has held solo shows in Phoenix and Albuquerque (New Mexico), and has participated in group exhibitions in Albuquerque (New Mexico), Bloomington (Indiana), Denton (Texas) and Phoenix. She is currently a member of the Eye Lounge cooperative gallery in Phoenix.

Camille Messina was born in Phoenix in 1980. Although she received no formal training, she has always been interested in clothing construction and fashion design, and was involved in her first large fashion show in 2002. Her designs mostly use unconventional materials like paper and metal. More recently, her work evolved to tailored pieces including a wedding dress. She works creatively in many different forms: besides fashion, she also makes music and works as a hairstylist in Tempe, Arizona.

was born and raised in Bulgaria and earned a Masters in Fashion Design and Textiles from the Academie of Fine Arts in Sofia. In 1992 she immigrated to the United States where she later received the Grand Prize in the International Furnishings and Design Association competition. The US Department of Justice in 1997 awarded her the Honor of Alien of Extraordinary Ability in the Arts. Most recently her designs have been featured on live television and in printed publications including Trends and Sonic magazines as well as the Arizona Republic and the East Valley Tribune newspapers. Her innovative designs are commissioned privately and by a growing number of fashion leaders. She has been commissioned to design costumes for Ballet Arizona, Sister Sledge and Bill T Jones. Unbounded by the old rules, Mihaleva now offers her work as a joyful testimony to the power of beauty and expression, and to the transcendent human spirit.

Matthew Jason Moore received a BA from Santa Clara University in 1998 and an MFA from San Francisco State University in 2003. He returned from San Francisco to manage his family's four-generation farm 35 miles West of Phoenix. He has participated in group exhibitions from the West to the East coast, such as SouthwestNET: PHX/LA (Scottsdale Museum of Contemporary Art), Tender Land (Armory Center for the Arts), Regarding the Rural (Massachusetts Museum of Contemporary Art). Most recently, Moore had a solo exhibition at the University of Southern Mississippi.

Mark Newport was born in Amsterdam, New York and now lives in Mesa, Arizona. He earned his MFA from the Art Institute of Chicago in 1991. Newport has been awarded grants from the Creative Capital Foundation and the Arizona Commission on the Arts. He has had solo exhibitions at the Arizona State University Art Museum, the Chicago Cultural Center, the San Diego State University Art Gallery and group shows throughout the United States, Canada and Europe. The lyonswier gallery of New York and the Greg Kucera Gallery of Seattle, WA, represent his work.

Matthew Paweski was born in Detroit and lives and works in Tempe, Arizona. In 2005 he graduated with a BFA in Printmaking from Arizona State University. He has had solo shows in Phoenix (1023 Grand Ave), Tempe (Third Street Warehouses) as well as group shows throughout the city. He was included in the Arizona State University Art Museum's New American City 2006 exhibition.

Darren Petrucci is Director of the School of Architecture and Landscape Architecture at Arizona State University where he also runs his applied research lab, SCAPE [Systems Components Architectural Products + Environments]. He is the founder and principal of A-I-R [Architecture-Infrastructure-Research] Inc. He received a Masters in Architecture and a Masters in Architecture & Urban Design with distinction from Harvard University's Graduate School of Design. His design and research focuses on what he calls "Amenity Infrastructure" which develops new public/private urban infrastructures that facilitate multiple scales of public use within the contemporary city. He is the winner of a Progressive Architecture Award from Architecture Magazine and the NCARB Prize for Excellence in Teaching and Practice. His work has been published widely and has been exhibited in Phoenix, New York and at the Scottsdale Museum of Contemporary Art.

Christy Puetz went to the University of North Dakota to swim and ended up with a Bachelors of Fine Arts, with a focus in Fiber Arts, in 1993. She has been creating and exhibiting her work across the United States since 1990 and her art has been shown in over 65 exhibits around the country including Eye Lounge contemporary art space, Phoenix, Arvada Center for the Arts (Arvada, Colorado) and the Delaplaine Visual Arts Center, (Frederick, Maryland). She has also been selected for numerous book compilations including The Best in Contemporary Beadwork and has created temporary public art for the City of Phoenix. Currently, Puetz works with all ages in school residency and community art programming.

Richärd + Bauer Architecture is a studio based, integrated architectural and interiors practice focusing primarily on higher education, research, public and academic library design. The studio was founded in 1996 by architect James Richärd AIA, and interior designer Kelly Bauer IIDA and subsequently joined by architect Stephen Kennedy AIA in 1999. The firm's principals were educated at the University of Arizona in the Tucson Sonoran Desert, developing sensitivity to the context of the region and environment. Having worked for large companies, they understand that even major projects are executed by small groups of dedicated people with a common vision. To that end, the firm remains an intimate scale of 10 highly skilled and motivated people. Richärd + Bauer Architecture has received over fifty local, regional, national and international design awards, and was recognized as an "Emerging Voice of 2001" by the Architectural League of New York and as one of the "New Vanguard" by Architectural Record in 2002.

The art of Hector Ruiz hovers between categories: fine art and folk art, insider and outsider, simple and complex. His medium of choice is wood and his carefully calibrated carvings take definite jabs at politics, consumers and materialism. Although the work seems immediate, it would be a mistake to assume that it is also one-

sided and simple. His work invites the viewer to become active, sometimes even forcing them to physically engage (touch, pull or turn) the work of art in order to reveal further and deeper meanings. Everything is painstakingly handmade, using intentionally simple materials (candy foil, papier-mâché, old signs and wood scraps) and a variety of hand tools.

Mark Ryan grew up in the desert near Phoenix. He received his initial training in architecture at the University of Cincinnati, while also lettering in Intercollegiate Athletics. As an undergraduate he also spent time in Greece, through the University of Illinois, studying Urban Design and later did his graduate work at the Architectural Association in London on a Foundation Scholarship. He lived and worked in Germany, Italy, England and various parts of the United States before returning to Phoenix to open his own studio. He is involved in public art, in addition to architecture, and is a visiting professor in the School of Architecture and Landscape Architecture at Arizona State University.

Gregory Sale is known for art that ranges from object making to a form of "constructed happenings." These experiential events often involve narrative, story telling or simple dialogue-based interviews. His solo and group exhibitions include Love Stories at Trunk Space (Phoenix), Tight at POST Gallery (Los Angeles), You Still Draw Like a Girl at Sixth Street Studios (Phoenix) and Nooks and Crannies at Arizona State University Art Museum (Tempe). Performance work includes Looking for Yoko Ono that debuted at Champ Libre (Montreal) and Touching Revolution for the Phoenix Art Museum. Gregory currently serves as Visual Arts Director for the Arizona Commission on the Arts.

Victor Sidy, AIA is an architect, inventor, writer and educator. He received his architectural training from the Frank Lloyd Wright School of Architecture after receiving Arizona's Flinn Foundation Scholarship. He has worked with artists, architects, and planners in Russia, Germany, the Netherlands and the United States on a variety of case-study projects, bridging the divide between art and architecture. He hosted a television series on architecture for EMG Satellite Television that aired from 1996 to 1998 and was the youngest member of Architecture Magazine's May 1999 feature "Young Americans". He currently serves as Dean of the Taliesin School of Architecture in Scottsdale, Arizona.

Randy Slack was born and raised in Phoenix, where he continues to work and live. He is a co-founder of the sometimes collective, 3carpileup, which has been seminal in defining the "Downtown Phoenix" style and attitude. Though shunned by mainstream galleries, he

has received extensive media attention from the local press including the Arizona Republic, Desert Living, Arizona Foothills, Java and Shade magazines, as well as numerous television features. He has been mentioned in Sunset Magazine, Elle and Art in America. His work is in the permanent collection of the Scottsdale Museum of Contemporary Art.

Erin V Sotak received her BFA in Photography from the University of Arizona and MFA in Photography from San Jose State University. She has instructed Photography at community colleges, a small liberal arts college and major university settings. As a photographer, installation and performance artist, her work incorporates a variety of mediums including film, video, sculpture, clay, textiles, painting and woodworking. Her work has been exhibited nationally in Texas, Arizona, California, Delaware, Georgia, Ohio and internationally in Bogota, Colombia and Slovakia.

Karolina Sussland was born in the Czech Republic and immigrated to the United States after being granted political asylum in Austria. Initially attending Arizona State University for a degree in Chemistry, she realized that art was what she really wanted to do and decided to pursue an education in drawing instead. Realizing that most people do not end up working in their field of study, it made sense for her to study what she loved. She is currently teaching Algebra and Geometry at Metropolitan Arts Institute, an arts focused college prep high school. Her work has been reviewed in Art Papers, Shade, New Times and the Arizona Republic.

Vernon D Swaback, FAIA, FAICP is an architect and planner. He began his training at the University of Illinois before moving to Arizona in 1957 to become an apprentice to Frank Lloyd Wright. He remained with the Wright Organization for 22 years where he served as Director of Planning and was responsible for many of the organization's major architectural projects. Swaback is Managing Partner of Swaback Partners pllc, a 40-person, multi-disciplinary firm established in 1978 and headquartered in Scottsdale. The firm provides planning and architectural services for a wide range of institutional, commercial and residential involvements.

The art of Beth Ames Swartz searches for the shared myths that unite societies. The evolving phases of her work intertwine myth-like visual elements from many areas of wisdom, including those of the American Indian, Buddhism, the Kabbalah, the chakra system of yoga, Taoism and Qi Gong. She received an MFA from NYU and a BS from Cornell University. She has had over 70 one-person art exhibitions, including a solo show at the Jewish Museum in New York as well as three major traveling museum exhibitions.

Her work may be found in public collections such as the National Museum of American Art, Phoenix Art Museum, the San Francisco Museum of Modern Art, Scottsdale Museum of Contemporary Art and the University of Arizona Museum of Art in Tucson Arizona. Swartz is represented by Vanier Galleries in Scottsdale and the Chiaroscuro Gallery in Santa Fe.

Christy Ten Eyck, FASLA founded Ten Eyck Landscape Architects inc in 1997. Ten Eyck fell in love with the wild Arizona landscape on a raft trip down the Colorado river in 1985 and has been working on various landscape architectural projects ever since her move from Dallas, Texas to Phoenix in 1986. The majority of Ten Eyck's work centers on public and private spaces in the Phoenix metropolitan area that speak of the region and connect the urban dweller with the quickly disappearing Sonoran desert. She holds a Bachelors in Landscape Architecture from Texas Tech University and was elected a Fellow of the American Society of Landscape Architects in 2003.

Chris Todd was born in Seattle, Washington, and now resides in Tempe, Arizona. He received his BFA in Digital Art from Central Washington University in 2002 and began graduate work in the Intermedia program at Arizona State University in 2003. He has shown his work in a variety of exhibition spaces and public/commercial sites, primarily in the Northwest and Southwest United States. His art-making process resists conventional categorical distinction, often blending hand-made objects, electro-mechanics, performance, photography, video and computation.

Theodore Troxel grew up in Phoenix and attended the University of Arizona earning a BFA in Painting and Drawing, followed by an MFA from Mills College. On his return to Phoenix, he has shown work at Eye Lounge and completed temporary public art projects in the area. He often combines animal forms with urban materials to explore the human instinct for survival.

blank studio was founded in 2001 by Matthew G Trzebiatowski who completed his Masters in Architecture at the University of Wisconsin at Milwaukee School of Architecture. The studio was created to honor the capacity for architecture to challenge, inspire and elevate design awareness in an environment that is directed toward increasingly simplistic and synthetic solutions. blank studio endeavors to transcend meaninglessness and create that which is a testimony to the potential of the designed environment. In addition to working on realized projects, Trzebiatowski has also actively participated in the theoretical realm through teaching and taking part in various local and international design competitions.

Ellen Wagener received her BFA from the Corcoran School of Art in Washington DC in 1989. She subsequently moved to Iowa and developed a practice of creating large-scale pastel drawings based on observation, personal photography and media imagery. She has had major exhibitions at the Cedar Rapids Museum of Art and the Figge Art Museum, Iowa. Contrary to the typical use of pastel, Wagener builds up her images in layers with almost photographic precision. She moved to Arizona in 2002 and continues her working methods in a more conceptually layered manner.

Kurt Weiser studied under Ken Ferguson at the Kansas City Art Institute and received an MFA from the University of Michigan. He was the Director of the Archie Bray Foundation for the Ceramic Arts in Helena Montana until 1988, when he began teaching at Arizona State University where he is now a Regents Professor. Weiser has twice received fellowships from the National Endowment for the Arts. He has exhibited extensively with the Garth Clark Gallery in New York and the Frank Lloyd Gallery in Santa Monica, California. His work is in the collections of the Victoria and Albert Museum (London), Los Angeles County Museum of Art and the Smithsonian Museum of American Art (Washington DC) among many others.

is a self-taught architect who also designs and builds furniture. He received his architectural registration in 1965 and has been in private practice since 1966. Intrigued by the possibilities of modernism and the desert, he relocated from Miami, Florida, to Phoenix in early 2001. Furniture exhibitions have included Interieur (Kortrijk, Belgium), Zeus / Noto (Milan), North Miami Museum of Contemporary Art, Fredric Snitzer Gallery (Miami), Icon 21 (New York) and New Urban Art (Phoenix). His one-off furniture is in the Montreal Museum of Fine Arts, as well as in the homes and offices of private collectors. His work has been featured in publications such as Abitare, Ambiente, Architectural Record, Eigenhuis & Interieur, Hauser, Wohnen and others.

William Wilson graduated from the University of New Mexico with a Dissertation Track MFA in Photography and promptly moved to Central America where he worked as a photojournalist with the Associated Press and the Tico Times. Since returning to the states he has taught Photography and Sculpture at the Institute of American Indian Art and Oberlin College. Presently, he is the Co-director of the Barrio Anita Mural Project, the largest public art project in Tucson history, comprising three murals rendered in Venetian glass mosaic tile, steel and cast concrete, measuring approximately 12,000 square feet. He teaches Photography at the University of Arizona in Tucson. Wilson is represented by the Berlin Gallery of the Heard Museum in Phoenix, Arizona. He recently served as Artist in Residence at the Heard Museum in Phoenix.

Michael A Wirtz moved to the Phoenix valley from the mountains of Wyoming to pursue his MFA at Arizona State University. Since graduating in 2004, he has been honored by the Contemporary Forum of the Phoenix Art Museum through the organization's Artists Grant program. His work has been included in many regional, national and international shows including the Arizona Biennial in Tucson in 2005 where he won the Award for Excellence, and the Americas 2000 international exhibition of works on paper in 2006 where he won the Juror's Award. He has taught classes in Drawing, Painting, Color and Design at Arizona State University, Central Arizona College and Mesa Community College.

has been exhibiting stunning, controversial and thought provoking works since the mid 1990s. The main body of Yazzie's painterly work is oil on canvas and panel, yet he also explores other media including charcoals, acrylics, house paints and enamels on vinyl and wood. Sculpture, found objects, mixed media and experimental printmaking are also entering his recent work. Yazzie combines several different elements in his work: a trenchant political sensibility, a certain irreverence of character and a black, though intellectual, sense of humor. He has described his paintings as "occasionally semi-autobiographical," drawn from the urban ethereal experience. Yazzie's unique convergence of universal truths, mythic past and contemporary vision brings an energetic presence.

PHOTOGRAPHY CREDITS Cover image, P.001-027: Tomoko Yoneda | P.028-031: Erin V Sotak | P.032-034: Peter Ellis | P.035: Aaron Abbott | P.036+037: Marcus Schwier | P.038+039: Claes Bergman | P.040-045: Bill Timmerman | P.046: Rose Lausten | P.048+049: Tomoko Yoneda | P.050: From the collection of Bill Hardin, courtesy of Bentley Gallery | P.053: Bill Timmerman | P.064+065: Nick Hazel | P.066+067: Tomoko Yoneda | P.069: Chris Todd | P.070+071: Carlton Wolfe | P.074+075: Jeff Lyon | P.078+079: Mark Newport | P.080+081: Brynn Kolinski | P.083: Tim Lanterman | P.084-089: Matthew Jason Moore | P.091: MetroChairs, New York | P.092+093: Tomoko Yoneda | P.094+095: William Wilson | P.096: Linda Foss Asakawa | P.098+099: Michael A Wirtz, courtesy of the artist | P.100+101: Jeremy M Briddell | P.102+105: Craig Smith | P.106+107: Brandon Sullivan | P.108+109: Brent Hirak | P.110+111: Tomoko Yoneda | P.112+113: Kurt Weiser | P.114+115: Theodore Troxel | P.116: John Nickolich | P.118-121: Steven Hilton | 122+123: Paul Warchol | P.124+125: Camerawerks | P.126+127: Victor Sidy | P.128+129: Steven J Yazzie | P.130+131: Tomoko Yoneda | P.132+135: Bill Timmerman | P.136+137: Kristin Fukuchi | P.138+139: Stills from the video Child of God, courtesy of the artist | P.140-143: Liz Cohen | P.144-148: Bill Timmerman | P.150+151: Tomoko Yoneda | P.152+153: Inchang Hwang | P.156+157: Cyndi Coon | P.158+159: Rebecca Ross | P.160+161: Wayne Rainey | P.162+163: Bill Timmerman | P.166+167: Jason Grubb, Camerawerks | P.168+169: Tomoko Yoneda | P.170-175: Bill Timmerman | P.180-187: Mark Boisclar | P.182+183: Timothy Hursely | P.188+189: Tomoko Yoneda | P.198-203: Wayne Rainey, Rainey Studios | P.204 (Top): Scott Morrow | P.204 (Bottom): Angela Johnson | P.205: Scott Morrow | P.206-207: Tomoko Yoneda | P.208-211: Mark Boisclair | P.212+213: Tim Hursley | P.214+215: Tim Lanterman, courtesy of Lisa Sette Gallery | P.216+217: Tomoko Yoneda | P.218+219: Denis Claude Gillingwater | P.220+221: Tomoko Yoneda | P.222-225: Bill Timmerman | P.226+227: Karolina Vera Sussland | P.228: Lew Alquist | P.230+231: Gene Cooper | P.232+233: Richard Lerman | P.234-240: Tomoko Yoneda |

PROJECT CREDITS P.004+005: Leonor Aispuro, Debris Blanc/Tee Roy, Miachelle DePiano, Kristin Dinnis, Catherine Garrigan, George Johnson, Matt Krise, Gloria Marsiglia, Rhonda Zayas | P.012+013: Apache Skateboard Team | P.036+037: Project engineering by SVR Inc P.053: Graphic design for canopies by Jennifer Brungart; (Foreground image) Electric Prayers by Quetzal Guerrero, 2004, acrylic and mixed media on wood; (Background image) Icarus Dreams by Erin V Sotak, 2004, C-print from installation P.080+081: Hair by Melinda Crick P.182+183: Co-created by Lord, Aeck & Sargent | P.204 (Top): Modeled by Monica of S.I.M. Agency; Hair by Urban Hair; Makeup by Robert Saenz | P.204 (Bottom): Modeled by Caitlin Turner | P.205: Modeled by Daynalyn of The Agency AZ; Hair by Urban Hair